PRE-COLUMBIAN MAN
FINDS CENTRAL AMERICA

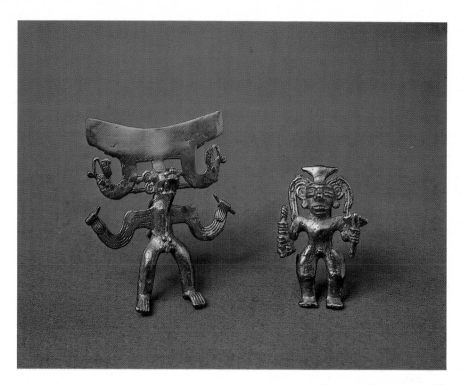

Lower Central American cult images in gold.

PRE-COLUMBIAN MAN
FINDS CENTRAL AMERICA

THE ARCHAEOLOGICAL BRIDGE

DORIS STONE

PEABODY MUSEUM PRESS

PEABODY MUSEUM OF ARCHAEOLOGY AND ETHNOLOGY

HARVARD UNIVERSITY · CAMBRIDGE, MASSACHUSETTS

TO MY HUSBAND
ROGER THAYER STONE
WHOSE INTEREST AND ENCOURAGEMENT
HELPED MAKE THIS BOOK

Introduction

Although the Museum has in the past published a number of special volumes not in their regular series (for example, Bowditch's book on Maya hieroglyphics and Willoughby's on New England archaeology), there has never before been a special Peabody Museum imprint. Therefore it is with great pleasure that we inaugurate a series that we hope will be a significant addition to our publishing program. The term "Peabody Museum Press" has been approved by the Museum Faculty and is now applied to this first volume.

As I have pointed out elsewhere, the Peabody has a long tradition of publishing the works of female archaeologists and ethnographers, going back to its first volume of Papers. This current author is, of course, no stranger to Peabody publications, having published four monographs in archaeology and ethnography in our other series. She has other ties with Peabody that go back to her Radcliffe days and to a warm friendship with Professor Tozzer. More recently we have been pleased to formalize her relationship to this institution with the title of Research Associate, and she has graciously served on our Visiting Committee as well.

Her background for this present work extends over a long period of time beginning with an early interest in archaeology combined with years of residence in Costa Rica. Her personal familiarity with the area she writes about is extraordinary, and although my own knowledge of the actual number of her field trips is somewhat anecdotal, her numerous journeys on mule back with Sam Lothrop and other archaeologists in pursuit of elusive sites in the Central American jungles were epic at a time when that sort of thing was not being done. So she has learned most of her archaeology at first hand and has a wide comparative knowledge of the adjacent areas.

The volume is intended as a popular presentation of the prehistory of the area and will serve as an introduction and guide for interested visitors. For ease of reading all footnotes have been eliminated, but the appropriate bibliographic references for each chapter are collected at the end of the work as a source for the topics covered. It is to be hoped that, as additional funds and manuscripts are available, the Museum will be able to add through such publications to the general knowledge of the archaeology of many parts of the world. It is a superb opportunity to illustrate, often for the first time, many of the lesser known holdings of the Museum's large collections.

<div align="right">
Stephen Williams, Director
Peabody Museum
</div>

Contents

Illustrations

Chapter 4

Acknowledgments

A book is seldom made by writing alone and this is particularly true of *Pre-Columbian Man Finds Central America: The Archaeological Bridge*. Constructive criticism from Gordon Willey, Robert Wauchope, and Carlos Balser, the suggestions of Carol Gifford, and the precise and constant attention of Stephen Williams have helped the story told in these pages. Likewise, the careful editing of Emily Flint and the painstaking planning and designing of the book by Burton Jones, the skill of the photographers and artists in the accompanying list, as well as the cooperation of private collectors and public museums have had important parts in the creation of this volume. To them all, the author gives her sincere thanks.

Doris Stone

PRE-COLUMBIAN MAN
FINDS CENTRAL AMERICA

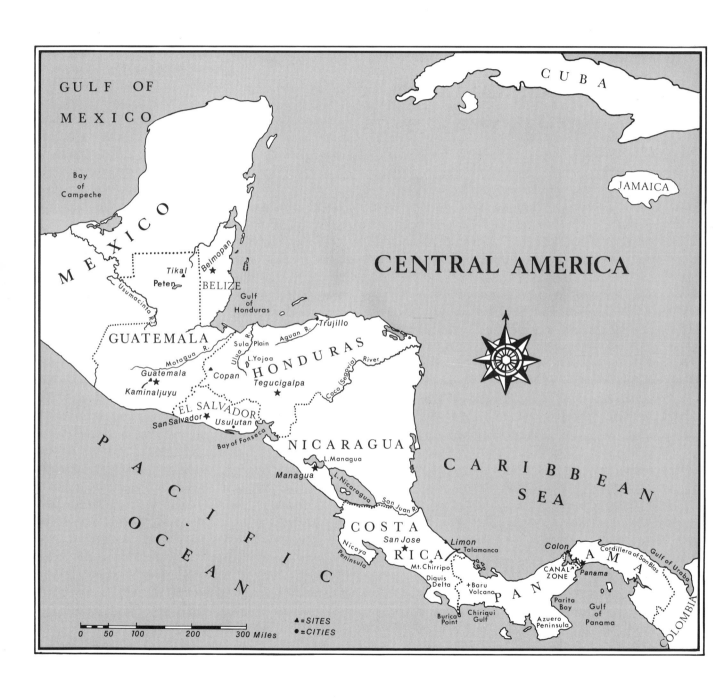

GULF OF
MEXICO

Bay
of
Campeche

M E X I C O

Usumacinta R.

Tikal ▲
Peten

Belmopan ★
BELIZE

Gulf
of
Honduras

GUATEMALA

Motagua R.

Sula Plain
Ulua R.

L.Yojoa

Aguan R.

Trujillo

HONDURAS

Copan ▲

Tegucigalpa ★

Coco (Segovia) River

Guatemala ★
Kaminaljuyu ▲

EL SALVADOR

San Salvador ★ Usulutan
Bay of Fonseca

NICARAGUA

L.Managua

Managua ★

L.Nicaragua

San Juan R.

CENTRAL AMERICA

CUBA

JAMAICA

C A R I B B E A N
S E A

P A C I F I C O C E A N

COSTA
San Jose ★
RICA
Nicoya
Peninsula

Mt.Chirripo +
Diquis
Delta
+ Baru
Volcano
Burica
Point Chiriqui
Gulf

Limon
Talamanca

Colon

P A N A M A

CANAL
ZONE Panama ★

Cordillera of SanBlas Gulf of Uraba

Parita
Bay Gulf
of
Panama

Azuero
Peninsula

COLOMBIA

0 50 100 200 300 Miles

▲ = SITES
● = CITIES

The Mingling of Peoples

Central America, the mountainous curving isthmus which joins the two continents of the western hemisphere, serves as a corridor for fauna, flora, and peoples. Upper Central America, the northern or western portion of this region, includes the republics of Guatemala, El Salvador, and western Honduras from the Gulf of Fonseca through the Comayagua Valley to the eastern limits of the Sula Plain. East and south of this frontier is Lower Central America, embracing the rest of Honduras, Nicaragua, Costa Rica, and Panama; culturally it is a marginal area between the highly developed civilizations of the north and south.

Competent scholars have written many books about the archaeology of Mexico and Upper Central America, territory included under the term Mesoamerica. Within this region are the Maya lowlands where the Guatemalan Peten and the headwaters of the Usumacinta River, usually considered the cradle of Maya culture, form component parts. None of these places has been stressed in the following pages and only a passing survey has been given of Classic Maya civilization with all its mastery of art and calendrical achievement. Instead, I have placed emphasis on Lower Central America, which for the most part has been neglected.

At the time of European arrival in the sixteenth century, Lower Central America, whose cultural roots point to South America, was coming more and more under the influence of peoples from the north. Even earlier, in the long-past era of the Preclassic, radiations of advanced esthetic and social developments penetrated east of the upper isthmus bringing with them a complex and lasting relationship to Mesoamerica. The concepts and the stages of such infiltrations as well as their impact on non-Mesoamerican culture helped to change the living patterns of many of the aboriginal inhabitants and are reflected in the archaeology of the region.

The first cultures in Central America are revealed only through ceramic phases without knowledge of the ethnic identity of the peoples responsible. In the Classic Period, many cultures in Central America can be associated with historic names, particularly in places where Mexican tribes had penetrated. In other words, the archaeological phases had developed into recognizable cultures. The Maya, Lenca, and Paya peoples are examples in point. However, the farther east one goes in Lower Central America, the less cognizant one is of tribal terminology. This is particularly true of most of Costa Rica and Panama where not until the Postclassic Period or the very end of the Classic can tribal names be assigned to specific cultures.

From Mexico, the northern neighbor of Central America, the movements of peoples through the entire isthmian territory and the impact of cultures as well as local artistic developments give us a better understanding of Lower Central America and its relationship to Mesoamerica. Only at the eastern end of the isthmus, from the Panama Canal to Colombia, is there little hint of Mesoamerican traits. As we pass from period to period, it becomes clear that the great cultures of Mexico with their inherent vitality had extended their influence beyond Honduras through constant economic expansion and often under the guise of religion.

In fact, the first evidence of cultural infiltration is religious in character. Jadeite Olmecoid figurines and gigantic stone heads, undoubtedly related to cultures of the Mexican Gulf coast, appear in Pacific Guatemala. Caches and the use of cinnabar mark the trail to western Honduras. Ceremonial centers, the concept of stone shaft and bench figures, jade axe-gods, distinctive pottery types, and rimless grinding stones used for the preparation of maize meal are among the many artifacts which in very early times were carried into Lower Central America by peoples from the north. The cult images were not always permanent, perhaps because those who introduced them did not remain for long in the new environment. In Lower Central America, for example, axe-gods were frequently reworked into deities associated with the south, but the blue-green stone of which they were made and similar types of stone became an integral part of the luxury inventory in much of the lower isthmus, thus strengthening the commercial relationship with Mesoamerica.

By the eve of the arrival of the Spaniards, Mexican peoples had

brought their gods, their calendar, and their manner of living so far east, particularly on the Pacific coast, that the boundary of Mesoamerica extended like a narrow tongue from El Salvador through the Nicoya Peninsula of Costa Rica, and its influence penetrated the periphery of central Panama. How long Lower Central America might have retained its own characteristics intact if the discovery of the New World had been delayed, one cannot say. It is clear, however, that the process of Mesoamericanization was well advanced when Christopher Columbus and his men sighted the shores of Honduras in July, 1502.

GEOGRAPHY AND TERRAIN

Although I am concerned chiefly with the archaeology of the six independent republics, Guatemala, El Salvador, Honduras, Nicaragua, Costa Rica, and Panama, it is necessary to discuss parts of Mexico, particularly the state of Chiapas, which plays an important role in the human history of the whole territory.

Occurrences on the central plateau and in other areas of Mexico affected the inhabitants of the land extending from the Isthmus of Tehuantepec to the eastern limits of the Darien mountains at the Panamanian-Colombian frontier. Volcanic chains are characteristic of this region as well as swamps and savanna land and palm, deciduous, rain, and cloud forests.

Four natural passes traverse the area: the Isthmus of Tehuantepec, the Comayagua Basin in Honduras, the San Juan Depression in Nicaragua, and the strip now known as the Panama Canal. The San Juan Depression divides this continental link geographically.

Physically, Upper Central America is a rugged, highly eroded area, which, on the Gulf of Mexico and the Caribbean side, has fertile alluvial plains favored by the northeast trade winds that periodically bring beneficial rains. Four glaciations in Central America have produced a heterogeneous vegetation similar in many ways to that of the southeastern United States. The last of these ice masses stopped at the San Juan Basin and brought the pine tree with it. Volcano-created lakes and occasional dry lowland basins form part of the natural environment. There are few rivers of importance on the Pacific side. Except for the Gulf of Fonseca, the coast is inhospitable from the lagoons of Tehuantepec southward, and throughout its length the Pacific coastal strip has become consistently drier during the centuries.

Most of Upper Central America is very well known. Guatemala, so closely akin to the Maya both today and yesterday, has two mountain ranges lying on an east-west axis: that of the pine- and oak-covered Alto Cuchumatanes with the Alto Verapaz, which extends into the Cockscomb Mountains of Belize, and a continuation of the Chiapas Cordillera along the Pacific with volcanic peaks such as Santa Maria and Fuego. The broad and in part desertlike Motagua Valley separates the two ranges. In the central highland area, Atitlan, the result of the formation of an immense volcanic cone, is a lake where the volcanic glass, pumice, still floats upward from the dark depths of often turbulent water. Deposits of pumice are also found in the vicinity of Lake Amatitlan, a favorite place for underwater archaeologists, who bring up incense burners and other ceremonial vessels cast as offerings in ages long past.

On the Pacific side, a southern coastal strip with soil washed from the steep slopes offers rich land for agriculture. Beyond this lie the estuaries and shore of the Pacific Ocean.

In the north, the Peten, dotted with lakes and cenotes (sinkholes), forms part of the Usumacinta basin, broken by low lines of limestone hills. A land of tropical rain forests, it is the heart of the Maya lowlands containing among its countless ruined sites those of Uaxactun, Seibal, Piedras Negras, and the towering Tikal.

The volcanic chain of Guatemala runs east into El Salvador and is partially broken by the Lempa River, much of whose water comes from Lake Guija, only to reappear in the east in northern Usulutan and San Miguel. From Guatemala and Honduras, spurs of the Merendon Range extend into the country in the north, while in the northeast the Honduran highlands thrust southward from the Sierra. The Pacific coastal plain, stretching south of the mountainous interior, is covered mainly with grasslands plus some palm and buttonwood trees and is interrupted by volcanic cones, the most eastern being Conchagua. Indeed, vulcanism is characteristic of El Salvador, and the central valley where the capital, San Salvador, is situated is called the "Valley of the Hammock" from the frequent swaying of the earth.

Cotton, sugar cane, and coffee are the chief agricultural crops. Cattle raising is important throughout the country. El Salvador was culturally a mixed region where peoples of eastern Central America such as the Cacaopera, speakers of the Misulupan language group, met those of Macro-Mayan tongue, the Xinca, who also inhabited

southern Guatemala, and the Lenca of eastern El Salvador and Honduras. The Chorti and Pokomam Maya likewise shared the land of Guatemala, El Salvador, and southwestern Honduras.

Nahuat speakers from Mexico whose descendants can still be found among the inhabitants of Izalco and Panchimalco were extremely important in the cultural life of much of ancient Central America. Once growers of cacao on a large scale, they now practice subsistence farming with coffee as the cash crop. They still cook on floor hearths, use the tumpline for carrying, weave on belt looms, have curers, and believe in magic. Izalcos live in wards and have a market. A chief, whose position depends on personality, represents his people before the national government. A head man in charge of a group of elders directs religious (Roman Catholic) matters. Authoritative staffs are kept in special organization (cofradia) houses. Panchimalco occupies a municipality and has community endogamy, patrilocal residence, and minor functionaries. The cofradias own rentable land but not houses and the town itself is without a market place.

Covering approximately 44,500 square miles (about the size of Pennsylvania), the Republic of Honduras is bounded on the north by the Gulf of Honduras, a part of the Caribbean Sea. Included in this northern region is a group of islands known collectively as the Bay Islands. At the south lies the Gulf of Fonseca, an arm of the Pacific Ocean, and here are the large islands of El Tigre, Zacate Grande, Guenguense, and Exposicion belonging to Honduras. Eastward is the Republic of Nicaragua, separated from Honduras north to south by a series of rivers, valleys, and mountain ranges. On the southwest is the Republic of El Salvador, while the Republic of Guatemala covers the greater expanse of the western frontier to the northern sea.

The Republic of Honduras is composed chiefly of the saw-toothed juts of mountains which form what has been called the backbone of Central America. Unlike the other Central American republics, where the cordilleras run in a single line parallel to the Pacific Ocean, in Honduras they spread out almost like two ranges and run parallel to both oceans. In the south, the chain continues except for a very narrow belt of swamp in certain places, until it drops to the Gulf of Fonseca. In the northern section there are low

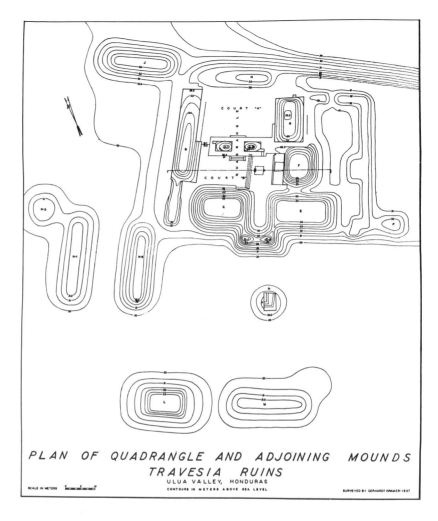

PLAN OF QUADRANGLE AND ADJOINING MOUNDS
TRAVESIA RUINS
ULUA VALLEY, HONDURAS
CONTOURS IN METERS ABOVE SEA LEVEL

SCALE IN METERS

SURVEYED BY GERHARDT KRAMER-1937

foothills and varied stretches of plains formed by river deposits.

The cordilleras divide the country into a northern and southern portion and are in turn subdivided into a series of smaller ranges. Because of the peculiar spread of the main groups, the larger territory is in the north, which is characterized today by cattle raising and agriculture. The trade winds, sweeping continuously over this section, are responsible for an increase in humidity which results in tropical strips of coast and many small streams that flow down the mountain sides bordering the northern sea. In the south there are fewer rivers, a dryer climate, and severer extremes in heat and cold.

Between the two primary ranges is a long, narrow plain, or

valley, known as the Comayagua. Flanked by mountains on the west and east, it is bordered at its southern end by the Valley of Goascoran. The Goascoran is formed by the river whose name it bears and continues southward until it reaches the Pacific Ocean. In the north the Humuya, or Comayagua River, cuts open a passageway to the southern end of the plain of Sula where, joining the Ulua, its waters finally pour into the Caribbean Sea. With river valleys as a link in both the north and the south, the plain of Comayagua is in reality the center of Honduras with the advantage of an easy approach from both the coasts.

Scattered throughout the large mountain chains are smaller plateaus and valleys, while down the mountain sides are the sharp, narrow beds of innumerable little streams. These rivulets feed certain large waterways which drain the interior country, making broader valleys near their mouth and offering avenues of access to the highlands above. The larger rivers, however, are not nav-

Temple of the Carvings, Travesia, Honduras.

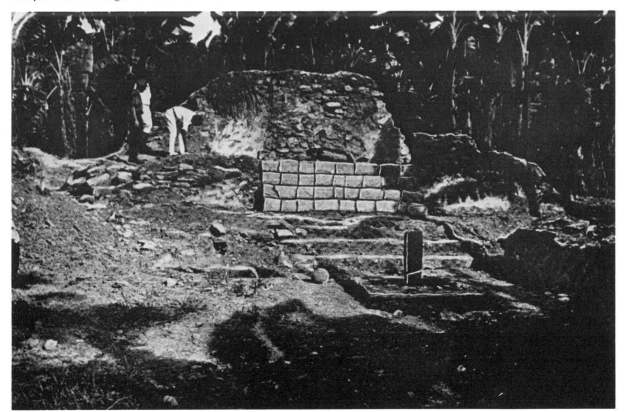

Bas-relief, Temple of the Carvings, Travesia.

igable for any distance, but they open up the interior to a canoe or to travelers afoot.

In the south besides the Goascoran, there is only one other important river, the Choluteca. It drains the mountains of Choluteca and Tegucigalpa and has carved a valley avenue to the Pacific. The northern section has five principal valleys suitable for habitation, created by the rivers whose names they bear. In the east the Guayape, called the Patuca at its mouth, drains the whole Olancho region. It is the largest western basin on the Mosquitia coast. The next river westward is the Rio Negro, or Black River, known also as the Tinto, which comes from the highlands of Agalta. Although of least importance as regards habitable land, when compared with the other three rivers, the Rio Negro was one of the most frequently used passages inland in Conquest times. West of the Rio Negro lies the Aguan, or Roman; its source is in the mountains of Yoro whose principal range, the Pijol, reaches 12,000 feet and is the highest in Honduras. Farthest westward is the Ulua River, perhaps the most culturally important of them all. It drains the department of Santa Barbara and also, with the aid of two of its tributaries, the interior department of Comayagua and the Cuyamapa, part of Yoro. Mention should be made also of the Chamelecon River, west of the Ulua. Its source is far southward in the Cordillera del Espiritu Santo and within reach of the great valley of Copan whose river flows into Guatemala. Here then is an avenue of approach from Guatemala over to the Chamelecon and down to the northern sea.

The only important lake in Honduras is Lake Yojoa, situated almost directly south of the Ulua basin. This lake is surrounded by high mountain walls on all but the northern side and a small portion to the south. Yojoa is popularly said to be an extinct volcano crater and to have no outlet. The Rio Lindo, a tributary of the Ulua, however, flows from the lake through a subterranean passage, while in the south there are two or more underground outlets running through a limestone formation.

Lower Central America, comprising eastern Honduras, Nicaragua, Costa Rica, and Panama, is a region of violent contrasts. Geologically as recently as twenty to fifteen million years ago, a large portion of this territory lay under the waters of the Caribbean Sea, which flowed south to unite with the Pacific Ocean. The eastern and western limits of this area are heavily forested lowlands; in

8

the extreme east, myriad small rivers mix with impenetrable jungle.

The largest country of all of Central America is Nicaragua, with an area of 57,000 square miles, about the size of Illinois. It is a land of waterways including two freshwater lakes (Managua and Nicaragua which drain into the Caribbean Sea), volcanoes, vast rain forest-covered mountains, lowland tropical forests, and savannas. The periodic eruptions of the single range of volcanoes which stretches from the Gulf of Fonseca to the southern end of Lake Nicaragua give the Pacific belt, one of the three geographical divisions of the country, the most fertile soils. This rich, narrow, and relatively dry coastal strip lends itself to large scale agriculture, a condition recognized even in pre-Columbian times when it had the greatest density of population, as it does today. There are actually almost twice as many people in the Pacific belt as elsewhere in the country.

It was in this region that migrating Mexican peoples, the Chorotega-Mangue, the Maribio, and the Nicarao settled in Classic and Postclassic times pushing most of the native populace to the less fertile and rugged central highlands and the wet Caribbean coast. There were plantations of medlar, sapodilla, and cacao trees, extensive fields of cotton, manguey, and cabuya, and smaller cultivations of alligator pears, guavas, anonas, papayas, gourd trees, and of course of the grain essential to all Mexican peoples, maize. Other crops included various types of beans, sweet and hot peppers, squash, and some sweet manioc. Mute dogs and turkeys were raised for meat, which was supplemented by wild game and human flesh, a vice of both the Chorotega and the Nicarao.

Large towns were established by these northern intruders on sites which are the foundation of the principal modern cities: Leon, Managua, Granada, and Chinadega. Even the volcanic cones which form the island of Momotombo in Lake Managua and those of Zapatera and Ometepe in Lake Nicaragua were important to this Pacific region, serving as locations for sacred shrines and religious centers. Today farms and cattle ranches cover much of the terrain.

Pre-Columbian burials in shoe-shaped clay vessels gave Zapatera (the Shoemaker) Island its name. This manner of disposing of the dead extended eastward into the Nicoya Peninsula of Costa

Face on rear of a bas-relief, **Temple** of the Carvings.

9

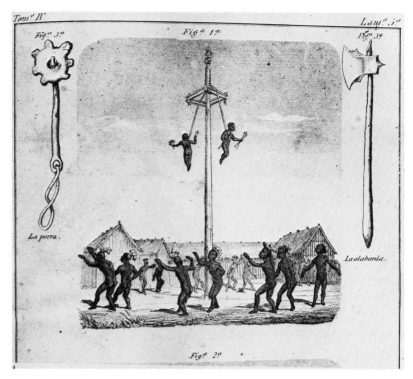

The Mexican "dance" of voladores in Nicaragua.

Rica. Corpses were often cremated and the ashes placed in urns in front of the houses or simply, as in the case of the children of the Nicarao, buried whole at the house door. Brightly painted polychrome pottery, some effigy vessels of men, birds, and animals with modeled heads or features are attributed to the Chorotega by some; other vessels bear symbols and figures relative to Mexican theology and are painted in part in blue, that rare and fragile color characteristic of the Maya and the Mexican. The form of some seated, spread-leg, flat-headed figurines and occasionally gold images suggest the southern hemisphere and offer evidence of culture blends and adaptations in this rich and fertile region.

The central highlands with their evergreen, deciduous oak, and conifer forests and their broken terrain form another geographical division embracing the actual department of Esteli and most of Matagalpa, Boaca, and Chontales with some of Jinotega. Gold mining once was important, although now many mines have been abandoned. The ruggedness of most of this area, to which pre-

sumably many of the coastal predecessors of the Mexican tribes were pushed, the poor soils, and the sparcity of level plains have resulted in the presence of small landowners who practice subsistence agriculture using the digging stick and wooden plow, and employing exchange labor instead of wage-receiving laborers such as are hired on the large farms and ranches of the Pacific belt. The introduction of coffee plantations and extensive cattle raising, however, in part of this territory has tended to change the cultural pattern to a degree.

The population of the central highlands, largely Indian, remains dispersed. Among the Matagalpa, for example, small numbers of wooden-pole or cane grass- or palm leaf-covered houses vine-tied are grouped in ravines or glades. Cotton, both white and brown, sugarcane, tobacco, and maize are raised for personal use or occasional interchange. Certain flowers and palm inflorescence are among the wild plants consumed, while fish are poisoned or shot with the bow and arrow along with game. Basketry and pottery are still produced, and there is a little weaving on the backstrap loom.

The ancestors of the indigenous peoples in the central highlands had sacred caves where human sacrifice by beheading took place. They practiced ceremonial cannibalism and had medicine men who participated in good and black magic and used powders, plants, and stones as curing agencies. A coiled serpent was one of their most reverenced deities.

The ancient inhabitants of Chontales in particular supplied red and black dyes to the Nicarao and Chorotega in exchange for cloth and cacao beans. Some of the settlements of this highland area must have been on important trade routes, for Olmec-like clay figures and marble vases similar to those from the Sula Plain, Honduras, have been found.

The third geographical division of Nicaragua is the Caribbean lowlands. Rain forests and open pine and palm savannas with swamps along the coast stretch from the Honduran frontier to the San Juan River. This is the wettest section of Central America except for the Esquinas area of southeastern Costa Rica. Rivers, gravelly or poor soils are characteristic but hardwood forests, which produce mahogany and Spanish cedar as well as slash pine, make up in a measure for the lack of extensive agriculture. Bananas used to be important until the Sigatoka disease took hold. Formerly,

rubber gathering and ipecac (in the San Juan Valley) furnished a source of livelihood as did gold mining for a time.

Now highways and the airplane are helping bit by bit to open hitherto inaccessible territory. Rural Nicaraguans are slowly thrusting into the bush, and as small farmers they are eking out a precarious subsistence.

The Caribbean lowlands have had a long and varied history. Beginning with the northwestern limit, Cape Gracias a Dios, rounded by Christopher Columbus September 14, 1502, south to San Juan del Norte or Greytown, a port which was to have been the Caribbean entrance to the long proposed Nicaraguan canal, relatively few people have inhabited this territory. By far the great majority of the populace is Misquito Indian, about 35,000 of whom live along the Segovia River, the Honduran-Nicaraguan frontier, and in the area south of it to Pearl Lagoon. Although all the indigenous peoples in the Caribbean lowlands have felt the impact of modern life, perhaps the most acculturated are those once daring warriors and raiders, the Misquito. They retain their old customs to a large degree, but many Misquito men abandon their communities for long periods to work for wages at lumber camps or as seamen on ships.

Extensions of eastern Honduran cultures such as the ware attributed to the Paya region, gold mixed with clay to form facial masks for the dead which is a southern trait, and long-handled monolithic axes reminiscent of the Antilles are archaeological items found in the Caribbean lowlands and may be due in part to the many accessible rivers and canoe harbors. Not the least in this regard is that impressive waterway, the San Juan River, which provides a route to the Caribbean Sea between Lake Nicaragua and the southern narrow isthmus of Rivas bordering the Pacific Ocean. From earliest times, trading canoes and later commercial and military vessels utilized the San Juan often bent on territorial usurpation or the control of this important water passageway.

Costa Rica with an area of just under 20,000 square miles is smaller than West Virginia, and the greater portion of its land is rough and mountainous. The heart of the republic is the central plateau where the bulk of the population is of Spanish descent with little indigenous blood and where the soil is highly cultivated or turned into pasture land.

Eastern Costa Rica is, for the most part, forest with concentrated

nucleuses of diverse aboriginal groups. The southern littoral of this section is formed by the plain of Talamanca, which geographically includes the region from the Reventazon River to the actual border with Panama. The long rugged ridges of the Talamanca Range commence at the eastern bank of the Reventazon River and run southward from the plain, rising to a maximum elevation of 11,750 feet, about 3,583 meters. Chirripo Grande, elevation 12,800 feet, 3,900 meters, is the highest peak in all the isthmus.

About 6,000 feet, 1,800 meters, above the plain of Talamanca is rain forest where many edible fruits, nuts, and medicinal plants are found. Behind this zone, extending over the continental divide, is an area of cloud forests broken only by small patches of *páramos* (cold, wilderness areas) on the highest crests. It is extremely rugged country with the south side being steeper than the side toward the Caribbean. The cloud forest vegetation consists chiefly of hard woods such as oak.

Pristine swamps, filled with cycads and cold *páramos*, fuse with

A well-roofed house in the province of Suerre, Costa Rica.

13

the heavy growth resulting from almost constant rains to construct a formidable natural barrier against the penetration of man. In fact, profuse vegetation, denser than that of many Asian and African forests, covers most of Lower Central America, the consequence of torrents of rain; in southeastern Costa Rica, for example, rainfall averages 234 inches, 5,900 millimeters, a year.

These woodlands so impressed the first Europeans who entered the region that the astute observer and chronicler, Gonzalo Fernandez de Oviedo y Valdes, an eyewitness to the Spanish Conquest, remarked that "the trees of these Indies are a thing that cannot be explained, for their multitude" and he called these forests "a great and dark sea."

On the Pacific slope of the range, in the vicinity of the two most eastern passes at an elevation of about 5,000 feet, 1,670 meters, and continuing intermittently to the two important upland valleys of southeastern Costa Rica, the General and Potrero Grande, there are savanna lands showing to a certain extent evidence of cultivation in the remote past.

Whether or not to include the Republic of Panama under the political term Central America has long been debatable, for Panama has maintained an aloofness from the politics of the other isthmian countries as well as that of Colombia, of which it once formed part. Nevertheless, Panama archaeologically and indigenously shares many things not only with Lower Central America in particular but also with the adjoining region of South America for which it has served as the gateway to the north. At least one trait associated with the pre-Columbian high cultures of South America, the working of gold and copper, passed through this territory; and it is probable that certain theological concepts and the beginnings of ceremonialism went from Upper Central America eastward through Darien.

The subhumid lowlands of the southern or Pacific side, the wet ones of the northern or Caribbean portion, and the Pacific highlands with extensive savannas constitute the three geographical divisions of western Panama, which includes the provinces of Chiriqui with the towering dormant volcano of Baru, or Chiriqui, rising 12,000 feet (nearly 4000 meters) above sea level, Bocas del Toro, Veraguas, Los Santos, Herrera, Cocle, and part of the provinces of Panama and Colon. The dividing line between western and eastern Panama is the man-made canal. From there to Colom-

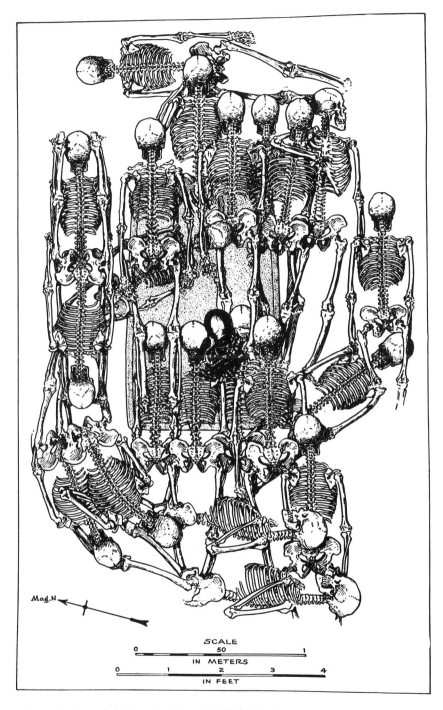

SCALE

0 50 1

IN METERS

0 1 2 3 4

IN FEET

Mag. N

Schematic plan of skeletons in Grave 26, Cocle, Panama.

bia lies the isthmus of Darien, a dense rain forest with many rivers. Its narrow Caribbean coast is backed by a hardwood-covered, jagged spur of the Andes, while on the Pacific side bordering the ocean is a continuation of the Colombian Baudo Ridge with the basins of the Chepo and Chuncunaque rivers in between. Today this eastern region is composed politically of the remaining portions of Panama and Colon, the province of Darien, and the district of San Blas.

Between 1500–1501, Rodrigo de Pastidas accompanied by Vasco Nuñez de Balboa and the pilot Juan de La Cosa sailed the northeastern coast of Panama in search of a strait to India, but it was not until 1502, when Christopher Columbus entered the beautiful "Bay of the Admiral," the western end of Chiriqui Lagoon, that contact was started by the Spaniards along the entire Caribbean littoral. From Chiriqui Lagoon eastward to the Cocle River, Columbus found a trading area where peoples of different tongues — enemies or friends — could barter with safety from war. Sometimes beads made of seashells were used as a medium of currency as was the North American east coast wampum; but the usual method was through exchange. Among the many items traded were slaves, shell beads, woven and painted cotton cloth, bark cloth, hammocks, dogs, dantas, wild pigs, birds, feathers, resin, gold figures, dyes, salt, and other foodstuffs.

Gold, not the copper-gold alloy found in the west but fine pure gold ornaments worn by the Indians and given to the Europeans in return for trifles, lured Columbus onward. Here was a land which promised more than Costa Rica, the "Rich Coast," and where surely must lie the route to India! The fame of the gold of western Panama continued long after Columbus's fourth and last voyage, particularly on the Pacific slope. During the first half of the nineteenth century, the Honduran general, Francisco Morazan, who later became President of the States of Central America, helped to finance his political activities with gold objects he dug from Indian graves in the province of Chiriqui, and many fine specimens of pre-Columbian handicraft have found their way to museums in this hemisphere and in Europe.

Today, the northwestern portion around Almirante Bay and that of the Pacific southwest near Puerto Armuelles are important agricultural areas stressing banana cultivation on the Pacific side, and bananas and abaca (a plant from which hemp is made) on the

Caribbean, with cattle raising on the inland savannas. The great majority of the populace of western Panama, however, are the Guaymi tribes, descendants of some of Columbus's first contacts. At home in their forest land, pre-Columbian clan systems are followed, bark cloth is made and worn as well as cotton cloth woven on back-strap looms. Following the custom of their forebears, both men and women paint their faces and bodies red, white, and black with native dyes. Men wear jaguar incisor teeth and elaborate bead necklaces which they fashion in ancient patterns out of European beads bought from nonindigenous merchants in Panamanian towns. Women still make beautiful agave string carrying bags strong enough to tote their babies in over the narrow precipitous trails which cross their wooded terrain.

From time immemorial, during the peach palm season, the Guaymi have held a stick dance or *balsaria* on invitation between villages. This is the combination of a fertility rite with a primitive form of justice. If one feels he has been wronged by a member of another group, he can demand retaliation by announcing to his adversary that a certain number of balsa poles await him at the annual meeting. The summoned one has to respond with an equal amount or more poles to maintain his own as well as his village's prestige. This is the basis of the stick dance in which only men participate but all others, including children, watch. Dancers and spectators don their gayest and best clothing, animal skins, feathers, and ornaments.

The dancers hurl the poles aiming between the knee and heel of their adversaries, yelling or singing taunts and boasting about their prowess. At times, permanent lameness or even death results, and wagers placed on the participants can mean the loss not only of money but also of wives and personal possessions. Promiscuousness and drunkenness are part of the background. Great quantities of food and drink are consumed at these gatherings, the expense of which falls on the host village.

This is the reason for the curious phenomenon. Periodically, groups of men migrate to the large agricultural operations and obtain temporary jobs in which they handle highly technical machinery, or work as houseboys or farm laborers. Generally, they pool their salaries, make their own living quarters, with one of their members acting as cook. When enough money has been accumulated and the peach palm season approaches, they return

A native house in Nata, Panama.

to their forest homeland and invite the designated village to a stick dance.

It is the Pacific watershed of this western portion of Panama that has appealed most to the European. David, the thriving capital of the province of Chiriqui, the city of Sona in Veraguas, Penonome near the ancient culture center of Cocle, and the cosmopolitan city of Panama itself are all on the Pacific slope. In contrast, from Bocas del Toro near the Bay of the Admiral on the wet, forested, inhospitable Caribbean side, there is no town of any importance until one reaches the man-made canal with its artificial lakes and mountain peak islands. Here Colon, built on Manzanillo Island but connected to the mainland by a strip of reclaimed land, serves as the northern port of entry to the canal.

The basic population of this region is black, descendants of Spanish slaves and of Negroes who were brought in by the French and by North Americans as laborers to build the canal. On the east side of this important waterway stand Cristobal on the Caribbean and Balboa at the Pacific entrance. These are the north and south ports between which lie the great and complicated mechanism of locks, the engineering and army camps, and towns for the numerous Panamanian and North American employees necessary for the functioning of this interoceanic route.

Farther to the east, at the time of the Conquest, the Caribbean coast enticed the Europeans with its well-cultivated fields, beginning with Portobelo, the "Beautiful Port" of Columbus, over to the Gulf of San Blas and beyond. In 1513 Balboa anchored his ships next to land belonging to the Chieftain Careta near the spot where Pedrarias Davila later founded the town of Acla, and crossed Darien to the great south sea. The isthmus of Darien was once the home of the Cuna Indians who even before the Spanish Conquest were being pushed by the South American Choco to the northern sea. The Cuna-Cueva, as they should be called at this period, were originally sub-Andean in culture, but the dense almost impenetrable woodlands of eastern Panama and perhaps the influence of the Choco have modified their culture to a rain-forest one.

The picturesque and important Cuna group of San Blas inhabit the Archipelago de Las Mulatas, where they live in a state of constant acculturation spurred by the acquired taste of many male Cunas who leave periodically to work as sailors on ocean-going steamers and as clerks, mechanics, or houseboys in Panama and

the Canal Zone. A large number, however, remain on the islands living off the coconut trade and working a narrow strip of mainland where they grow bananas, root crops, and other foodstuffs. Some even live on government reservations along the upper Bayano and Chucunaque rivers and on the tributaries of the Tuyra River, places which the migrant Choco also inhabit. Weaving of cotton is occasionally done on the vertical loom but the technique of appliqué with bought cotton cloth and the persistent use by the women of gold ornaments including nose rings offer superb examples of cultural continuity. There are some Negroes also in this eastern territory, but the principal occupants are the Cuna and the Choco. These last people lead a nomadic life and are found as far west as the Chagres River. What changes will result from the Pan-American highway, which is in the process of penetrating this hitherto isolated and forest-covered retreat, must be awaited.

PRECERAMIC EVIDENCE OF MAN

The earliest evidence of man in Central America — Clovis-type projectile points — denotes hunting cultures associated with Upper Pleistocene mammals such as the mammoth, camel, and sloth. This kind of point which was originally identified in Texas has a radiocarbon date of 9250 B.C. Unfortunately, in the isthmian region, such artifacts are widely separated from corresponding remains which could help to define a more complete cultural picture. A single Clovis point made of the volcanic glass, obsidian, came from San Rafael near Guatemala City; one of flint was from Gua-

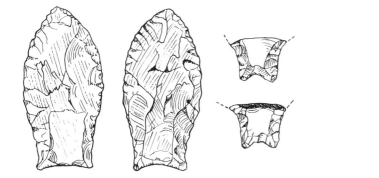

Projectile points.

nacaste province in the Pacific northwest of Costa Rica; one of agatized wood was from Macapala Island in Madden Lake, Panama; and one of red jasper was found on the Pacific side of the Isthmus of Panama below sediments which yielded a radiocarbon date of 4300 B.C. In connection with this point, maize pollen, probably wild, was discovered in deposits associated with the Gatun Basin. These date from 5300 B.C. By 2200 B.C. indications that slash-and-burn agriculture was practiced in the same region give an insight into the way of life of these early isthmian hunter-collectors.

A fragment of another fluted point of *Turritella* agate, from Butler Island also in Madden Lake, represents a shape known as "fishtail" and is among the oldest dated types from South America. These "islands" are mountaintops which remained above water when the area was flooded to make locks during construction of the Panama Canal. Fishtail points are associated in particular with caves in the Strait of Magellan, and their age, determined by radiocarbon dating, reveals that the earliest was made eleven thousand years ago. Fishtail points have also been found in Argentine Patagonia and at El Inga site near Quito, Ecuador.

ARCHAIC CULTURES

Archaic cultures are associated with non-pottery-making people who lived by hunting, fishing, and gathering wild plants, and by incipient agriculture. Characteristic of these groups were ground and polished stone artifacts. One of the earliest sites which indicate the presence of such a culture is the cave of Santa Marta on the Isthmus of Tehuantepec, Mexico. This rock shelter gives evidence of five early occupations, two of which yielded radiocarbon dates referring to seasonal camps there between 7000 and 3500 B.C. The chief foodstuffs consisted of game such as squirrels, armadillos, and birds, supplemented by snails, land crabs, seeds, and possibly wild plants. Flint chips, side scrapers, nut stones, and pebble mullers suggest that the earliest occupants used snares to catch game; fire-cracked rocks and carbon imply that the meat was roasted. Later in this period white-tailed deer, peccaries, monkeys, snakes, and iguanas (large lizards) were consumed. Hides, which may have served as clothing, were worked with scrapers and flakes. Bone awls, needles, and stone projectile points were known in later times, but nowhere is there a sign of maize in the form of either pollen or cobs. Instead, basin or trough grinding

stones and pebble mullers indicate the use of tubers and perhaps beans and squash.

The last of the five incipient occupations had a multiple burial of four individuals, three flexed and the uppermost extended. This could imply a disaster such as an epidemic or perhaps religious practices including human sacrifices. Santa Marta cave continued in use during the Preclassic Period, but a gap of approximately 2,180 years separates the last preceramic occupation from the phase corresponding to the appearance of pottery.

Farther east and south, in Lower Central America at Cerro Mangote near Parita Bay, Panama, excavations in a large shell mound on a hill revealed that the earliest inhabitants, according to a radiocarbon date of 4858±100 B.C., subsisted primarily on oysters and crabs. There is no evidence of agriculture, but shallow man-made basins with boulders to serve as grinding stones, plus pebble pounders and choppers, point to the inclusion of fruits and seeds in the diet. Fragments of worked deer antlers broken from the cranium and one long bone of a bird, probably used for an awl, show that hunting likewise provided a source of food. Although flakes and cores of petrified wood, jasper, and chalcedony were numerous, stone points and pottery were completely lacking, a fact which leads us to believe that wooden weapons, traps, and hot stones were used respectively for defense, hunting, and cooking. A few burials were flexed, on the back, but the majority were secondary bundle burials, meaning that the flesh had been removed from the bones, which were then placed in a container, probably a basket or net, before permanent interment.

Beyond these, there are finds of a problematical nature which suggest Archaic type cultures in the Central American isthmus and Chiapas, Mexico. On the banks of the Rio de la Pasion in the southern Peten of Guatemala a petrified sloth bone with three V-shaped incisions appeared in association with other extinct fauna of the Upper Pleistocene and stone flakes left by primitive workers.

Footprints, pointing in all directions, of more than forty human beings, together with prints of bison, white-tailed deer, nutria, alligator, and a single-crested guan, occur in lahar and ash at Acahualinca near the cemetery in Managua, Nicaragua, without accompanying artifacts. The haphazard position of these footprints, which are approximately five thousand years old, suggest that the ash fall darkened the atmosphere, adding to the panic and con-

fusion caused by the eruption of one of the cones of the Masaya volcano. Some prints are so deep that they were probably made by human beings bearing heavy burdens.

El Salvador and Honduras supply additional indications of pre-ceramic man in the upper isthmian region despite the meager evidence and the lack of exact dating. At La Rama, El Salvador, in the department of Usulutan, a district lending its name to one of the oldest ceramic styles of Central America, footprints of at least five human beings and prints of various members of the feline family were found in sandstone and are thought to date at approximately 1500 B.C.

In Honduras, evidence of a hunting-collecting economy belonging to the Archaic Period presumably following that of Clovis points appears about half a meter below the lowest pottery-bearing soil at the Classic Maya site of Copan. Excavations yielded obsidian and flint fragments buried in sterile river clay, together with pieces of charcoal, some of which derived from small sticks and nuts, as well as broken and charred bones of animals such as rodents.

In the region of Costa Rica which borders Nicaragua, between the Sapoa River and Salinas Bay, there are vestiges of a fossil lake and riverbed. Recently, lithic sites have been located here and rock shelters have been reported in the vicinity. Although their place in time has not been determined, it is possible that they are further links of a preceramic cultural extension.

Also of unknown date but possibly indicative of Archaic culture were the remains in two shell mounds on the coast of Chiapas near the small Cacaluta River at the edge of the Pampa de Chanuto. Built on low flats surrounded by brackish water, one is called Islona de Chantuto and the other Campon. Potsherds were mixed with fish, turtle, bird, and animal bones at the top levels. Evidence of this same diet occurred in lower deposits without pottery. In the Islona mound were a hammerstone, a retouched obsidian flake, and cut bird bones; while at Campon among the man-made artifacts a reworked gray obsidian flake was found with the bone remains. Unfortunately, there is not enough evidence to determine whether these coastal middens should be associated with a pre-ceramic culture stratum or whether they were made by people with a more advanced manner of living who periodically journeyed to the shore in search of food from the sea and surrounding

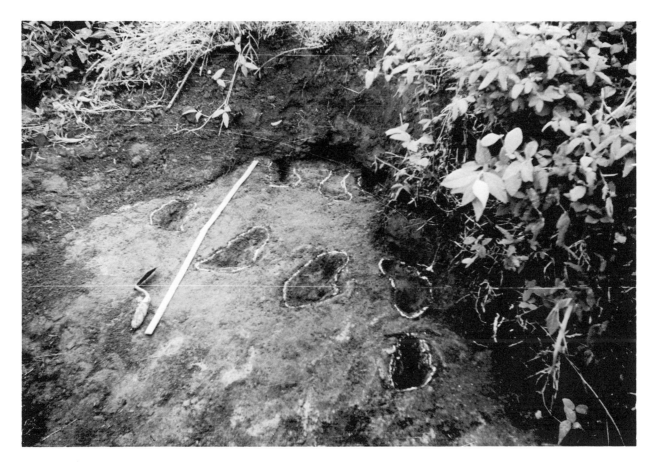

La Rama footprints in volcanic ash laid down by fluviatile action, 1500 B.C.

swamps. The rest of the early record of man in Chiapas and Central America, as we shall see, is very distinct in its cultural composition from that of the hunters and the makers of shell mounds.

THE EASTERN FRONTIER OF MESOAMERICA

Mesoamerica is generally considered to be a region associated with Mexican and Maya cultures. The presence of Mexican- and Maya-speaking peoples in the Central American area, historical documentation referring to social organization and customs, and archaeology all give us evidence which helps us place the eastern boundary of what we call Mesoamerica. This boundary was created by the meeting of two distinct cultures, one from the north and the other from the south. The northern one, Mesoamerica, went

Female figurine from La Honduras, Cuyamapa Valley, Honduras.

beyond the boundary in cultural penetrations which were almost a complete complex. The southern culture, non-Mesoamerican, which was an extension of South American cultures, manifested itself only through trait survivals near the fringe of the Mesoamerican border.

Archaeologically, we can enumerate the major characteristics associated with Mesoamerica and use historical documentation to corroborate our conclusions where the ravages of time and the Spanish Conquest make material elements impossible to obtain.

Communities built around plazas, the use of oriented ceremonial mounds often but not always supporting temples, rimless grinding stones with elongated or tubular mullers, and cylindrical and flat pan vessel forms are characteristic of eastern Mesoamerica. Less common items include Chac Mool figures, vessels with figures rising from the interior rim, black outline around painted designs, and Olmec art styles.

Ceremonial sites with a plaza and oriented mounds with or without temples on the top offer archaeological evidence in Honduras as far east as Travesia in the Sula Plain, the Comayagua hill site of Tenampua, and Agalteca. Less pronounced vestiges are seen at Los Calpules or Santa Ines in the Yeguare Valley, in northeastern Honduras, and at Tonjagua in the Agalta Valley. This last is a site historically associated with the Paya, situated in territory which was also frequented by Mexican peoples, and oriented mounds and vestiges of a staired mound might be considered a cultural penetration.

In El Salvador, Quelepa is the most eastern example of a ceremonial site marked by oriented mounds. From here on, the mound and plaza complex is unknown archaeologically until we reach Pacific Nicaragua.

Geographically, we can consider the eastern and northeastern boundary of Costa Rica as one area and the central plateau as another, but archaeologically, the region is one. There are, nevertheless, certain specialized and distinct characteristics in the territory as a whole.

The Atlantic watershed is a lowland area, including the southern or Costa Rican side of the San Juan Valley as far west as the volcanic range of Guanacaste, and the Caribbean littoral south from the mouth of this river through the plains of Santa Clara to the northwestern boundary of Panama.

This region was inhabited by peoples of southern extraction with slightly different speech all related to the Chibchan language of Colombia. Many small realistic stone statues of human beings and animals have been found. Excellent jade carvings, a large variety of ceramic objects, and gold idols also appear. The region was part of a major trading route as is shown by finds of Olmec, Maya, and Mexican objects.

The entire Caribbean region shows signs of having been a great trading zone, which extended beyond the political boundaries of today into northwestern Panama. The reason is obvious. At its northern limit lies the San Juan River, a logical passageway flowing from freshwater lakes which are separated from the Pacific by only a narrow strip of land. The streams which serve as its tributaries are on the whole navigable for shallow craft and lead inland toward the high plateau. Many of the rivers which empty into the Caribbean Sea are adaptable to canoe traffic near the mouth, while some, such as the Reventazon (the ancient Suerre), the Estrella, and the Sixaola, permit movements in dugouts a considerable distance upstream. There is also one sizable lagoon, Tortuguero, and a large off-shore island, La Uvita, which offer protection from storms.

In contrast to the Pacific coast, two long plains in part only broken by low groups of hills skirt the Caribbean and give easy access to the mountain passes which lead to the high interior. These compose the main geographical divisions in this region. The eastern plain is called Limon, and the western, San Juan. The Reventazon River forms the dividing line. Three archaeological subareas of the Atlantic watershed can be noted.

The plain of Limon is what we culturally designate as the Talamanca area. It extends from the eastern drainage of the Sixaola River system to the Pacuare and Reventazon rivers. Its southern boundary is the Talamanca range, and its northern, the Caribbean Sea.

At the time of Columbus's voyage, the eastern limits of the Sixaola Valley lay on the western periphery of an extensive trading region where peoples of different tongues and cultures met and could mingle freely without fear of attack. The river valley itself, when the Europeans first set foot there in 1540, was controlled by a Mexican group speaking Nahuatl. The neighboring population

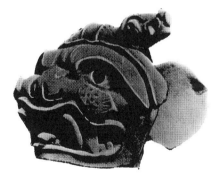

Jaguar head from Chasnigua Creek, Sula Plain, Honduras.

25

which inhabited the rest of the area under discussion, spoke languages related to the Chibchan tongue of South America.

There is not enough known of the archaeology of this area to present a complete picture. Burials are usually on ridges, but in the case of Banana River, they are in the lowland. Some graves are indicated by a circle of stones. In the region of Chirripo, decorated stone slabs standing erect have been reported as marking graves.

The Reventazon River once served as the boundary between the ancient provinces of Suerre and Pococi and Suerre and Tayutique, and flowed through territory associated with the historic Guetares. The Reventazon area follows closely the river drainage and bordering slopes. Although containing many objects such as grinding stones and unpainted vessels, similar to those from the Talamanca area and that of the Linea Vieja, it shows evidences of a certain stylistic individuality.

Stone cist graves found on slopes are the most common type, at times located in low mounds.

The area abounds in pictographs on boulders. These often have rounded depressions with canals leading from them and must have served as sacrificial stones.

The Linea Vieja is so named because the first railroad in northern Costa Rica once traversed a part of this section as far as Carrillo. Today, the railroad runs from the Reventazon Valley at Las Juntas to the village of Toro Amarillo. The culture associated with the Linea Vieja begins with the Pacuare River and continues north to the San Juan River and west to the plains of Guatuso following the foothills of high volcanic peaks. The Linea Vieja seems to have been what might be best compared to a bazaar. Archaeologically, it is the exhibition region of Costa Rica. Here objects related to the north, the south, and the Antilles and pieces suggesting Colombia, Ecuador, or even distant Peru and Bolivia appear at random.

The Linea Vieja region is one of heavy rainfall and many rivers. Living sites and often burial sites and trade routes had to be protected from excessive water and floods. It is not surprising, therefore, to find that mounds and raised causeways are characteristic of this area. The mounds are of earth with stones placed generally at the base as an aid against erosion. Las Mercedes is exceptional in that the large mound group is built in a swamp and of necessity stones were used for almost the entire outer retaining walls, the center being filled with earth. The mounds at each site

are connected with one another and with a water hole or stream by cobblestone roads and steps. The graveyards are about 150 to 200 feet from the dwelling mounds. Some sites have what might have been ceremonial enclosures, rectangular, circular, or oval in form, and connected with the living mounds and graveyards by stone roads. Pictographs and female figures in bas-relief, with a circular depression in the center as if for offerings, occur on boulders near the dwelling mounds.

In addition to the roads which are a part of each site, a wide cobblestone highway, which is raised in the swampy sections and still shows evidences that log or vine bridges were used to cross swollen rivers, runs between the principal sites and can be traced into the deep interior. This must have connected with the inter-isthmian causeway which permitted Aztec traders to take such secrets as the art of metalwork to their far-away empire. Farmers, cattle, tractors, and time have erased much of this road, but sufficient vestiges remain to enable us to retrace the route through this territory.

There are several kinds of graves in the Linea Vieja region, most of which are side by side, with no markers on the surface. The only site in this region known at present where multiple burials were usual in the same grave is El Indio. The graves are rectangular and the walls and floor are so well-lined with stones that the term "paved" can be employed to describe them. From two to ten bodies form one burial. They are separated from one another by a large stone at each side of the head, the feet, and the center. The floor under each body appears to have been made for the individual. Over the head a few small stones were placed. All occupants must have been buried at one time because the earth covering the whole appears to have been filled in at the same time, and there are no dividing walls. In the very center near the top, as if they were from a last offering, some sherds were found.

Grave articles in this type of burial were usually located next to the top of the head and were protected by a covering of small stones. Some vessels were placed directly on top of the body, however. In a corner of the tomb, a nest of vessels in a stone niche seems to have been customary.

All of the Linea Vieja region is noted for its grinding stones. Those with a raised edge were used for grinding tubers, *pejibaye* (the peach palm fruit), and cacao. Those with a curved and rimless

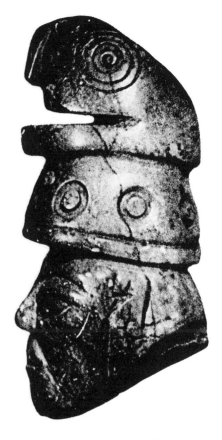

Greenstone head (jadeite) with macaw or parrot headdress from Guare, Honduras.

27

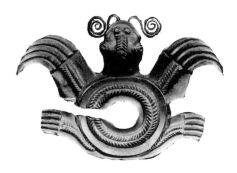

Gold ornament from Cocle, Sitio Conte, Panama.

plate which are associated with the grinding of maize are rare. Stirrup and loaf-shaped mullers are the most common although an occasional rounded or elongated one appears. Pestles likewise are found.

With the exception of the Maya area, the Linea Vieja has yielded some of the finest examples of carved jadeite. The materials usually classified under this term include such semiprecious stones as nephrite, jades, serpentines, and agates. The materials used to work jadeite were primarily sand, water, vegetable fibers, rawhide, and the wooden bow drill. Obsidian, which was used to make knives, was sometimes imported from the north. Polishing was accomplished by rubbing with flat stones, a heavy bamboolike cane, and beeswax.

It is perhaps more in metalwork than through any other medium that the importance of the Linea Vieja as a trading area can be most easily demonstrated. Very little gold is found in this territory. In other words, much of the raw metal had to be brought from distant regions to be worked by the indigenous craftsmen. This may be why large figures such as appear in southern Costa Rica are rare. It is also interesting to note that the *mise en couleur* process used elsewhere on gold and copper alloyed objects to bring the gold color to the surface is not common in the typical local styles. In fact, the Linea Vieja is outstanding for small pieces of pure gold made in the form of "eagles," "chieftains," and frogs.

There can be no doubt that these objects were made here. The most common technique used in their manufacture was the lost wax process. This is one of the oldest processes of casting metal known in the world and existed in many parts. A figure was made of beeswax and resin and carved into the shape desired. A coating of beeswax was then put over this and the whole placed in a mold of clay and charcoal with venting canals. If the figure was large, thorns or gold pins were used to anchor the model in place. Gold was made liquid in a crucible over a fire which was kept going by the constant blowing of many men through long canes. The mold was then heated to melt out the model and the gold entered the cavity left.

The important routes indicated by the gold objects which stylistically point to other regions seem to stretch from Cocle in Panama to the Linea Vieja and south to Nicoya in Costa Rica, and from Veraguas to Chiriqui in Panama and over to the Linea Vieja. Of

course, the foreign type objects found in this region are not limited to Panama. There are many pieces which suggest trade from Sinu, Qimbaya, Tairona, and Chibchan cultures in South America. The Linea Vieja, however, provides evidence of closer connections with the gold work of Cocle and Veraguas than with any other non-Costa Rican cultures.

The Highland region extends west from the Reventazon Valley to the Pacific Ocean. It is bordered on the north by a series of volcanoes and the plains of Guanacaste. Its southern boundary is formed by the Candelaria range. Within this area lies the central plateau of Costa Rica.

The archaeological culture associated with this region was fundamentally an extension of that of the Atlantic watershed but with less evidence of the influence of extensive trade, which seems to have been mainly with the Nicoya Region. Polychrome pottery is the chief denominator of the interchange. There are also certain distinctive and local elements.

The common burial customs of the Linea Vieja continue in the Highland area. Although graves are sometimes in low, artificial earth mounds, they are more often found in natural ground. Slab-lined and individual stone-lined cists, both with and without a slab cover, and stone-lined graves with a covering of cobblestones are found. There are also burials marked by a stone circle.

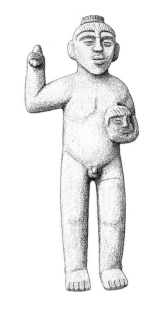

Stone figure of a nude man holding a trophy-head and axe from Guacimo, Linea Vieja, Costa Rica.

Another interesting feature is the continuation of paved stone causeways with a stone border which connected the Caribbean littoral with the very heart of the interior. In some parts they are 26 feet, 7 meters, wide and are buried under a meter or more of earth. Sherds and tools have been found along their route.

On the Pacific coast, the province of Guanacaste and the entire peninsula compose the Nicoya cultural area. It is known for its fine pottery, carved jades, and elaborate grinding stones. This region was originally inhabited by peoples of southern origin, but the major section of this territory at the time of the Spanish Conquest was populated by tribes who had migrated from Mexico. These included the Chorotega of Mangue tongue and the Nahuat-speaking Nicarao.

The Diquis region extends from the General Valley south to the Panamanian frontier. It is bordered by the Talamancan range on the north and the Pacific Ocean on the south. In this area we have the nearest approach to abstract art. There are highly stylized

Variations of scroll design at Travesia and Lake Yojoa, Honduras.

stone figures often with a peg base and particularly in the flood plain of the Diquis. These are large, completely spherical stone balls, some of which weigh over fifteen tons. The purpose of these spheres is problematical. Among the pottery types, fine "Biscuit Ware" elegant in the simplicity of form and scarcity of adornment is outstanding, as is Black and Red Line Ware including figurines with a cream slip (the covering of a vessel with a thin layer of clay to assure a smooth coat; slips vary in color, quality, and thickness and may be painted or polished). Both are extensions of cultures from Chiriqui, Panama. Some of the finest gold pieces in Costa Rica have come from this region. They demonstrate most of the known techniques of pre-Columbian metalwork. Many of the Diquis graves were looted by pot-hunters attracted by the contents of gold artifacts. These illegitimately dug gold pieces have for years been bought by collectors and dealers from abroad, and as they have grown scarce there has been an immense production of fakes.

THE EVIDENCE OF HISTORY

Historical evidence gives us further information about the eastern frontier of Mesoamerica. Sites connected with the Pacific coast of Nicaragua had plazas and temple mounds.

Rimless grinding stones with elongated or tubular mullers extend all over western Central America but are rare in Costa Rica with the exception of the Nicoya Peninsula and occasionally the Linea Vieja area. Cylindrical and flat pan vessel shapes follow the boundary of Ulua-Polychrome pottery, and appear at certain sites in southern Honduras, western Nicaragua, the Nicoya Peninsula, and at times on the Linea Vieja of Costa Rica. Vessels with figures rising from the interior rim are found in Guatemala, western El Salvador, and the Sula Plain of Honduras. Black outlines on polychrome design continue the route of Ulua-Polychrome ceramics in Honduras and El Salvador and appear in western Nicaragua, the Nicoya Peninsula, and the Linea Vieja. To date, Olmec art styles have been found in Guatemala, Honduras, the Nicoya and Linea Vieja regions of Costa Rica, and western Panama.

Historical records point out northern-speaking groups as far east as the Naranjo River, formerly called Rio de los Mangues, on the Pacific side of Costa Rica, and Mexican enclaves were found by the Spaniards on the Caribbean coast of Nicaragua, Costa Rica, and Panama. Farther to the west, but in territory associated with

non-Mesoamerican peoples, Mexican-speaking groups were known in El Salvador, and southern, central, northern, and northeastern Honduras, where, outside of a small contingent near Trujillo, they appear to have roamed without permanent villages in the Honduran Mosquitia and the woodlands of Olancho.

Tribes with nonnorthern customs, definitely related to the southern continent, inhabited the Central American Caribbean littoral as far west as the Aguan River in Honduras, where they met a non-Maya, non-Mexican group, the Sula-Jicaque, who spoke a language of northern origin. Interior Costa Rica and Nicaragua, much of southern Honduras, and eastern El Salvador also were inhabited by peoples indicating a strong relation with South America. The Xinca in southeastern Guatemala and the Lenca of southwestern Honduras, the greater portion of central Honduras, and part of eastern El Salvador show a closer linguistic relationship to one another than to any other peoples at the present state of our knowledge. Ethnologically, they seem to be a melting pot between Mesoamerican and non-Mesoamerican peoples.

Historical and ethnological documentation offers further evidence apart from peoples of cultural boundaries. There were two important foodstuffs used in Central America at the time of the Spanish Conquest: the grain maize, and the tuber manioc. Both plants were described in detail by the Spanish historian, Oviedo, writing as an eyewitness, who also recounted the different methods of preparing bread from them. He reported that the tortilla or thin flat maize cake was brought by Mexican peoples from the north to Nicaragua. Maize was not important in eastern Costa Rica even at the time of the Spanish Conquest, and the tortilla is not common in Costa Rica today, nor was it known by the majority of the aborigines outside of the Nicoya area. Most peoples on the mainland of Central America boiled or roasted the nonpoisonous kinds of manioc or yuca and did not try to make bread. This method of preparing yuca is seen today through the Aguan region and is also utilized by the tribes who seem to blend Mesoamerican and non-Mesoamerican cultures, such as the Sula-Jicaque, the Lenca, and the Xinca.

Cacao and cocoabutter, which are associated with Mesoamerican cultures, were prepared in the Mexican or northern manner in Nicaragua as distinct from the method known in Chiriqui, and seen today in the Talamanca region of Costa Rica. The use of coca,

a non-Mesoamerican trait definitely connected with the southern continent, had its western and northern boundary in the province of Nicaragua. The peach palm found on the Caribbean coast of Central America as far west as the Aguan River in Honduras, is another significant sign of food penetration from the south.

Apart from plants and their use, there are a number of relevant points to be examined in the cultural and political field. Non-Mesoamerican items within the southeastern border include the presence of people who performed a dance which was similar to the stick dance of the Panamanian Guaymi, and the cutting off of the human head instead of cutting out the heart for sacrifice, although the severing of heads was practiced by northern peoples also.

The available historical documentation suggests that an area starting in the Honduran highlands and going south and east along the Pacific coast through the Nicoya Peninsula in Costa Rica provided a meeting ground for Mesoamerican and other cultures.

The Earliest Villagers

THE FIRST POTTERY (2000 B.C.)

Based on radiocarbon dating, we know that so far the oldest Central American pottery remains are those found on the coast or along the fertile river valleys of Lower Central America, but it is impossible to apply a tribal denomination to the people responsible for them. The earliest pottery-containing sites are in the Parita Bay area of southern Panama and are associated with shell refuse mounds bordering rivers where drinking water was available. They give evidence of a people whose living depended primarily on the sea although they did practice a rudimentary agriculture.

For the most ancient group, Monagrillo, there is a radiocarbon mean date of 2130 B.C. The remains of this settlement, built on sunken beaches near Cerro Mangote, seem to show a link with the prepottery or hunting-collecting way of life. The stone artifacts are identical with those from Cerro Mangote and there was little difference in most of the economy, a fact which leads one to suspect that Monagrillo might be a continuation of Cerro Mangote. The important distinction is that the Monagrillo inhabitants had grinding stones with mullers, which suggest the cultivation or use of tubers such as manioc, and they made pottery by coiling the clay and then firing it.

Centuries of inclement weather, poor soil, earthquakes, and perhaps the very weight of the shells plus the quality of the pottery itself, which was only moderately well-fired, resulted in the destruction of all vessels. The thousands of sherds or broken pieces recovered, however, show that the majority came from handleless, legless bowls, which divide into three principal groups. Monagrillo Plain Ware, probably destined for kitchen use, extends throughout

the site. It ranges from red through a dirty buff to gray and black, depending upon the clay and the firing; it was smoothed by scraping.

Red painted pottery, which seems to be slightly later in time, almost always has a buff background with red pigment applied by dipping the vessel or by brushing it with bird feathers dipped in the pigment. The vessels were decorated, some all over and some in parts, with bands, hanging triangles, semicircles attached to a rim band, or vertical or rectangular zones hanging from the rim without a band. Whether this was purely esthetic or else the beginning of ritual ware is impossible to say.

The most recent group is called Monagrillo Incised and Punctate Ware. Incising implies the use of a pointed instrument, in pre-Columbian times usually of wood, bone, stone, or shell, to cut lines on the vessel surface. The amount of pressure applied and the variation of the sharpness and point of the tool, for example whether rounded or fine, control the type of line, that is, deep, wide, or narrow. Punctate decoration is obtained by punching a sharp tool into wet clay. If the lines are elongated, the term used is dash punctation. When an awl is employed the result is a cuneiform dent called awl punctation. Shell was also used to produce a punctate pattern. The Monagrillo pottery has predominately curvilinear elements but also has bars and rectilinear motifs incised or punctated before firing and sometimes combined with bands of red paint. These designs, too, may have ritual significance.

These wares, representing the oldest known Central American pottery, and the percussion stone tools from Monagrillo resemble items in certain early ceramic and lithic phases of South America such as Guanape in Peru, Barlovento in Colombia, and Valdivia in Ecuador, and thereby indicate a relationship with the southern continent. As a site, Monagrillo has a long history of use and reuse even after the disappearance of this cultural complex.

Contemporaneous with at least part of Monagrillo, or immediately succeeding it, is the Sarigua shell mound lying in the southernmost portion of the salt flats on the northern side of the Parita River. All the pottery here consisted of monochrome deep bowls, which vary from brick-red to a dark brown-black, light tans, and grays. Decorative techniques include shell incising, punctation, and appliquéd clay ridges which were modeled by hand and applied to the vessel. Strangely enough, this pottery is thinner

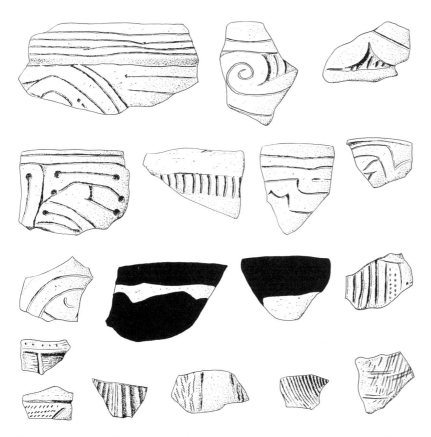

Fragments of the oldest decorated pottery from Central America, Monagrillo culture, Panama, 2130 B.C.

than any yet seen in Panama and better made than that of Monagrillo.

More than a thousand years later and nearly 1200 miles to the west, we find our next clue to Early Preclassic man in the isthmian area. In Upper Central America, the oldest radiocarbon date, 1320 ± 200 B.C., comes from the cave of Santa Marta in Chiapas, Mexico, and is associated with crude pottery from the Chiapa I or Cotorra phase, with an approximate starting date of 1500 B.C. However, underlying the Chiapa I type of vessel at the site of Altamira on the Pacific coastal plain of Chiapas lay the remains of a slightly older phase called Barra.

This small community of the Barra period presents many problems. The question of who was responsible for this culture, which disappeared about 1400 B.C., cannot be answered at present. We

can only point out that the people of Barra times used stone vessels of a type associated with the cave dwellers of Tehuacan, Mexico, one of the most ancient cultures in Mesoamerica, and that they possessed excellent pottery painted with specular hematite, which is iridescent, and made in vegetable shapes reminiscent of vessels from Ecuador and Colombia. Sea food must have been an important part of their diet, but the squash or gourd forms of the pottery indicate some small-scale agriculture. Quantities of obsidian flakes locally chipped may have been set in green palm wood, and the tool which resulted was then utilized as a manioc scraper. If so, this would add a root crop as a staple. Since obsidian does not occur in the vicinity of Altamira, its presence here is evidence of trade even at this early date.

At least one of the decorative techniques from the Barra period, the use of specular red paint, offers another sign of intercommunity relations. This decoration is seen at La Victoria in Guatemala, a mile and a half (3 km) from the Mexican frontier, during the partially coeval Ocos phase. Here was another ancient coastal settlement situated alongside an estuary and dependent on a marine and agricultural economy.

People lived in straw-roofed huts made with poles and partly daubed with adobe. Pits, perhaps for storage, and mud floors were found in some habitations. They used finely woven cloth, probably cotton, and imprints of it have been left on some of the pottery found at the site. Ropes and cords were also made, perhaps of agave.

Seeds, nuts, or tubers were crushed in crude stone mortars or on common river boulders. Some of these products must have been kept in the brilliant red jars associated with this phase. These were frequently adorned with an iridescent paint varying from metallic pink to a silvery tone depending on the thickness with which it was applied. Stripes and zoned curvilinear areas marked by wide grooves were also painted on the jars with this pigment. The style and particularly the kind of paint are southern and are characteristic of the lower Sinu Valley in Colombia and the Guayas Basin in Ecuador, whence they must have been carried by canoe since they are absent in the lower isthmus region. Some vessels found at La Victoria had three elongated legs, which kept the pot upright either over the fire or on the ground. Rocker-stamping, cord-marking, pinching, and textile impressions also formed part

of the technique of decorating Ocos phase pottery, methods which probably had been diffused overland from the north.

Although there is a suggestion of temple mounds during this period, monochrome clay whistles and crude handmade figurines usually depicting nude females offer more positive hints of ritual, perhaps in connection with fertility rites. Characteristic of the figurines are the eyes, with a very small punctate pupil on an eyeball formed in a narrow depression framed by thin clay strips.

Cultural ties between the sites of Altamira in Mexico and La Victoria in Guatemala did not cease with the disappearance of the Barra phase. About a thousand years later, perhaps between 1300 and 1200 B.C., a periodic reoccupation of Altamira occurred possibly by Ocos people from La Victoria, or if not by them, certainly under their influence. They even went farther up the coast to other estuary island sites in the mangrove swamps, carrying with them coarse neckless jars known during the Ocos phase at Altamira and other household wares, named Michis Thin Tecomate and Specular Red Ware.

The influence of Ocos is apparent not only in the temporary settlements of the estuary islands, but also later at the interior valley site of Chiapa de Corzo, Chiapas. These people, although culturally less developed, must have lived somewhat like those of Ocos. The river supplied fish for food; and game, fruits, and tubers, probably produced by simple agriculture, provided the rest of the diet. The people of Chiapa I phase, however, lacked the artistic talent as potters which distinguished those of Ocos times at La Victoria, even though communication with the south must have brought cultural inspiration to the Chiapa de Corzo artisans. The result is the appearance of Ocos traits such as decorations using specular red paint and rocker-stamping, of which four distinct types are defined: shell-edge in which the crinkly edge of a mollusk shell is rolled repeatedly over the surface to form a design; shell-back, or the use of the exterior of the shell to impress the pattern of its ribs; plain, accomplished by rocking a bone, wood, or any shell tool on the wet clay; and dentate, which necessitates rocking over the surface a curved edge tool with cut or ground spaced teeth. Thin walled neckless jars with shallow grooving and some clay figurines also occur. The concept is there, but the workmanship suggests poor or technically untrained local artists.

There are also evidences of other extraterritorial influences during this phase at Chiapa de Corzo. Remains of polished adobe plaster and carefully squared corners intimate a more elaborate ritual than at La Victoria and hint at actual ceremonial construction. Although we do not know its source, the idea of this architectural beginning possibly came from the north, perhaps from that distant cultural center, La Venta in Tabasco, Mexico, where pottery sherds of the Chiapa I period have been found.

Ocos culture penetrated much of Chiapas and its immediate environs. Padre Piedra, in the vicinity of Chiapa de Corzo, should be added to the sites already mentioned, as well as the earliest or Cuadros phase at Salinas La Blanca near La Victoria. There were cultural extensions within the same territory from the Chiapa I phase too, not only at Santa Marta cave as has been noted, but also at Santa Cruz, Padre Piedra, Mirador (a site where Olmec figurines are found), and Altamira on the coast.

One other Central American phase in the same time span as Ocos and Chiapa I is Yarumela I. It appears at a site of the same name near the Humuya River in the center of a transcontinental pass, the great valley of Comayagua in Honduras. Its geographical position should make Yarumela of utmost importance, but because little work has been done there we are forced to rely on potsherds for a glimpse of the life of this period. Among the many shapes were plates, globular jars with cylindrical necks and thick rims, and simple jars and bowls sometimes decorated with red paint, incising, or fillets (narrow ribbons of clay) and appliquéd clay knobs occasionally reed-stamped. Again there is a hint at religious beginnings in the form of a hollow figurine head. In addition to the pottery, there were obsidian flakes, possibly implying that the plates served as manioc griddles. If they did, then manioc can be considered a staple for the people of that time, indicating along with the ceramic types the basic cultural pattern of the Early Preclassic Period in isthmian territory.

Slightly later than any of the cultures we have mentioned and closing the Early Preclassic phases in Central America is the Arevalo phase at Kaminaljuyu in the rich valley of Guatemala near the present capital. This site reveals human occupation from at least 1500 B.C. Not much is known about Arevalo people except that they were year-round farmers living in scattered clusters of mud-walled houses. Burned adobe containing imprints of poles shows

that these dwellings were much like those of Ocos. There were also rectangular and bottle-shaped pits with small circular openings which might have served for storage or ritual purposes. A few artificial earth mounds and solid flat-chested asexual figurines made of clay denote religious practices, perhaps in connection with farming.

During Arevalo times, as in all the Early Preclassic, there was no polychrome pottery. Most vessels had only one color — dull buff, red, brown-black, or gray. There were some bichrome wares, and frequently burnishing took the place of a slip. As yet, however, nowhere in this period was there any attempt at formal design.

OLMEC INFLUENCE (1200 B.C.)

The Middle Preclassic Period begins around 1000 B.C. and lasts to 300 B.C. It, too, is concentrated in Chiapas, Mexico, and Upper Central America, chiefly at the sites of Chiapa de Corzo, La Victoria, and Kaminaljuyu, Guatemala. Contact among these settlements continued, but about this time Upper Central America began to strengthen its connections deeper within Mexico. There is a break in the Ocos-Chiapa I (Cotorra) ceramic tradition and the first evidence of maize in this territory now occurs.

At Chiapa de Corzo, the phase Chiapa II, 1000–600 B.C., followed the earlier Chiapa I, extending to many sites in the area with the exception of the cave of Santa Marta. Among the new features are terraced platforms faced with stone and rectangular foundations made of small boulders. They might have served to support dwellings but the presence of three-pronged incense burners and handmodeled clay figurines with punctate pupils indicate an established religion and suggest a ceremonial use for these constructions.

Where these ideas came from, we do not know, but trade and intercommunication over large distances were characteristic of this period and through them religious and cultural traits were exchanged. At this time also lived a people more culturally advanced than any other in the northern hemisphere — the Olmecs. Their name means "dweller in the land of rubber," and this suggests an origin in tropical country associated with rubber trees. Their generally accepted homeland is southern Veracruz, Mexico, where as early as 1200 B.C. they had attained such a superior standard of living that they can be considered the cultural forebears of Meso-

american civilization. Although La Venta in Tabasco seems to have been a very important center, the Olmecs were not confined to one region. Both as traders and colonists they spread north, west, and south taking with them their religion, art, and intellectual achievements, which were absorbed in part by the peoples with whom they settled or were fused with local concepts. The Olmecs who lived with alien groups and blended their culture with that of original inhabitants are known as Olmecoid.

Certain traits in Upper Central America are evidence of the Olmecoid. Among these diagnostic elements are planned settlements, usually on a north-south axis; clay platforms and pyramidal mounds, which were located around courtyards and often supported earth and adobe buildings; the *talud* or short sloping wall on pyramids; the excavation into a mound to make a tomb; basalt columns and plain stelae, column-shaped monuments usually made from a single stone block; carved basalt stelae and altars; colossal stone heads; jaguar masks as decoration on mounds which served as platforms for buildings; a cultlike fondness for jade; baby-faced and feline-faced figurines, mostly of jade but sometimes of clay; stone axes, or celts, and figurines covered with the vermillion dust of cinnabar, as well as certain pottery types which will be examined later; the spiritual association of jaguar, bird, and serpent; a 260-day ceremonial calendar, a 356-day solar calendar, and a Long Count which measured elapsed time from a fixed period; and a stratified society. All of this formed a major part of the Olmecoid pattern and had a tremendous influence over a vast area.

The censers and simple clay *tecomates* (coarse clay jars, copies of the gourd used to carry water) associated with the pottery of Chiapa II appeared at Kaminaljuyu, Guatemala, during the coeval phase of Las Charcas. Likewise there are close resemblances between certain types of figurines and bowls or dishes with a flat base and outflaring walls, and examples from La Venta. There are also similarities between Chiapa II pottery and ceramics of the oldest period at Altar de Sacrificios on the Rio de la Pasion in the Caribbean lowlands of Guatemala.

One of the most exciting features of this phase, however, is a stela or monolith six and a half feet (2 m) high carved in low relief, showing the figure of a man who wears a feline mouth mask and

kneels in front of a standing personage dressed in a skirted loin cloth. A cape hangs from the shoulder and a pectoral from the neck, and in one hand the man holds a ceremonial axe. Although badly destroyed, the art still can be identified as Olmecoid. This stela comes from Padre Piedra and associated Chiapa I and II pottery suggests that it was erected during the transitional period between these two phases. The same style is seen on a boulder at Chalchuapa, El Salvador.

Boulder sculpture, or human or animal figures and heads carved from a boulder but adhering to the form of the stone, is also associated perhaps with the Early but definitely with the Middle Preclassic Period in Upper Central America. Such sculptures are found in Chiapas, for example at Izapa, and at Kaminaljuyu, Monte Alto, El Baul, and many other sites in highland and Pacific Guatemala. They occur also in western El Salvador in the department of Ahuachapan, and at Copan, Honduras, where two lay underneath Stela 4, which bears the date A.D. 731. The wearing apparel carved on the Copan sculptures suggests the influence of a formative Maya culture.

Small boulder-style Olmecoid stone head, Kaminaljuyu, Guatemala, Late Preclassic. Height 35 cm.

Outstanding because of their facial characteristics and enormous size are the boulder sculptures from Monte Alto, Guatemala. Eleven boulder figures are now known. Five are monumental human heads, the largest approximately four feet (1.25 m) high; and five are complete human figures with the limbs carved in low relief. The other sculpture is a feline head. Most of these monuments were associated with earth mounds but jade earspools and late Middle Preclassic pottery tentatively dated from 500 to 300 B.C. were found at the base of a human effigy boulder sculpture. Perhaps these figures can be attributed to the provincial Olmec; at least these heads can be thought of as Olmecoid.

Some boulder sculpture can also be classed under the term petroglyph, for example, the carved boulder six feet two inches (2 m, 4.5 cm) tall from Las Victorias, Chalchuapa zone, El Salvador, shown on pages 43 and 44. On each of the four sides there is an image of a man cut in low relief. Three of the figures are standing; one is seated. The heavy squat forms are portrayed in precisely incised lines with rounded joints, asexual bodies, helmetlike headdresses, and circular pendants, traits that bespeak the Olmecs. Further indications of such a cultural relationship include the thick-lipped, turned-down mouth of the seated man, the two glyphlike motifs he

Boulder sculpture, Monument 2, Monte Alto, Guatemala, late Early or Middle Preclassic. Height 140 cm.

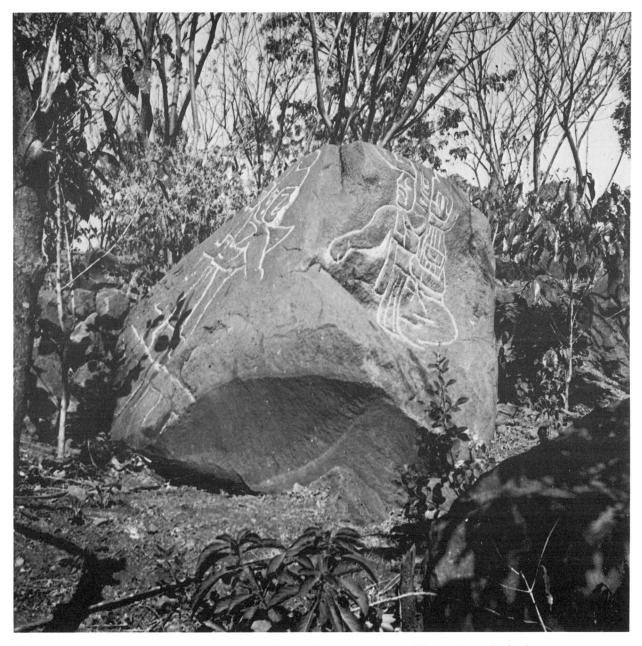

Olmecoid figures carved in bas-relief on a large boulder, Las Victorias Group, Chalchuapa Zone, El Salvador. There are two other figures on the same boulder.

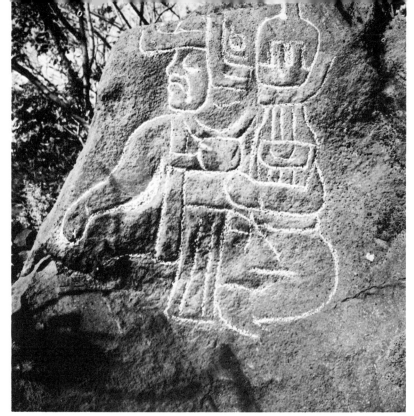

Details of Olmecoid figures on
boulder.

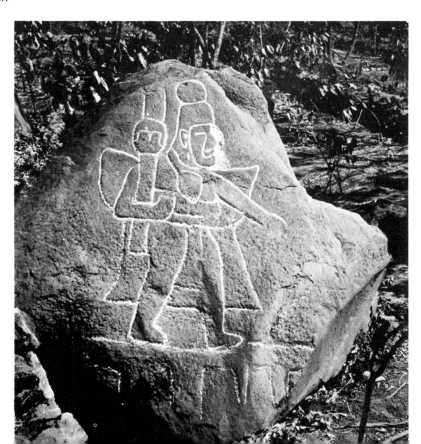

clutches in his left arm, of which the upper one is known as the step design, and the hanging apron of his loincloth. The pomponed helmet, the war club, the winged cloak, and the hanging loincloth of the largest personage, who is standing on a hieroglyph which resembles a colonial aqueduct, are additional evidences of Olmec influence. Petroglyphs representing cleft human heads, another Olmec trait, are also known in El Salvador and Nicaragua.

THE EARLIEST MAIZE

Many Pacific coastal Guatemalan sites are located in mangrove swamps, as at La Victoria, and some show a cultural connection with one another as well as with interior communities. At Salinas La Blanca the Cuadros phase which began at the end of the Early Preclassic offers evidence of the earliest maize in this region. Cultivated foodstuffs included pod corn, as shown by cob impres-

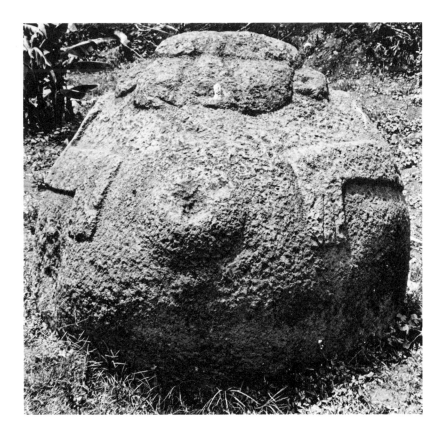

Boulder sculpture, Monument 1, Santa Leticia, department of Ahuachapan, El Salvador, probably Middle Preclassic. Height 1.45 m, width 1.5 m.

45

sions, alligator pears, and the plum called *jocote*. The two fruits were identified by their seed. Fields usually bordered estuaries or river banks. The diet was supplemented with deer, water fowl, fish, iguana, crab, and mollusks such as oysters, mussels, and snails.

Thatch-roofed, pole-walled houses built on earthen mounds characterized these settlements. Only one figurine has been associated with this period but ceremonial cannibalism, or the ritual consumption of parts of a human being in order to absorb magically the power of the individual, indicates some religious activity.

Palm-leaf mats and coiled pottery still decorated as in Early Preclassic times with groove zoning or deeply indented lines made by pressure with a tool, incising, and rocker-stamping, formed part of household furnishings. The most popular local pottery was Guamuchal Brushed tecomates. Non-specular hematite paint was used on vessels of the same shape called Mendez Red-rimmed tecomates. Both of these ceramic types, Red and White Bichrome pottery, white-black differential firing and white slipped vessels, as well as oval grinding stones, have a close resemblance to Chiapa I artifacts. A similarity also appears between Brushed neckless globular jars of Cuadros and the earliest pottery from Santa Marta cave, Chiapas, and the lowest levels at Izapa.

In the same area and first recognized at Salinas La Blanca, the Jocotal phase, 850–800 B.C., seems to be transitional between Cuadros and Conchas 1, 800–500 B.C. Constructions of clay platform mounds and pyramidal mounds on the coast appear to date from Jocotal times. Ceramic relationships are partly with Arevalo and partly with the end of Chiapa I and the beginning of Chiapa II. The first two periods are part of the Early Preclassic.

The Conchas phase follows Ocos at La Victoria and consists of two divisions: Conchas 1 and 2, 500–300 B.C. The first partly equates with Chiapa II. There are indications of a population increase and sites of the Conchas culture spread inland and along the coast. The ceramics display a relationship with the more developed pottery of the Las Charcas phase at Kaminaljuyu, Guatemala, but at the same time retain their own individual character. Among the wares common to both are Incised Black, Incised White, Ocos Gray, Red and White Bichrome, and Conchas Red-on-Buff, a transitional type. The wares have distinctive shapes with the greatest variety occurring in Conchas 1.

Both solid and hollow clay figurines, some slipped and painted,

are plentiful. Many represent pregnant women and imply a votive role or religious cult. Ceremonial cannibalism continued. Further evidence of religious activity was the periodic destruction of all household goods in renewal ceremonies. No possessions were placed with the extended body in the grave, however, and burials were under house floors.

New tools appeared in Conchas times. Long prismatic obsidian blades, some polished celts, and a percussion-flaked axe as well as a ground stone axe with a rough groove were made. Ornaments consisted of wide earspools of pottery and fish vertebrae, and animal teeth. Clay roller stamps were used to paint the face and body with red and black motifs which possibly denoted clan signs. Most significant of all were a single jade bead and a baby-faced figurine, showing the existence at this early date of trade with distant regions such as the contemporaneous culture of La Venta in the north. These items may indicate the first appearance of Olmec influence in the south unless, as some investigators have suggested, the Padre Piedra stela in Chiapas and some of the colossal heads hewed from boulders as at Monte Alto, Guatemala, date from this period.

The cultural sequence of Las Charcas, about 1000–600 B.C., follows the Arevalo phase at Kaminaljuyu. The dead were buried in pits, sometimes covered with stone slabs, instead of under house floors, but living conditions were much the same. Agriculture was important and for the first time cobs and husks indicate maize in the Guatemala highlands. Possibly the alligator pear was also cultivated.

The material culture of these early inhabitants can scarcely be termed primitive. Some plain columnar basalt stelae in front of

Clay figurine head, Kaminaljuyu, Guatemala, Las Charcas phase. Height 4 cm.

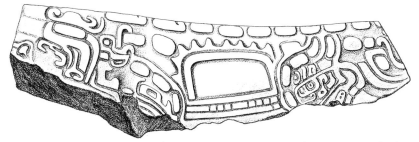

Carved motif in Olmecoid style on Monument 2, Kaminaljuyu, Guatemala, late Las Charcas phase. The motif represents a serpent with scales whose head has long, divided fangs. Length 2.65 cm.

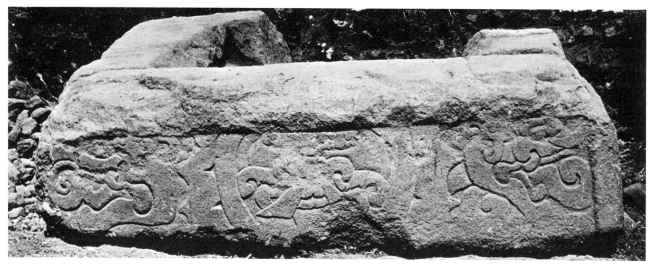

Jaguar altar with jaguar and serpent faces carved in low relief on the sides in Olmecoid style, from the edge of the West Group, Quelepa, eastern El Salvador, late Las Charcas phase? Height 80 cm, length 3 m.

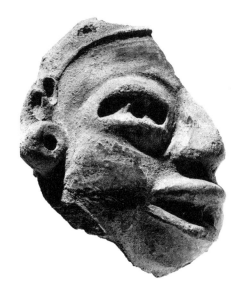

Clay figurine head fragment, Kaminaljuyu, Guatemala, Las Charcas phase. Height 8.5 cm.

low platform mounds built in parallel north-south rows appear during Las Charcas phase at Kaminaljuyu and other highland sites, although they are more typical of the later Providencia phase. It is a concept associated with the Olmec culture area, coastal Veracruz and Tabasco, Mexico. Established religious practices are indicated by "altars" carved in low relief, incense burners with three prongs like Chiapa II, handmodeled solid figurines representing human beings and animals, and boulder figures. Bird and animal effigy whistles occur and may have been used in hunting.

The common ware consisted of simple bowls, *comales* (griddles), small cups supported by slender tripods, and "graters" cut with heavy lines (perhaps used for preparing manioc as well as for chili peppers), a feature shared with Conchas. All were reddish-brown, coarse, and without slip or polish.

The most popular shapes among Fine wares were large globular jars with a thick outflaring rim from which two half-loop handles extended to the vessel body, bowls with a flat base and an incurved rim, and spouted jars. Modeled effigy and shoe-shaped vessels were also fashioned and they have a long tradition in Central America. All were slipped and polished. Some were incised on top of the slip after firing; others were incised before application of the slip. Widely used were White, Red-on-White, Red-on-Buff, Pallid Red, and Streaky Gray-Brown.

Linear patterns, both straight and curved in a plano-relief technique, and a fat-bellied monkey with raised tail predominate. This last motif took a prominent place in the Nahuatized religion of Classic times.

Other artifacts associated with the early Middle Preclassic culture of Las Charcas are grinding stones and mullers, obsidian flake-blades and scrapers, and jadeite or greenstone celts, perhaps indicating the beginning of an Olmec cult. Cylindrical and stemmed stamps made of clay may have been used for body painting. The purpose of effigy stones shaped like mushrooms is unknown.

From 900 to 500 B.C. some of the small communities in upper Central America were developing well-defined cultures and ceramic styles. Although Usulutan pottery is generally placed in the later Providencia phase at Kaminaljuyu, a small amount of it appeared at the end of Las Charcas, during the slightly later but partly contemporaneous Mamom period at Uaxactun in the Guatemalan Peten, and at Playa de los Muertos in northwestern Honduras, a site equivalent in time with Mamom. Therefore, it seems wise to discuss this important pottery before examining the phases in which it occurred. The term ware has not been used for Usulutan pottery because there is no uniformity in the paste, shape, or motif, the common element being the technique of decoration which was produced by a resist process, perhaps using wax and an implement with several brushlike points.

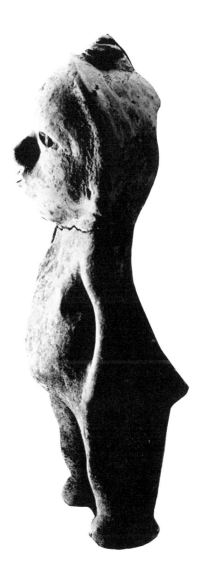

Clay figurine, Kaminaljuyu, Guatemala, Las Charcas phase. Height 21 cm.

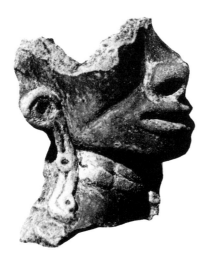

Fragment of a clay figurine, Las Charcas phase. Height 8 cm.

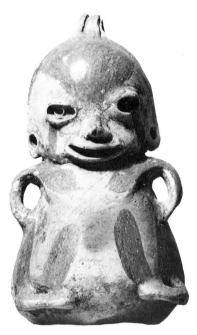

Red and White Ware figurine,
Kaminaljuyu, Guatemala, Las Charcas
phase. Height 15.5 cm. Note the
loop for suspension on top of
the head.

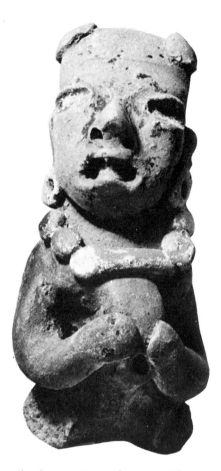

Clay figurine, Kaminaljuyu. Las Charcas
phase? Height 12.5 cm.

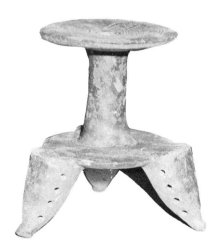

Clay effigy of a mushroom stone from
El Salvador, early Middle Preclassic.
Height 27.5 cm.

The Usulutan technique, one of the earliest in Upper Central America and one with the widest areal and temporal distribution, is assumed to have originated in eastern El Salvador because of the high frequency of its appearance there. It was first recognized, however, at Cerro Zapote near San Salvador, where sherds decorated in this style were found with handmodeled figurines under a humus layer isolated by a heavy deposit of volcanic ash. Above the ash were artifacts associated with "archaic" Maya and Pipil cultures.

The background color or the slip of pottery decorated in the Usulutan technique varies from an orange or yellow-buff to cream or from pale red to pink. Generally, design was limited to groups of equal numbers of parallel lines lighter in color than the slip and usually wavy. Most typically, but not always, these line groups covered the exterior and interior of a vessel and were not arranged in bands or panels, as occurred in the ceramic decoration of northern Central America. In some cases running lines produced a blurred area.

Vessel forms vary greatly and include cups on ring bases, spouted effigy pots, and bowls with a flat base or with a basal concavity. Characteristic, however, are tetrapod vessels with feet — solid nipples, pointed, flat, rounded rattlelike (cascabels), or large swollen mammiforms.

Beyond the fact that they were sedentary agriculturists, little is known about the inventors of this important ceramic style. The earliest appearance of Usulutan technique in eastern El Salvador was at Gualacho near La Rama. Here the common local pottery, an Orange Ware, and Usulutan specimens have the same shapes, differing only in the manner of decoration. Although the age of Gualacho is not reinforced by a radiocarbon date, it is thought by some investigators to be as old as Las Charcas.

The significance of this technique in Upper Central America is great. Its predominance in eastern El Salvador, a section that played a most important role among the small communities of this northern region, and the antiquity of its presence emphasize the highly developed character of this ceramic tradition. As yet there is too little archaeological evidence to pick one site as the origin of the Usulutan technique. We do not know whether the pottery

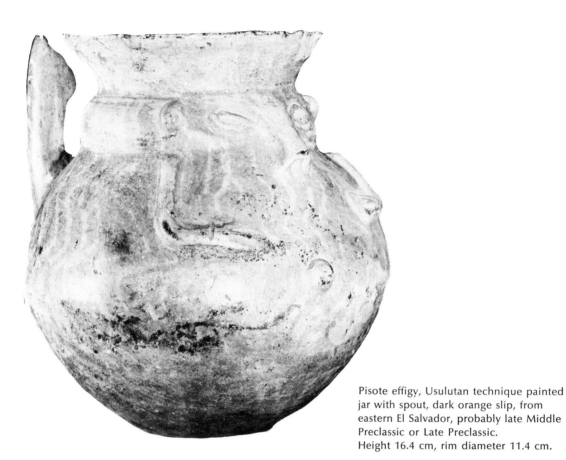

Pisote effigy, Usulutan technique painted jar with spout, dark orange slip, from eastern El Salvador, probably late Middle Preclassic or Late Preclassic.
Height 16.4 cm, rim diameter 11.4 cm.

Usulutan technique decorated pottery jar with orange slip and polished surface, El Copinol, department of Ahuachapan, El Salvador, probably late Middle Preclassic. Height 12.2 cm, rim diameter 15.3 cm.

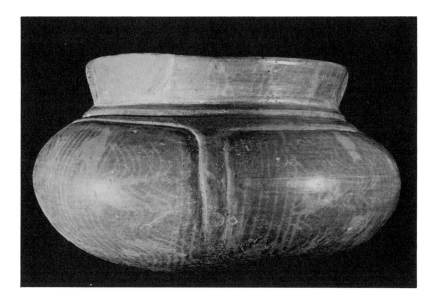

Usulutan technique decorated pottery vessel with an orange slip and decorations on the interior and exterior from eastern El Salvador, probably late Middle Preclassic. Height 10.5 cm, rim diameter 15 cm.

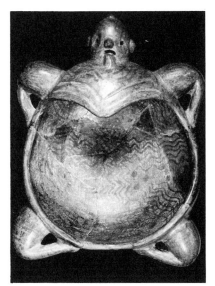

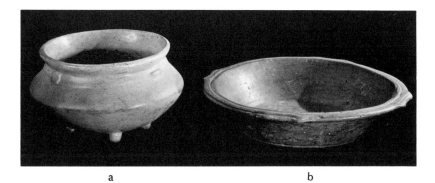

a b

Usulutan technique from Kaminaljuyu, Guatemala, Late Preclassic.

a. tetrapod vessel, whitish yellow with solid nubbin feet. Height 11 cm, diameter 14.5 cm.

b. flat-bottomed vessel with flaring sides and tetrapod solid nubbin feet, orange-yellow with wavy yellow lines; four indented decorations and incised lines on rim. Rim width 1.5 cm.

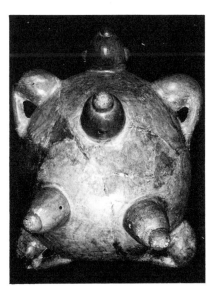

Human effigy vessel in the Usulutan technique with three solid slightly mammiformed feet, El Hacha, province of Guanacaste, Costa Rica, Zoned Bichrome, 300 B.C.–A.D. 300, corresponding roughly with the Late Preclassic in Upper Central America. Red slip, length from head to opposite end of bowl 24 cm, width 18 cm.

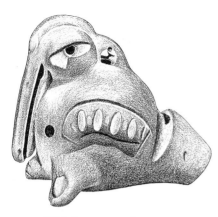

Whistle representing a cormorant,
Uaxactun, Guatemala, Mamom phase.
Height 5.5 cm.

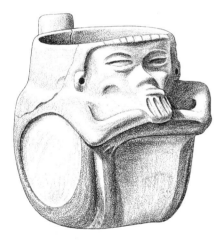

Red-on-Cream effigy vessel,
Kaminaljuyu, Guatemala, Mamom-late
Las Charcas phases. Height 9.8 cm.

was traded or the style was copied within the area of its greatest distribution, that is from western El Salvador to Guatemala and western Honduras.

Extensive if not intensive communication undoubtedly took place between the farming settlements of Upper Central America even before 1000 B.C., and cultural ideas if not material culture were widely diffused. For example, Usulutan technique is the principal method of decoration on the Preclassic pottery from Copan, Honduras, where, as in El Salvador, it lasted from the Middle Preclassic into the Early Classic. In addition to western Honduras, including the Sula-Comayagua-Goascoran valleys, it appears in much of Guatemala and occurs in southwestern Chiapas near the Guatemalan border; at El Cauce, Nicaragua; and at El Hacha, province of Guanacaste, Costa Rica, where it was found with the very early Palmar Ware and jade. Certainly its presence in Nicaragua and Costa Rica, where it is associated with the Zoned Bichrome period, 300 B.C.–A.D. 300, suggests that it long survived in the isthmian region. During this interval the painting technique remained the same although distinctive decorative features such as red rims, incised bands, and stucco finish appear at some places.

In the vast lowlands of the Guatemalan Peten at the site of Uaxactun, the people responsible for the Mamom phase (900–550 B.C.) lived a life similar to Las Charcas phase people but had identifying characteristics. Again farming was the principal occupation, but for the first time there is evidence of a village settlement pattern. Thatch-roofed pole houses with stone alignments were built on earth- and rubble-filled platform mounds, arranged singly or in groups of up to five around squares or plazas. Flexed or extended burials occurred in unlined holes, or bodies were placed in fill during the construction of a mound. Although there is no indication of an elaborate religion, mortuary offerings of shell, some jade, and an abundance of mainly female modeled clay figurines, bespeak at least a simple ritual. Whistles, ocarinas, and flat clay stamps were also made and may have had some religious significance. Some effigy whistles might have been used to mimic bird or animal calls in the hunt. It has been suggested that clay stamps were employed to decorate cotton cloth.

Figurine heads, Uaxactun, Guatemala,
Mamom phase. Largest head 5.5 cm.

54

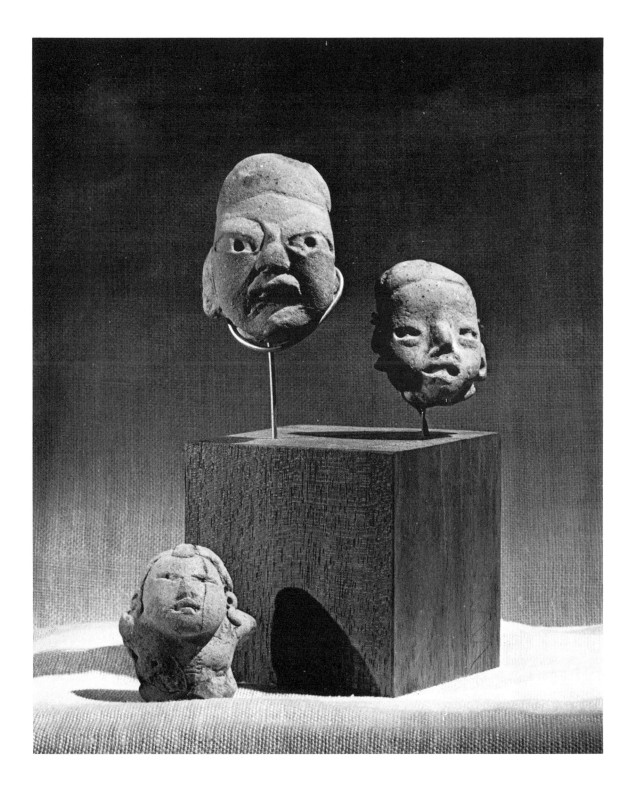

The solid handmodeled figurines have a prognathous open mouth, eyeballs formed by impressing with an awl and pupils indicated by punctation. Headdresses range from turbans to topknots and varied hair styles. Aside from a few puff-cheeked whistling faces with the mouthpiece on top of the head and with one or more stops, whistles are generally in the shape of birds, although deer, bat, peccary, pisote (*coati*), and lizard representations occur.

Spindle whorls indicate that cotton cloth was woven. Personal adornment included ornaments of shell, bone, clay, and very rarely jade. Bone tools were known but more common were flint axes, scrapers, and awls. Obsidian razorlike lancets were present but scarce.

Similar to Pacific and highland ceramics, the pottery of the Mamom period is technically well advanced and serviceable. A distinguishing trait is the waxy feel of most of the wares. Types included slipped and polished water jars; wide-mouthed storage vessels for food and seeds were decorated by incising with simple lines, crosshatching, and parallel-lined triangles. Modeled human and animal heads were also used as decoration on both large and miniature vessels.

At Uaxactun, Guatemala, a number of ceramic traits appear only in Mamom times and do not continue in later phases. Among these are two wares, Daub or Palma Daub and Mars Orange, along with the modeled figurines and whistles referred to earlier. Daub Ware consists of unpolished and unslipped jars with pinched rim and red painted neck and lip. Its name is derived from red vertical or horizontal bands or crude swirls daubed on the vessel body. Mars Orange Ware includes bowls, dishes, plates, flat-bottomed dishes with flaring sides and a basketlike handle, and one jar form. Diagnostics are paste hardness, color, and finish. Decoration is limited to horizontal grooving and incising in oblique and horizontal fine lines.

Red-on-Cream Ware occurs principally during Mamom but is not confined to this period; in both color and form it closely resembles Red-on-White vessels from the Las Charcas phase at Kaminaljuyu.

The people responsible for Mamom ceramics were not isolated from similar communities noted elsewhere. The figurines, whistles and ocarinas, certain styles such as Red-on-Cream and the Usulutan technique, and jade and obsidian show that Uaxactun in the Ma-

mom era had communication and trade with other sites in the Peten, British Honduras, Yucatan, highland Guatemala, the Pacific coast, and possibly El Salvador. In Honduras the Playa de los Muertos phase and the earliest period at Copan were also contemporaneous with Mamom, although not all authorities agree that Mamom pottery was present at Copan.

The early ceramics from the caves at Copan reveal a cultural influence derived from the north. The pottery, including a bottle-shaped vessel, suggests relationships with Tlatilco–Middle Tlatilco, Mexico. Sometimes called Tlatilco II, this site was an Olmec colony around 900–500 B.C. There are indications to suggest that La Venta culture was present at La Victoria in Conchas times and that possibly some of the colossal heads of the Guatemalan Pacific slope date from around 1000 B.C. It is, therefore, not surprising to find that Olmec influence or even provincial Olmecs reached the fertile Copan Valley at relatively the same period, for here, too, are boulder figures of a very early date.

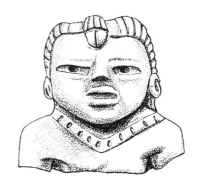

In northwestern Honduras a dramatic change in the social and religious life appeared during this time. This phase is known as Playa de los Muertos or Beach of the Dead after the place in the Sula Plain where it was first located. Although elements associated with this phase occur at other sites, it is here that all the diagnostic traits are found together and in greatest quantity. So far, an early and a later period have been distinguished.

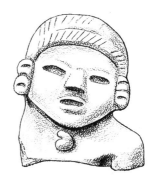

There are no visible mounds at Playa de los Muertos, but baked clay with wattle-and-daub impressions on house floor levels reveal that people lived in dwellings of plaited rods or canes, probably with thatched or palm-leaf roofs as we find today. Cooking was over wood or charcoal fires within the house. A diet of agricultural produce was supplemented by game or fish and included mussels and fresh-water snails. And as always in these ancient communities, there were refuse deposits containing broken pottery and other artifacts.

Unlike the earlier Las Charcas and the contemporary Mamom inhabitants, the Playa de los Muertos people had grave areas with multiple interments side by side or superimposed. Burials were flexed or extended, but at least one seated body was found. Rich mortuary furnishings testify to a well-advanced culture with reli-

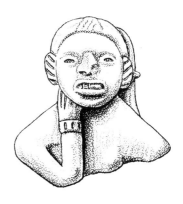

Figurine heads, solid hand-modeled and polished, Playa de los Muertos, Sula Plain, Honduras, Middle Preclassic.

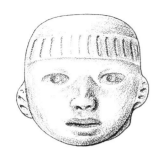

Solid hand-modeled and polished figurine heads from Farm 11, Sula Plain, Honduras, Middle Preclassic. Height of larger 4.5 cm.

gious ritual and the beginning of a stratified society. Whether the social organization included hereditary rulers and a dominant priesthood cannot be determined, but a definite distinction in rank is revealed by the contents of two graves of the early period. One contained a small child who still had his milk teeth, with the skeleton surrounded by many clay vessels, some for daily use but others decidedly ceremonial in appearance. One of the finest pots covered two clay figurines, one portraying a pregnant woman holding her right hand on her enlarged belly and her left hand raised to her head in a gesture of pain or horror. The child was adorned with a necklace of white shell beads with a carved shell in the center flanked by two small jadeite pendants. A beaded belt or girdle of more than ninety jadeite beads was around the waist. By contrast, the excavation of an adult grave at the same site yielded only skeletal remains.

The early phase of Playa de los Muertos was by far the richest. Stone adzes and obsidian blades, small rectangular mullers, and polishing stones and hammerstones served as tools and household implements. Vessels for mixing red, black, and possibly pink pigments have been preserved from this period.

Jadeite was extremely important during the first part of this cultural phase but less so in the second. One of the oldest cult images in Preclassic times, the axe-god, was carved in jade. This axe-shaped pendant usually has a bird or human head but may be so stylized that the distinction between the "body" or axe and the "head" is vague. Jadeite votive axes with a feline head and hands resting on the abdomen are northern features. The presence of bird and anthropomorphic head axes at Playa de los Muertos could be another sign of the penetration south of Olmec religious ideas slightly changed in a new environment. Axe-gods of this type are known from around A.D. 100 in Lower Central America and one appeared in a jadeite cache at Cerro de las Mesas, Veracruz, Mexico, associated with objects of varied periods including Olmec and Early Postclassic.

In addition to the body ornaments described earlier, the affluent Playa de los Muertos individual had bracelets of jadeite beads, some combined with shell. Those of lesser status used simple jadeite amulets, while the still poorer person had clay earplugs. A single jadeite bead was placed in the mouth between the upper and lower incisers at death, probably to assure safe passage of the spirit to another world.

The richness and uniqueness of the material culture of these

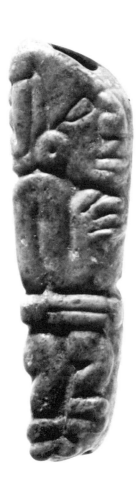

Jadeite pendant, Playa de los Muertos, Honduras.

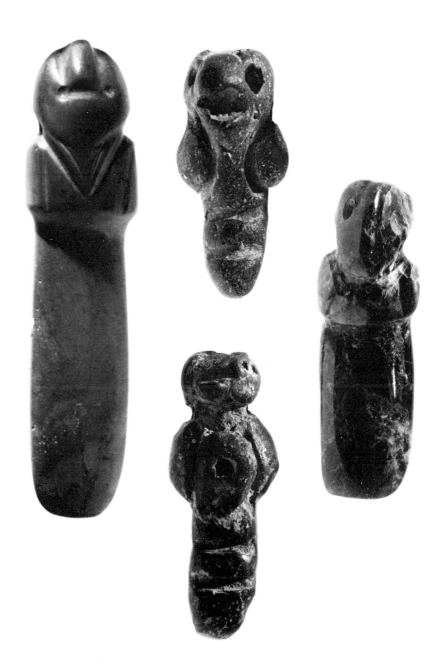

Jadeite axe-gods, Playa de los Muertos, Honduras.

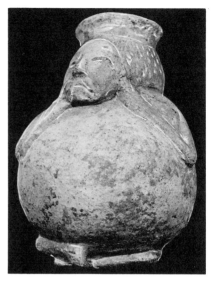

Unpainted, burnished cylindrical flat-bottomed and pattern-burnished vessel from Farm 11, Sula Plain, Honduras, early Playa de los Muertos, Middle Preclassic. Height 18 cm, rim diameter 15.1 cm.

Unpainted effigy vessel representing a female in distress from Farm 11, Sula Plain, early Playa de los Muertos, Middle Preclassic. Height 12.75 cm.

people are also indicated by their pottery. There are flat clay stamps, queer hollow unpainted clay objects with a loop handle which somewhat resemble a candle snuffer but whose use is unknown, and miniature and large pots. Forms include spouted, shoe-shaped, effigy vessels with either filleted or modeled features and extremities, straight-walled flat base vessels, bowls with thick lips, and bowls of composite silhouette. Some have strap handles, often with vertical ridges.

Unpainted or monochrome pottery predominates with six distinguishable types consisting of an unslipped coarse brick-red to sooty gray, a slipped and burnished orange-red to brown, a chalky whitewash ware, and three highly polished wares — a dark gray to black, a slate-gray to black, and a slate-gray to buff. The unpainted pottery appears at the lowest level and continues in diminishing amounts throughout the existence of this culture. One style of decoration is realistic and includes effigy vessels depicting, for example, a person in distress. The other decoration is characterized by pattern burnishing — vertical wide-line panels run from a plain rim to the flat base alternating with fine line panels which are divided in half, the upper portion slanting in the op-

posite direction from the lower. The lines seem to have been impressed in the clay with a stick, producing a burnished finish; at the same time the irregularity of the artist's hand is revealed as some lines were worked over more than once. The sense of design and its application to the vessel form is mature. In addition to polishing, filleting, and modeling, characteristic decorative devices are incising and fluting, which is accomplished by pressing straight or semicircular channels of any width or depth in the wet clay.

Less frequent styles include irregular areas painted in red, red and black, and red and buff, occasionally outlined by incising; and there are a few examples of blotchy white designs on exterior and interior. The Usulutan technique is also present.

The most widely distributed elements of Playa de los Muertos culture, however, are unpainted, highly polished, solid figurines modeled by hand. Few complete specimens have been found — heads broken from the body at the neck, some with a part of the torso, and headless torsos with limbs are common. They seem to be genre figures, since almost every one has individual characteristics. Their physical similarity suggests a homogeneous racial group.

The typical head is brachycephalic. Each one has its own expression and needs no torso to aid the portrayal of feeling. The nose is straight and slightly triangular with usually an indication of nostrils. Lips are full and everted, divided from one another by a deep impression. As a rule, but not always, the eyes are portrayed by an elliptical groove surrounded by a raised rim. Pupils are punched generally in the center by a sharp tool. The outward form of the ear is modeled and earplugs or a stylization of ear ornaments consisting of three parallel grooves are common. It is the arrangement of the hair, however, that emphasizes the realistic aspect of these heads; no two are exactly alike. The hair is indicated by fine and coarse incised lines, by punctation, or by slight dotlike marks that give the impression of peckings. Some heads are partially shaved down the center over the crown, leaving a narrow band of hair at the rear or around the bottom. There are long tresses decorated with tassels on one side, topknots, bangs, tassels in the center, and even what might be a cap. Hanging plaits are strangely lacking.

Artistic skill shows, too, in the realism of the female torsos. Details such as firm, plump, or drooping breasts and distinct man-

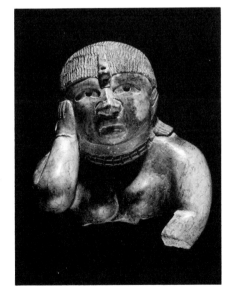

Hand-modeled figurine fragment from the Sula Plain, Honduras, Playa de los Muertos. Height 8 cm.

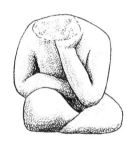

ners of sitting suggest individual models. Some clutch one breast and hold a hand to the face or on the hip with elbow akimbo. Others have one hand supporting the chin and one in the lap or resting on a folded-under knee, while still others have an arm crossed to the opposite shoulder in an attitude of submission. Generally these torsos are nude except for a necklace and bracelets. A few have indications of the backbone.

The upper level of the Playa de los Muertos period changes slightly. Solid handmodeled figurines continued to be made but were rare. Instead, hollow handmodeled figures, partly white-slipped with red decorations, and painted miniature solid figurines predominate.

Characteristic of this later time are the objects found at Farm 11, part of Playa de los Muertos in the Sula Plain. Located eight feet (2.5 m) above the oldest deposits but under the same sterile level of clay were a solid painted head with a modeled round nose plug, a painted hollow figurine fragment, two pottery pendants, a solid monkey and a human figure, a vessel with an incised diamond-shaped monkey motif (like the pot-bellied simian seen at Las Charcas, this motif later became a popular symbol of Nahua-tized religions in Central America), two miniature dishes, and a clay stamp. All the figurines, except the woman who wears a long shawl covering her head and most of her back and the fat seated monkey, have the traditional Playa de los Muertos-style face and head. The small pendants have a hole for suspension laterally through the neck and are adorned with incised earplugs, a necklace, and bracelets. One portrays a breastless female with her knees doubled in the position of an infant despite the mature appearance of the face with its slightly down-curved mouth; the other pendant represents an adult male with the breasts indicated only by an indented dot while an apron or loincloth covers the front lower portion. These are unusual traits but may be a reflection of La Venta or Olmec influence that moved south during Chiapa II, Las Charcas, and Conchas times.

Playa de los Muertos demonstrates a mixture of elements. The burnished design technique on unpainted ware is familiar to South America and is known on the Caribbean side of Lower Central America but is not yet placed in time. Stirrup-handled ves-

Solid hand-modeled highly polished torsos, Playa de los Muertos, Sula Plain, Honduras, Middle Preclassic.

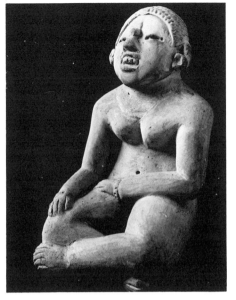

Hand-modeled figurine, Sula Plain,
Honduras, Playa de los Muertos.
Height 11.4 cm.

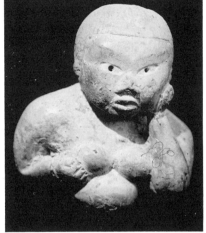

Fragment of a hand-modeled polished
figure of a woman in distress, Sula Plain,
Middle Preclassic.

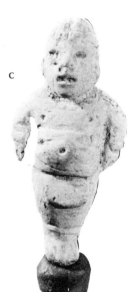

d

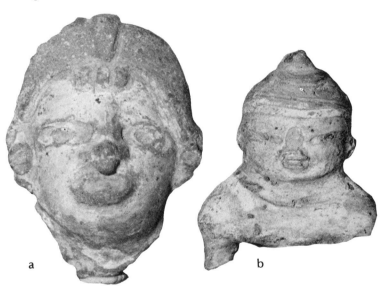

a

b

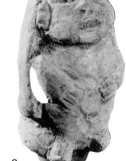

c

e

Solid hand-modeled figurine heads from Farm 11, Sula Plain, late Playa de los
Muertos. a. Has nose ornament and is painted white; height 6.5 cm.
b. Fragment painted white and red; height 8.75 cm. Solid hand-modeled
Olmecoid polished clay pendants from Farm 11. c. Note necklace, bracelets, and
apron loincloth. d. Note hair, necklace, and bracelets. e. Solid hand-modeled
polished figure of a woman wearing a shawl; height 4 cm.

sels also show affinities with the southern continent. Archaeologists note resemblances in Playa de los Muertos ceramic forms with certain vessels from Mamom and the later Chicanel periods at Uaxactun, Guatemala. In addition, there is a resemblance between the solid round heads of some Uaxactun figurines and the solid Playa de los Muertos specimens described earlier. Such relationships suggest that Playa de los Muertos culture may have played a role in the formative period of the Peten Maya.

Possibly coeval with the late period at Playa de los Muertos is the phase of Yojoa Monochrome, first identified near the site of Los Naranjos at the north end of Lake Yojoa, Honduras. The only diagnostics are sherds derived from a refuse stratum. Although we do not know the manner of living, the pottery is basically the same as that from the Sula Plain — flat-bottomed vessels without lugs or supports and with swollen lips often slightly flaring, globular jars with cylindrical necks, no formal painted designs, and hand-modeled solid figurines.

On the Pacific slopes of Guatemala near the town of Santa Lucia Cotzumalhuapa there are a number of sites, including Bilbao, El Baul, and El Castillo, where the Cotzumalhuapa art style was produced in the Classic Period. Bilbao is considered the type site because it is the largest and has yielded more stratigraphic evidence. Bilbao begins about 750 B.C. with the ceramic phase Algo-es-Algo. Pottery is similar to Middle Preclassic ceramics with zoned painting and stamping, rocker-stamping, pattern-burnishing, and tool-impressed fillets as common decorative techniques. These appear on flat-bottomed dishes, simple and composite silhouette bowls, thick rimmed jars, tecomates or neckless globular jars, and incurved-rim bowls. That Bilbao was in communication with important settlements of the region is noted by trade wares from the Ocos and Conchas phases, including specular hematite paint, Chiapa I, Las Charcas, and Providencia phases of Kaminaljuyu, a Zoned Bichrome Ware from the Guatemalan highlands called Utatlan, and the Usulutan technique.

In Chiapas around 600 B.C., the short-lived Chiapa III phase reveals a distinct minority group intrusive in the cultural environment. Chiapa III pottery is characterized by highly polished Red, Black, Brown, and White Monochrome wares; the polish produced a resinous or waxy finish on the vessel. Most of the pottery techniques came from the southeast, especially from the Mamom

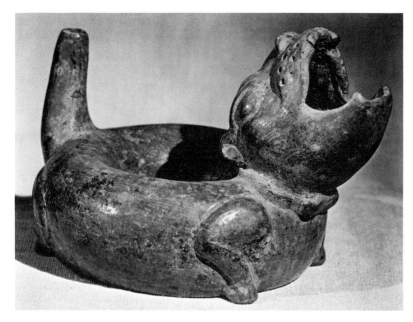

Doughnut jaguar vessel from the south coast of Guatemala, Middle Preclassic? Height 15 cm.

phase in Guatemala. This extension of formative Maya influence is combined during the Chiapa III phase with a seemingly provincial Olmec style.

For the first time in Central America a new pottery trait, the whistling jar, appears associated with the Oaxacan phase Monte Alban I, about 790–390 B.C. This curious vessel is made of two pots — one open at the top, the other closed except for a small hole. The closed half is decorated by either a large or miniature effigy of an animal, bird, or human figure, or only the head of one of these. A hollow tube connects the two compartments at the base. When liquid is poured into the open half, air is pushed through this tube and out the small hole at the top of the covered side. A whistling noise is produced, creating the impression that it comes from the decorative figure.

Large earthen platforms and a stepped structure over twenty feet (6 m) high of tamped clay are first found in this area during the Chiapa III phase. In conjunction with subfloor burials these platforms indicate quite definitely the idea of a ceremonial center.

THE FIGURINE CULT
Following Las Charcas at Kaminaljuyu, the Majadas phase (also

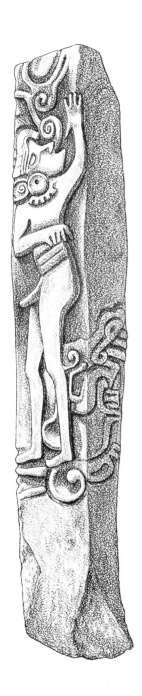

about 600 B.C.) shows signs of participating in new cultural movements. Figurines gradually disappear, a fact which suggests the introduction of different religious practices. The *comal* was shaped flat like a plate rather than like a bowl, and therefore was much steadier on the fire. Other stylistic modifications were labial flanged bowls, faceted shoulders on bowls and jars, and pottery decorated with purple or purplish paint. Among the rarer ceramic innovations were wares classified as Incised Zinc Orange, Glossy Gray-Brown, and Purple-on-Fine Red.

The figurine cult reappeared during the Providencia phase following Majadas at Kaminaljuyu. Conventionalized solid hand-modeled male and female figures classified as "archaic," a style first described from central Mexico, and often demonstrating abnormalities such as goiter and pop-eyes, are common. Perhaps they played a role in ceremonies held to cure the sick. There were also articulated figurines both in highland Guatemala and El Salvador. New ceramic styles include vessels with solid conical feet and well-polished Coarse Incised Black-Brown Ware; the Usulutan technique on pottery became very popular.

Most important over a wide area at least in the early Providencia phase were stone pedestal sculptures of small animals or men carved in the round on top of low or tall shafts. They have been found near Tres Zapotes in Veracruz; at Tonala, Mexico, and various locations on the Pacific coast and slopes of Chiapas to western El Salvador; in the Guatemalan highlands; and in western Honduras. Temporally equivalent are sculptured male figures kneeling or seated on four-legged or scroll-decorated benches. Some are depicted with ropes around the neck and hands and ankles bound behind the back, a condition suggesting they represent prisoners or victims for human sacrifice. Recent excavations on the Chiapas coast have revealed bench sculpture in association with vessels of the Hato phase of Izapa, 0–A.D. 100. Given the mammiform legs of one of these pieces and the Usulutan technique on the other, a technique which lasted throughout a long

Stela 9 from Mound C–III–6, Kaminaljuyu, Guatemala, Majadas phase, late Middle Preclassic. The basalt stela has five sides with carving on three faces. The one shown here has a praying man with an arm raised and a speech-scroll coming out of his mouth. The front face of the column was cut away leaving the figure in high relief. Height 1.45 m.

Three clay figurine heads, Kaminaljuyu,
Guatemala, Providencia phase. Height 4–5 cm.

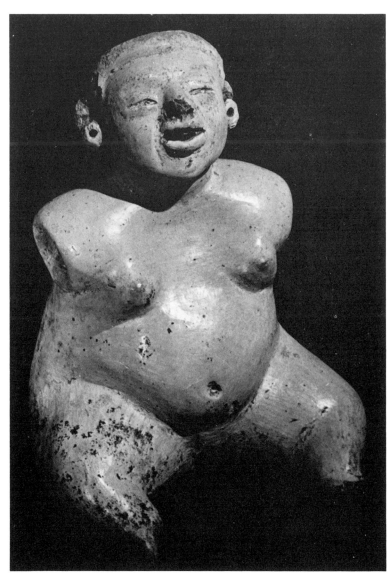

Articulated clay figurine, Kaminaljuyu,
Guatemala, Providencia phase, late Middle
Preclassic. Height 23.5 cm.

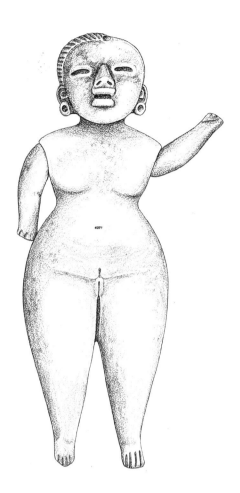

span as we have seen, it is possible that the bench figure likewise enjoyed a lengthy period of popularity or that the 19 cm example in question from Rio Arriba, Chiapas, was conserved as an heirloom from earlier times. Potbelly boulder sculptures also occur.

Associated with the Providencia phase are carved stelae; some have dragon masks, scroll-eye variants of the dragon, and many beautifully executed details showing a well-developed artistic tradition. Possibly some of the Izapa stelae date from this period and not from the Late Preclassic as has been supposed.

RELIGIOUS AND CIVIC ARCHITECTURE

Coeval in part with the Providencia phase of the Guatemalan highlands, the Chicanel phase at Uaxactun in lowland Guatemala (ap-

Articulated clay figurine, Planes de Renderos, El Salvador, Providencia phase, late Middle Preclassic. Height 24.5 cm.

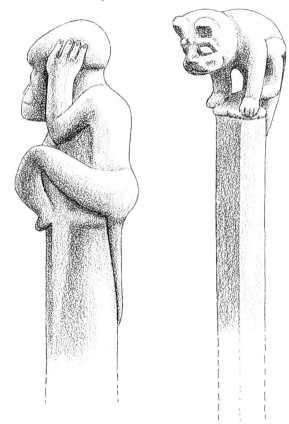

Shaft figures or pedestal sculptures, Tecpan, Guatemala, early Providencia phase. Height about 2.5 m.

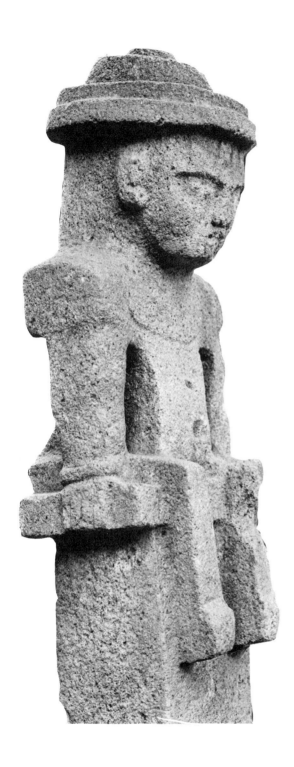

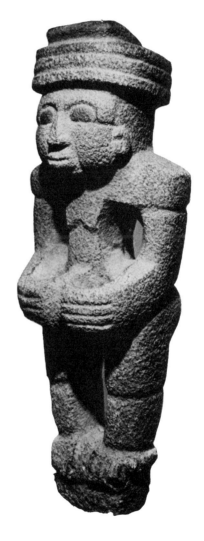

Left: Bench figure, San Jose Pinula, department of Guatemala, Guatemala, early Providencia phase, late Middle Preclassic. Height 57.5 cm. Right: Low pedestal or peg-base sculpture, Patzun, Guatemala, Providencia phase. Height 60.4 cm.

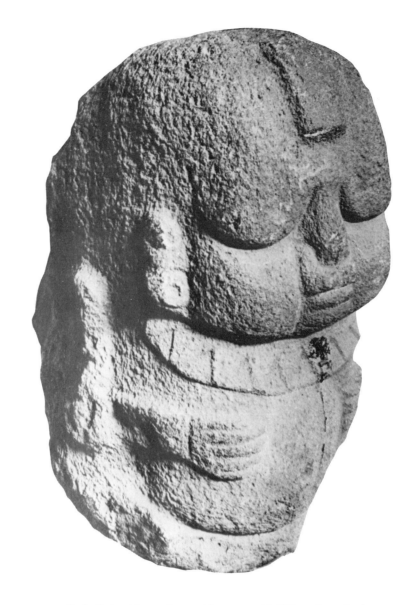

Potbelly boulder sculpture, Monument 47, Bilbao, Santa Lucia Cotzumalhuapa, Escuintla, Guatemala, probably Middle Preclassic. Height 110 cm.

Stela 4, Kaminaljuyu, Guatemala, Providencia phase, late Middle Preclassic. This shows the lower portion of a dancing figure who wears a chest ornament with two part scrolls and is surrounded by scrolls. Note the serpent head protruding from the top of the right thigh and the scroll-eye variant of the dragon at the left knee. Height 86 cm.

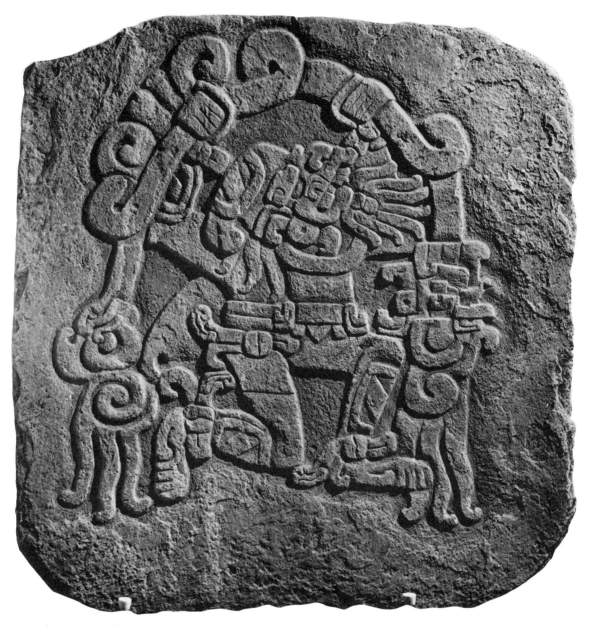

Stela 19, Kaminaljuyu, Guatemala, Providencia phase, late Middle Preclassic. This is the companion piece of Stela 4 and shows a human figure wearing the mask of the Long-nosed god and holding a serpent supported on the left by the mask of the Snub-nosed dragon, usually associated with the earth. Note the same chest ornament as on Stela 4. Height 109 cm.

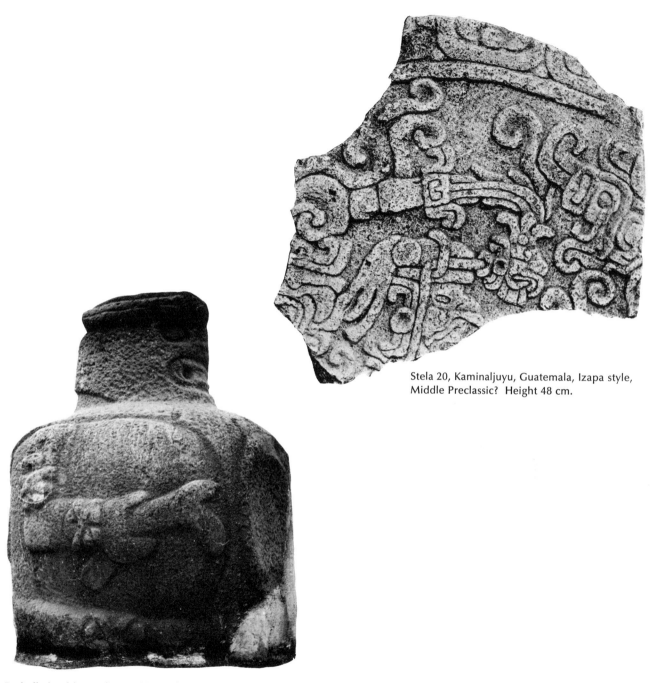

Stela 20, Kaminaljuyu, Guatemala, Izapa style, Middle Preclassic? Height 48 cm.

Potbelly boulder sculpture, Kaminaljuyu, Guatemala, Middle Preclassic. Height about 90 cm.

Tetrapod vessels with Usulutan technique, Cauac phase coeval with Chicanel, from Burial 85, Tikal, Guatemala. Top: Black-on-orange yellow; diameter 18.4 cm. Bottom: Red and positive black-on-orange; height 30 cm.

proximately 550 B.C.–A.D. 100) follows Mamom and covers the late Middle Preclassic and Late Preclassic Periods. Its principal relationships are with Peten sites such as Tikal and Altar de Sacrificios, with British Honduras at Barton Ramie, and with much of the Yucatan Peninsula. There is also evidence of this phase in Honduras at Copan and Los Naranjos.

Apsidal low stone platform mounds, which were filled with dirt and stone, supported houses built of perishable material. These mounds rarely occur singly but in units of two, three, or more around a court, frequently on a common substructure, near a good water supply in well-drained country. Truncated pyramids faced with cut stones coated with lime plaster occasionally have stucco masks; they supported religious superstructures made of wood and thatch like the dwellings. Arranged around plazas, they mark the start of the impressive ceremonial centers. Painted stucco masks on a platform, 5D-Sub.1–1st, at Tikal relate this site to Pyramid E–VII Sub at Uaxactun and hint at provincial Olmec influence.

Although simple burials continued, cists or graves with definite outlines and sometimes walls were placed under platforms, courts, and residential rooms. At the beginning of the phase, grave furnishings consisted of jade and shell offerings with never more than two vessels.

Despite religious architecture, the figurine completely disappeared in lowland Guatemala during Providencia times. There were almost no decorated wares but some rare spiked dishes, possibly incense burners, were made. Unslipped jars were ornamented only by raking and about three-fourths of all slipped vessels were plain. Decoration on the remaining fourth was usually limited to grooving. It was an era of such profuse pottery making, however, that Chicanel sherds are found frequently as base fill beneath structures and plazas of later periods.

The last phase at Salinas La Blanca and La Victoria was Crucero, 300 B.C.–A.D. 100. Mollusks disappeared from the diet. Censers of unslipped Julain Coarse Ware and ceremonial cannibalism postulate religious activity. Distinct pottery shapes such as composite silhouette bowls with dimpled bases, bucketlike cylinders, low-necked restricted orifice jars, and new ceramic classes again indicate extraterritorial connections. Among these were waxy wares, Conchas Streaky Brown-Black, Conchas Orange-Waxy, and the Usulutan technique; Orange Monochrome and Red-on-Orange

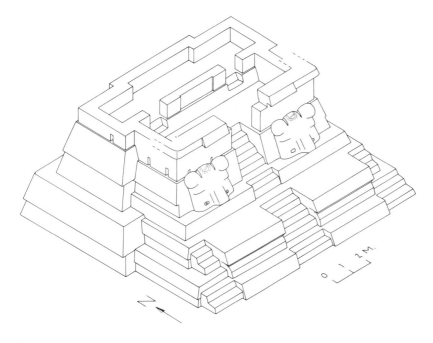

Structure 5D–Sub. 1–1st from the Cauac phase at Tikal, ca. 50 B.C., coeval with the Chicanel phase at Uaxactun. Isometric view.

wares suggest Izapa and Kaminaljuyu. Decorative elements include engraving and excising with the lines or cut-away portions rubbed with red paint, interlocking scrolls, and parallel lines and "scallops"; and one bichrome vessel was found with a crudely painted step-and-fret motif used as a serpent symbol in Classic times.

The last important phase of the Middle Preclassic at Kaminaljuyu was Miraflores, around 500–300 B.C. Clay figurines were made while the principal pottery forms are everted grooved-rim bowls and spouted shallow dishes. Among the new wares are Fine Incised Black-Brown and Incised Fine Red, and painted clay stucco decoration occurs on vessels and specially made pot covers.

Fragments of adobe bearing the imprint of small parallel poles indicate that wattle-and-daub constructions with thatched roofs were used for houses and temples. Some of these buildings were painted in contrasting colors — orange-red, hematite, and blue-green, sometimes separated by a narrow black line.

The introduction of both religious and civic architecture marks the difference between Miraflores and earlier phases at Kaminaljuyu. Stepped and terraced platform adobe mounds and pyramids

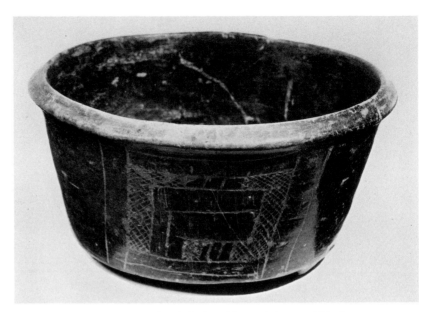

Chocolate Brown Ware vessel with flaring sides and three nubbin feet, Kaminaljuyu, Guatemala, Miraflores phase. Cross-hatched design is in two panels and is filled with white and red ochre.

Flat-bottomed Prussian Red-on-White Ware bowl with flaring sides, Kaminaljuyu, Guatemala, Miraflores phase? late Middle Preclassic. Height 6.5 cm, diameter 21.5 cm.

finished with wet-troweling were arranged around rectangular courts. The ball court made its first appearance around 500 B.C., and another innovation was the use of tombs for important personages. Even before the end of the Middle Preclassic, it is possible that some of the governing members of the ceremonial center, or

at least certain outstanding individuals, were deified on death, thus adding to the pomp and ritual as well as the sacredness of the holy places.

In addition, there is evidence of a strong outside influence — whether the result of actual occupation of the site by foreigners or not, cannot be stated. More probably it represents the beginning of a religious conquest that left its cultural mark on the old way of life. Clear signs of contact with the provincial Olmec world appear in the style of a sculptured stone altar found in a temple mound (Mound E–III–3) and in many carved stelae, some with hieroglyphs, others with masked figures.

It is during this time that the zeal for building reached its height at Kaminaljuyu — around two hundred mounds were constructed. Some mounds were partly destroyed and new ones were

Effigy vessel with painted clay stucco, Kaminaljuyu, Guatemala, Miraflores phase, late Middle Preclassic. Height 30 cm.

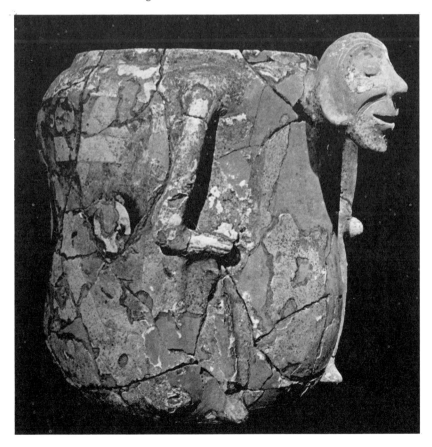

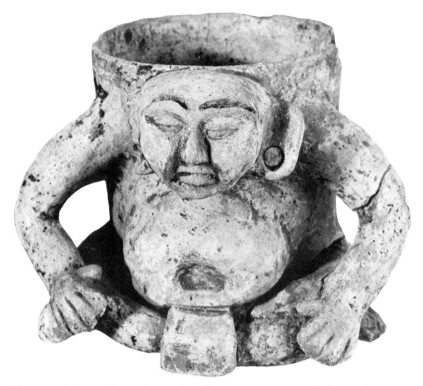

Effigy vessel, Kaminaljuyu, Guatemala, Miraflores phase, late Middle Preclassic. Height 20 cm.

Handle in the shape of a deer's head from a vessel painted in the Usulutan technique, Kaminaljuyu, Guatemala, Miraflores phase, late Middle Preclassic. Height 5 cm.

Pot cover, Kaminaljuyu, Guatemala, Miraflores phase, late Middle Preclassic. Height 30 cm.

78

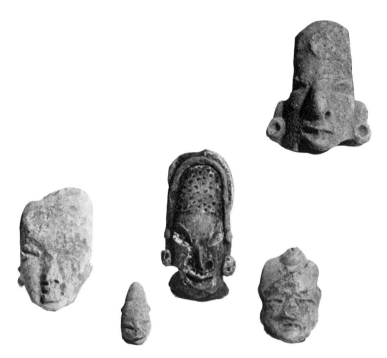

Figurine heads, Kaminaljuyu, Guatemala, Miraflores phase, late Middle Preclassic. Height of top head 10.3 cm, large head, middle row, 9.6 cm, smallest head 4 cm.

added on top of the old remains. The largest mound, E–III–3, was a platform-topped rectangle over 60 feet (20 m) high and is calculated to have required 117,000 tons of earth in its construction! This pyramid revealed many architectural changes within it, in addition to two rich burial chambers cut into earlier mounds. Each room contained a low wooden platform to support the principal deceased. Grave furnishings, including pots of jade and marble, over four hundred pottery vessels, a headdress with jade, and a pyrite mirror, were piled around; the rooms were roofed and more offerings were heaped on the mound terraces. The open space from the tomb roof to the top of the pyramid was then filled and a floor was constructed over it.

Such building expansion and concentrated religious activity in both the highlands and the lowlands were bound to cause a serious change in the manner of living at these and related sites. A metamorphosis probably started during Las Charcas and Mamom times with the erection of stelae, truncated pyramids, planned

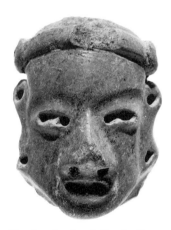

Clay figurine head, Kaminaljuyu, Guatemala, Miraflores phase. Height 7 cm.

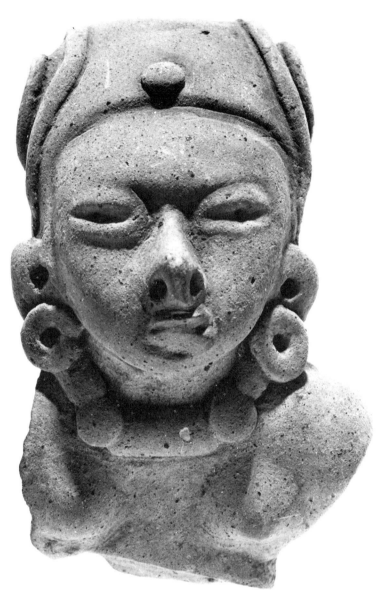

Clay figurine head, Kaminaljuyu, Guatemala,
Miraflores phase. Height 12 cm.

courts with mounds, and a growing ceremonialism. Certainly in
the Miraflores and Chicanel phases when the ritual area occupied
a prominent position, the village farmer moved to where more
land was available for agriculture. Probably small groups formed
rural hamlets or subcenters at the periphery, returning to the
larger settlements in order to participate in religious ceremonies.

These rituals, focused as they were around pyramidal and mor-

tuary constructions made more elaborate by carved altars, stelae, and at times decorated façades, required labor and skilled technologists. So the farming groups, who represented the economic sector of the centers, periodically gave both their time in labor and the produce of their fields to the common religion. Even the governmental structure had to change. Officials were needed to supervise the quarries, the stone masons, and the timber cutters, while others directed the building of houses and temples. Certain hamlets may have been responsible for particular crafts, such as pottery making or the fashioning of tools. Individual artists who specialized and remained near the temples to carve the stones in honor of the gods or to work the jade and obsidian emblems used in ceremonials probably eventually formed an artisan class. A priestly group understood the mechanism of ceremonial organization and probably possessed a flair for showmanship.

But the majority of the population in the centers must have been temporary, with the various hamlets sharing in providing craftsmen, manual laborers, and clerical workers. Because particularly the center but in part the hamlet were dependent on trade for the

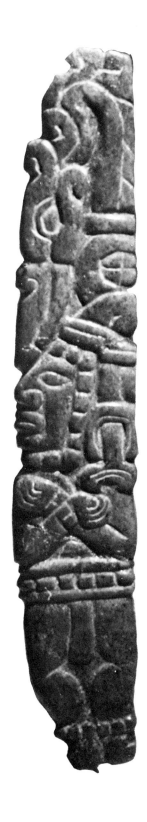

Jadeite pendant from Tomb 2, Kaminaljuyu, Guatemala, showing a human figure with an alter ego feathered serpent whose head is a combination of a bird and a serpent, Miraflores phase, late Middle Preclassic. Height 17 cm.

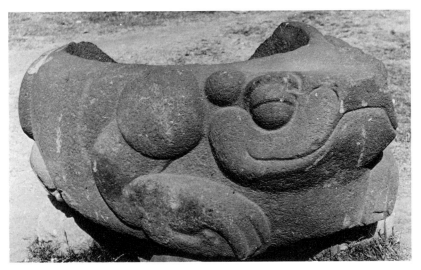

Toad altar, Kaminaljuyu, Guatemala, Miraflores phase, Middle Preclassic, made of stone. Height 52 cm, length 105 cm.

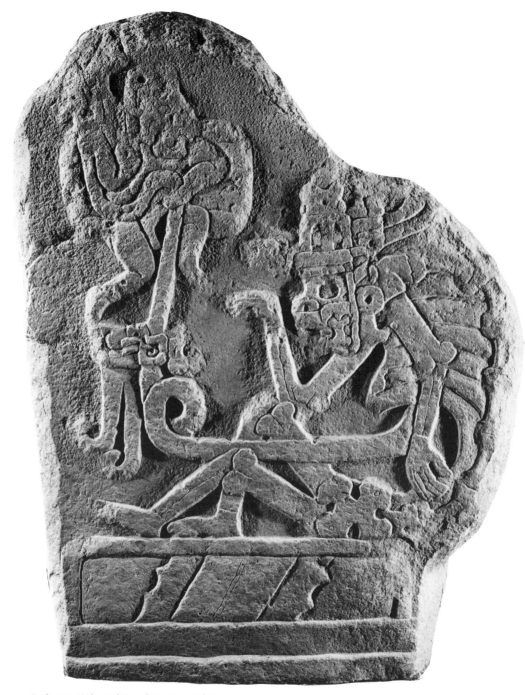

Stela 50, "Life and Death," Izapa, Chiapas, Mexico, Late Preclassic.
Height 1.52 m.

raw materials needed to expand religious culture, they were continually confronted with other peoples and new ideas.

These well-developed cultural and social manifestations lead one to suspect that even before the late Middle Preclassic Period there occurred the formation of what in the Classic era is termed Maya civilization. The growth from multiple lowland settlements, including Playa de los Muertos, Chiapas, and the Pacific Guatemalan slopes, was strongly stimulated by the provincial Olmecs or even the Olmecs from the Mexican Gulf coast. Many cultural ideas associated with the Classic Maya, for instance the zero and the Long Count, were Olmec traits adopted by the Maya in Preclassic times.

Olmec influence, possibly carried by groups of these people, traveled beyond the ceremonial centers of Kaminaljuyu and Uaxactun during Miraflores and Chicanel times. In Honduras at the site of Los Naranjos at the north end of Lake Yojoa, associated with the recently recognized Jaral phase (approximately 500–200 B.C.), Olmec artifacts consisting of a figurine, axe, and cinnabar offerings were found with a large quantity of sherds. The ceramics included unslipped culinary pottery, the majority of which was legless; jars with vertical necks; flat-bottomed bowls with flaring-sides and large rims, some exteriorly thickened and others horizontally everted. There were linear incised decorations, some with hooks and scrolls enclosed in small rectangular panels; roughened areas set off by grooves; red and white painted decoration; and occasionally zoned punctating. Labial flanges on some of the sherds suggest that there was communication between the people of the Jaral phase and the early Chicanel period at Uaxactun.

THE TROPHY-HEAD CULT

The Chicanel phase closes at Uaxactun during the Late Preclassic Period with a ceramic degeneration similar to that in other sites of the same era in Guatemala. Despite local traditions, the most widespread ceramic complex is southern in origin. Important wares are included under the collective term Paso Caballo Waxy Ware, embracing even the Usulutan technique. A rare innovation is the hollow rattle (cascabel) foot containing pellets.

By the end of Chicanel times, however, there was at least one new cult, the trophy-head, associated with human sacrifice and perhaps war victims. It was probably brought north from Lower

Central America by itinerant merchants who were themselves warriors. Frequently during this period heads were buried between two bowls placed lip to lip. The trophy-head cult was still practiced by tribes of South American descent who inhabited parts of the lower isthmus at the time of the Spanish conquest, and undoubtedly it was very ancient. In Costa Rica the Spaniards noted that at every moon a human being had to be sacrificed. Because of this there was continual war as one looked for nonrelatives to serve as victims. It has been postulated that Costa Rica, especially the Nicoya Peninsula, furnished some of the treasured blue-green jade of the Olmecs. Whether it was actually collected here in raw form or brought in from elsewhere is not known. So far no source of this stone has been discovered in Lower Central America and some mineralogists think that the geological conditions responsible for this material are totally absent. Travelers seeking jade or other products quite possibly returned to their communities with the new religious cult. The custom in the farming communities of incorporating new gods into the rituals seems to have expanded with the development of the ceremonial centers. The Olmec or provincial Olmec traders may have reinforced this pattern. Certainly the trophy-head cult appears at this time in the Peten, on the Pacific slope of Guatemala and Chiapas, and on the Mexican Gulf coast in territory which had been Olmec during the Middle Preclassic Period.

THE RECORD IN STONE

In Upper Central America architectural features included elaborate burial tombs roofed by capstones resting on corbels. At Tikal a corbeled vault tomb has a radiocarbon date of about A.D. 1, and another occurs at Altar de Sacrificios. "Maya" is the only term applicable to such traits, but when we consider Maya culture we must remember that one of the principal components was a complex of stylistic and intellectual elements adopted from the Olmec culture. Evidences of this are apparent at Izapa in Chiapas and the Cotzumalhuapa district on the Pacific slopes of Guatemala — sites partly associated with Middle Preclassic which evolved as complete cultural units in Late Preclassic.

At Izapa, elongated platforms and pyramids of earth were associated with plazas and stone monuments. The ceramics are related to Chiapa IV which manifests strong links with the Gulf

coast and Chiapa V, but above all it is the stone work that tells a story of stimuli from the outside resulting in a characteristic style and new religious cults. Typical of Izapa are stelae carved in a "narrative" manner, almost as if myths were being interpreted. The distinct artistic technique of an all-over treatment becomes familiar in the Classic Maya sense of *horror vacui*. Among the new cult motifs are trophy-heads, U-shaped symbols called the "Izapa signature," scroll-eyed dragon masks, descending sky deities, flying figures often bearded, and the "long-lipped god." Some of these motifs are attributable to the Olmecs, such as the U-symbol and the scroll-eye, but other elements are probably the combination of recently crystalized Maya culture that absorbed from its neighbors and from traders new deities for its pantheon and new traditions for its rituals. Izapa was abandoned at the end of Late Preclassic, but the beauty of its lithic craftmanship inspired Classic Maya sculpture.

Polished red-brown vessel with basket handle from Mound 3, Chiapa de Corzo, Chiapas, Mexico, Francesca phase, Chiapa IV, Late Preclassic. Height 22 cm, shoulder diameter 20 cm.

Although Chicanel spans the Middle and Late Preclassic Periods, certain phases beginning around 350 B.C. follow the cultural continuity of earlier ones. Some developed at the same sites while others occurred in the vicinity of the older phases. In central Chiapas the brief Chiapa IV phase, appearing toward the end of Miraflores and ending around 300 B.C., showed close connections with Monte Alban, La Venta, and Los Tuxtlas but has little contact south.

Extraterritorial movements began seriously in the isthmian area between 350 and 300 B.C. The site of Bilbao, with its lengthy Algo-es-Algo phase, felt the pressure of cultural change. The Ilusiones period, 350 B.C.–A.D. 100, indicates relationships with much of the Chiapas, Pacific, and highland Guatemala world around it. Contacts beginning in part with Chiapa de Corzo during Chiapa IV continue through Chiapa VII. Contacts with La Victoria during Crucero times and with Kaminaljuyu at the end of Miraflores continue through the following Arenal and Santa Clara phases, and contacts with Uaxactun during the Late Chicanel continue in subsequent Matzanel times.

At Chiapa de Corzo the pottery of Chiapa V, approximately 300–100 B.C., shows definite relationships with the Chicanel phase; other sites in the central region of Chiapas were influenced by the Guatemalan highlands. Such connections show the spread of the same culture as existed at Kaminaljuyu and Uaxactun — a culture

Effigy vessel of Gray Ware from Mound 3, Chiapa de Corzo, Chiapas, Mexico, Horcones phase, Chiapa VI toward the end of the Late Preclassic, ca. A.D. 1. The opposite side presents a completely fleshless skull. Height 21 cm, base diameter 12 cm.

Black Ware vessel with red, white, and green stucco and the motif of the Bat god or priest, from Mound 3, Chiapa de Corzo, Chiapas, Mexico, Early Classic, ca. A.D. 250, Istmo phase of Chiapa VII. Diameter 22 cm.

which not only diffused traits but also absorbed and combined elements of foreign origin and which is known as Maya in the Classic Period.

Chiapa VI, 100 B.C.–A.D. 1, also showed the influence of the same culture although the source was not the Caribbean lowlands but Kaminaljuyu. Religion continued to dominate man's life. During this phase Chiapa de Corzo grew rapidly as a ceremonial center. Starting with one- and two-room adobe brick temples on low platform mounds, the era ended with big stone-faced platforms and multiroomed structures with flat roofs made of clay and large leaves covered by a hard-finished lime plaster. These may have served as habitations or "offices" for priest-leaders. Diagnostic ceramic characteristics were mammiform tetrapod vessels and shallow censers with a central vent encircled by three inner prongs placed on deep vertical-walled bowls of coarse ware. The same type of incense burner is found in western El Salvador. Effigy vessels also show a relationship with El Salvador and Guatemala even though at this time there is evidence of trade with southern Veracruz and Oaxaca.

The following phase at Chiapa de Corzo, Chiapa VII, ended at A.D. 200. Very little relationship with either lowland or highland Guatemala is indicated; instead, connections point north. Pottery included bowls with flaring or vertical sides and a hard-fired Smudged Black Ware consisting of low-necked jars and bulbous-bottom vessels without incised motifs or adornments. A new architectural feature is a stucco frieze. Skeletal remains suggest the prevalence of a jaguar cult.

Chiapa VIII, A.D. 200–300, ties the Late Preclassic with the Early Classic Period at Chiapa de Corzo. Northern influence was still present but the settlement itself became an important ritual center with a stone-faced pyramid complex and larger and higher platform mounds than previously. Smudged Black Ware continued to be popular and some vessels were adorned with incised cross-hatched triangles or wave motifs filled with red paint. The end of this phase marked the termination of the development of local culture at Chiapa de Corzo. Both architectural construction and the manufacture of native pottery types ceased, perhaps signifying a change from an Olmec-dominated tradition to Teotihuacan influences.

At Kaminaljuyu, Guatemala, the Late Preclassic begins in the

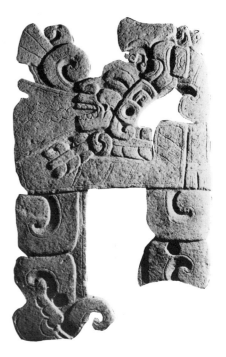

Silhouetted relief sculpture, Kaminaljuyu, Guatemala, Late Preclassic or Early Classic. Note the use of scrolls and the incised serpent coming from the open high-relief mouth of the human head. Height 62 cm, width 39 cm, thickness 6 cm at center, 3 cm at edge.

Silhouetted relief sculpture 2 from Arenal Mound C–II–4A, Kaminaljuyu, Guatemala, Late Preclassic? This is thought to be a ball court marker carved with stylized dragon or serpent heads. Height 107 cm.

Arenal phase with the religious ideas and culture of the Olmecs now incorporated into those of the Maya. Stelae carved in La Venta style but with the Maya number system of bars and dots, a stela showing a priest wearing a mask and an elaborate headdress and carrying a scepter, an eccentric flint sculptured in Izapa fashion, and similar monuments appear. Arenal sherds were found in connection with Stela I at El Baul in the Cotzumalhuapa region. Other stone carvings belonging to this phase, such as Altar 1 from Kaminaljuyu, indicate that Arenal sculpture developed from that of the Miraflores period and was partly responsible for Early Classic monuments.

Three-pronged stone censers, some 33 inches (85 cm) high, with stylized snarling jaguar faces and fantastic headdresses that end in a knotted band at the back are another example of adoption by the Maya of Olmec religious concepts. Further evidence of this merger is seen in obsidian spools, blades, highly polished jade carvings, a life-size jade mosaic mask, smaller figures, pendants, earspools, and vessels made of marble, soapstone, and schist.

Among the ceramic innovations were tripod and tetrapod vessels with hollow feet, censers with three top "loop handles," and censers with three plain hollow or solid prongs and the upper and lower chambers decorated with conventionalized feline representations similar to the stone ones. This last type and tripod rim-head pots, bowls of a coarse reddish-brown color with flaring sides and three projecting hollow or solid heads on the rim, also suggest the provincial Olmec influence.

In Honduras, around 300 B.C. on the Humuya or Comayagua River not far from Playa de los Muertos in the Sula Plain, Ulua Bichrome manifests many of the early traits associated with Playa de los Muertos and "Archaic" Period pottery from Copan. Wares include both monochrome and bichrome as well as vessels decorated with the Usulutan technique. Most of the pottery is thin and slipped with orange and red. Forms include small vessels with a flat base, little solid tripods or tetrapods, and even everted or swollen comma-shaped lips. Decoration was confined to broad incising, rocker-stamping, and simple painted designs. Clay seals with a vertical handle also formed part of this culture complex.

Pottery of the Eden phase (approximately 200 B.C.–A.D. 550 following Jaral at Los Naranjos) shows closer ties with Uaxactun during the Late Chicanel period and relationships with sites in the Comayagua Valley and Early Classic Copan.

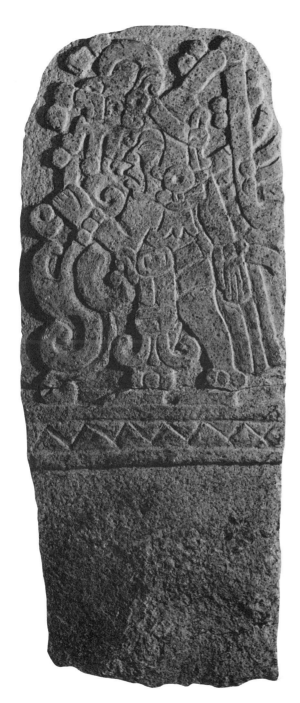

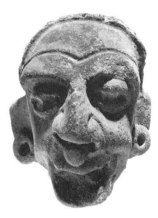

Clay figurine heads, Kaminaljuyu, Guatemala, Arenal phase. Height of upper head 7.5 cm; lower head 7 cm.

Stela 16, Kaminaljuyu, Guatemala, Late Preclassic? The carved motifs show a man with anklets and bracelets of beads, holding a dragon or serpent the lower part of which is formed by elaborate scrolls. Total height 70 cm, carving 46 cm.

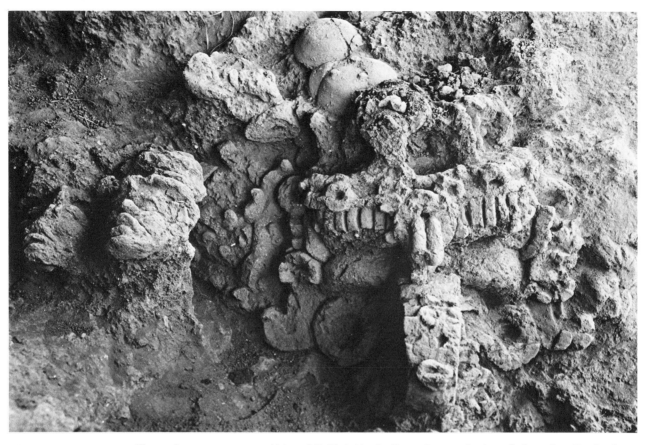

Clay sculptures on terrace of Mound D–III–1, Kaminaljuyu, Guatemala, Arenal phase, Late Preclassic, or Aurora phase, Early Classic.

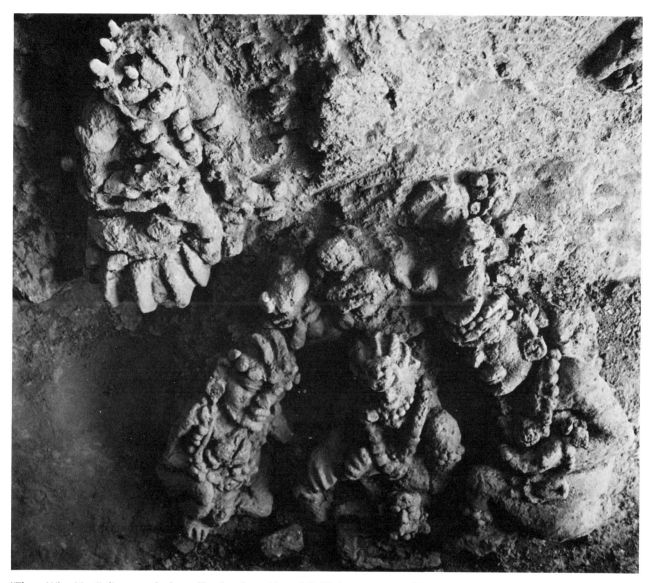

"Three Wise Men" discovered when effigy heads on Mound D–III–1 were removed for preservation, Kaminaljuyu, Guatemala.

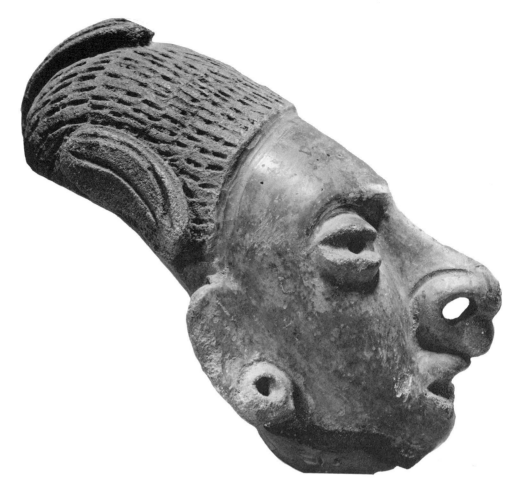

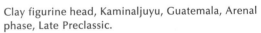
Clay figurine head, Kaminaljuyu, Guatemala, Arenal phase, Late Preclassic.

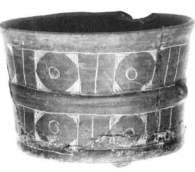

Tetrapod brown-black cylindrical vessel, Kaminaljuyu, Arenal phase. Height 7.9 cm, diameter 11.5 cm.

THE MIXTURE OF NORTH AND SOUTH

Cultural movements likewise began to occur in Lower Central America where the Zoned Bichrome period corresponds roughly in time with the Late Preclassic in the upper isthmian region, 300 B.C.–A.D. 300. Two phases have been defined in Pacific Nicaragua —Aviles and the slightly later San Jorge. In Costa Rica there are three phases in the northwest, all related through trade — Chombo by the Santa Elena Peninsula near the Nicaraguan border, Monte Fresco farther south by Tamarindo Bay, and Catalina in the Tempisque Valley.

Most people lived in small villages but some, at least in Costa Rica, dwelt in caves. Around Tamarindo Bay, dead, new-born babies were placed under inverted large wide-mouthed vessels. Fishing expeditions probably were made to the coast, as similar pottery types at inland and sea sites imply. Salt from the Pacific flats was an important item of diet and of trade. Game was caught in snares and perhaps killed with clay pellets from a blow gun, as no projectile points have been found dating from this period. Circular, raised-rim grinding stones in the Catalina phase suggest that tubers were a basic foodstuff in Costa Rica. Maize seems to have been important in Nicaragua, however, and may reflect influence from Upper Central America.

In fact, certain features of the pottery of the Zoned Bichrome period hint of an isthmian cultural diffusion from north to south. In the Greater Nicoya archaeological subarea (as Pacific Nicaragua and the Nicoya Peninsula are sometimes called), the diagnostic ceramic traits are vessels decorated in red, black, or unpainted zones plus incising or engraving. Rocker-stamping, punctation, and reed impression are also characteristic, as are wavy lines painted in black and red with a multiple brush, zoned incised figurines, and occasionally unpainted clay figurines with incised lines and appliquéd pellets, sometimes with an open head and Olmecoid features.

Rosales Zoned Engraved, the earliest of the zoned and painted wares found in the Nicaraguan Aviles and all three Costa Rican phases, is composed of simple silhouette bowls, pedestal base bowls, jars, effigy vessels, and hollow female figurines with open head. The background is red with designs in black outlined by very fine incised lines. Sometimes zigzags are engraved within the black-painted spaces. Among the motifs are felinelike creatures, men, and

Jadeite pendant from Tamahu, Alta Verapaz, Guatemala, Late Preclassic, portraying a man carrying a jaguar. Note the Olmecoid aspect. Height 20 cm.

Jadeite head pendant from Nicaragua?
Zoned Bichrome period. Note the
Olmecoid aspect. Height 11.5 cm.

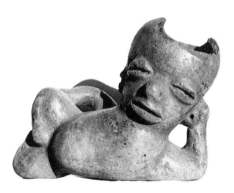

Open-head figurine, Olmecoid styles, from
Nicaragua, Zoned Bichrome period.

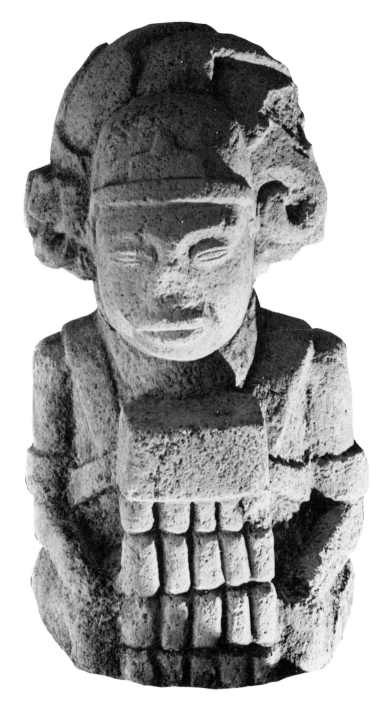

Kneeling figure of stone with alter ego animal on top of head, Kaminaljuyu,
Guatemala, Arenal phase, Late Preclassic. Note the elaborate necklace
representing jadeite beads. Height 51 cm.

symbols of a feline-serpent combination. Artistically this is not a primitive ware. The curvilinear style and scroll-like elements used in some designs recall Olmec art. Jadeite axe-gods have been found with this ware. Rosales Zoned Engraved pottery has been compared with Utatlan, the zoned bichrome ware from Kaminaljuyu and the Quetzaltenango Valley in Guatemala that was traded to Bilbao in Middle Preclassic times. The motifs on the Lower Central American pottery, however, are usually more sophisticated and realistic.

Toya Zoned Incised, another early ware that is principally red-and-black-on-natural with color zones outlined by broad incised lines, consists of jars and bowls with incurving and outcurving walls; it suggests a close relationship to Ancon Zoned Incised Ware of the Chavin period in Peru. It is diagnostic of the Chombo phase and is also known in the Catalina phase; it appears in San Jorge times in Nicaragua.

Obando Black-on-Red Ware has wavy lines painted in black with a multiple brush and is associated with Monte Fresco, Catalina, and San Jorge. It was during this last phase that the Usulutan technique reached Nicaragua. In Costa Rica this technique is applied to bowls and effigy vessels at El Hacha on the Nicoya Peninsula. Jade axe-gods and Palmar Ware accompanied these pieces.

Palmar Ware is found in the Greater Nicoya archaeological sub-area and is characterized by broad grooved lines on gray-brown to black clay with red pigment applied to emphasize the linear decoration. Sometimes a red slip occurs. Three principal forms compose this ware — subglobular jars, globular bottles, and small cylindrical vessels. The division into zones through the use of grooves and paint relates this pottery to Middle Preclassic Utatlan Ware and, like the associated Usulutan technique, shows the tardiness of cultural diffusion in the lower isthmian region.

Sites along the Linea Vieja, the old railroad line which runs from Cairo to Guapiles with a branch to the Santa Clara River, on the Caribbean side of Costa Rica also show a mixture of influences during this period. Charcoal from a pit under the base of a circular stone mound eight feet (2.44 m) high and fifty feet (15.24 m) in diameter gave a radiocarbon date of about A.D. 144. In the pit were a string-sawed human figure of blue jade and a thompsonite

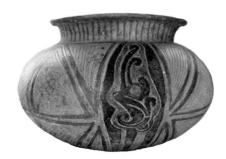

Rosales Zoned Engraved Ware, Zapotillal, Guanacaste province, Olmecoid style? Upper: Round-bottomed bowl; rim diameter 25.5 cm. Lower: Pedestal bowl; height 3.25 cm, rim diameter 16 cm.

Rosales Zoned Engraved jar from Aguas Claras above Bagaces on the slopes of the Miravalles volcano, Guanacaste province, Costa Rica. This was found with jadeite axe-gods and owl-effigy mace-heads made of chalcedony. Height 10 cm.

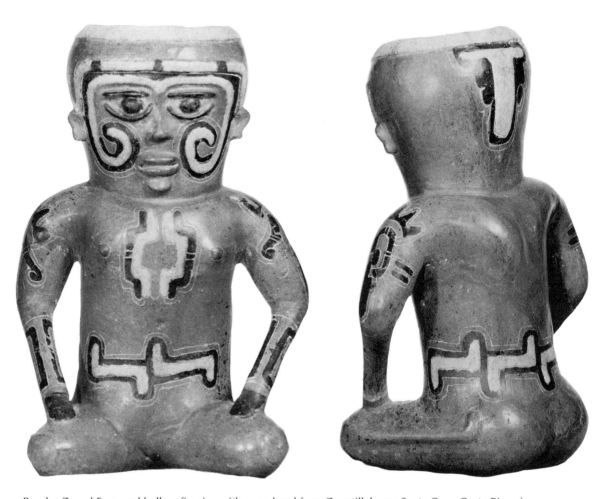

Rosales Zoned Engraved hollow figurine with open head from Zapotillal near Santa Cruz, Costa Rica. [5] Height 35 cm.

mace-head in the shape of a human head. Effigy mace-heads are common in the Nicoya Peninsula. The technique of string-sawing (the use of a cord, with an abrasive such as sand and water, pulled back and forth to cut the stone) coupled with blue jade is an Olmec heritage, while the stone mace-head is typical of Costa Rica but has both northern and southern relationships. Other luxury or ceremonial objects of northern origin are two slate-backed pyrite mosaic discs found near the edge of the mound. With them were both rectangular and circular grinding stones, as well as pottery with appliquéd figures and incised designs indicating a southern cultural source.

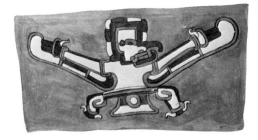

Three panels in Olmecoid style? from a Rosales
Zoned Engraved vessel found at Zapotillal, Costa Rica.

From Porvenir on the Linea Vieja an approximate date of A.D.
279 based on radiocarbon tests was obtained in relation to "choco-
late pots," oval-shaped tripod vessels resembling a *jicara* (gourd
used for drinking) with long legs bearing modeled animals, birds,
reptiles, or human figures, and double-tubed nasal snuffers of
clay — all southern traits. Other items excavated with these, how-
ever, were mace-heads and a clay replica of a slotted wooden
drum with a bird with outspread wings on top. This type of
drum is northern, reminiscent of the *tunkul* or *teponaztli*, the
name in Maya and Aztec respectively for a hollowed-log drum
enclosed at both ends, which has a rectangular opening at the

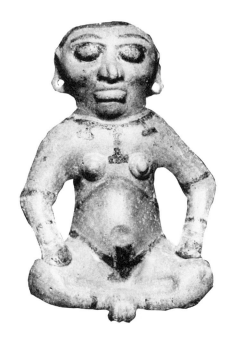

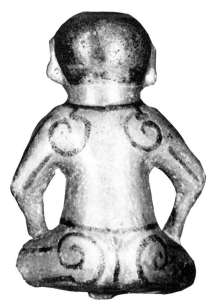

Rosales Zoned Engraved hollow figurine,
open head, from Samara, Guanacaste
province, Costa Rica. Height 12 cm.

Pot stand of Palmar Ware,
Guanacaste province, Costa Rica.

Palmar Ware vessel from El Hacha,
Guanacaste province, Costa Rica.
Height 7.2 cm.

Carved stone mace-head, human head
design, Nicoya Peninsula, Guanacaste
province, Costa Rica. Height 10.2 cm,
width 7.75 cm.

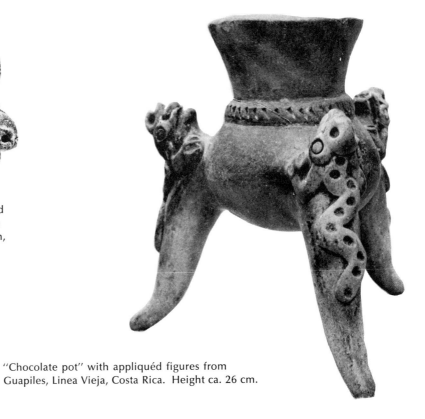

"Chocolate pot" with appliquéd figures from
Guapiles, Linea Vieja, Costa Rica. Height ca. 26 cm.

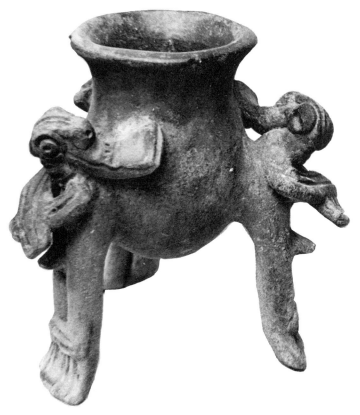

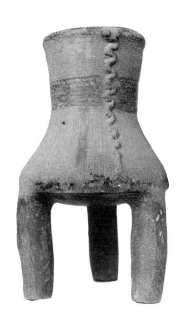

"Chocolate pot" with appliquéd figures from Guapiles, Linea Vieja, Costa Rica. Height 25 cm.

bottom and an H-shaped incision on top, and is played with rubber-tipped mallets. It differs from the hour-glass shaped drum with an open base and a skin-covered top, played with the hands, which is so typical of Costa Rica, Panama, and the Amazon basin. In both the charcoal pit and at Porvenir most of the ceramics were without paint. Colors, when used, were red or orange, sometimes contrasting on the same vessel at Porvenir.

Between 300 B.C. and A.D. 300 the farther east one looks, the more static are the cultural remains, and influences from the north dwindle. In southeastern Costa Rica, the Early Diquis Monochrome Horizon, characterized by Brown Ware and Fugitive Red Ware, appears.

In Panama the La Concepcion phase, named from the site where its significance was first recognized, corresponds to the five phases

Scarified Ware vessels from Panama.

"Barrel" from San Vito de Java, Costa Rica. Height ca. 20 cm.

of the Zoned Bichrome period in the Greater Nicoya subarea. La Concepcion has recently been considered as the single phase for the time span from 300 B.C. to A.D. 300. The people of La Concepcion phase were simple villagers, but they buried their dead in cemeteries in long shaft graves and shoe-shaped burial chambers closed off by stones on one side, a custom associated with Colombia. The only similarity between their ceramic complex and those to the west is seen in the Variété Non Peignée type of Bocana Incised Bichrome Ware from the Catalina phase in the Tempisque Valley, Costa Rica. Most of the pottery is characterized by scarification, hence the name of the period. This manner of decorating consists of closely spaced and roughly parallel incised lines often in zones and sometimes with a reddish slip. Peculiar to this complex is a chimney-shaped vessel with three solid legs.

Besides the type site in the province of Chiriqui, four locations with close relationships are now known — Solano and Pueblo Nuevo, Chiriqui, and Guacamayo and El Limon in the province of Cocle. There is also one which might be considered on the frontier of Panama — Aguas Buenas, Costa Rica — where Scarified Ware apparently was imported.

Three other pottery groups were defined at La Concepcion, including a plain non-decorated variety. Among the many forms were vessels with solid tripods shaped like duck feet, tall solid tubular tripods, and animal effigy vessels. Tall jars with a flat bottom, globular body, and neck with a flaring rim are characteristic of Guacamayo and El Limon and are also known from La Concepcion.

Aguas Buenas, A.D. 0–300, is a partially contemporaneous phase associated with the highlands of the Costa Rican-Panamanian frontier and the western part of Chiriqui province, including Barriles and two sites in the valley of the Santa Clara River, a tributary of the Chiriqui Viejo River. Two wares are characteristic — Red and Red Rimmed. Both have a dark red slip partly or completely over the vessel. Other decorative devices are incising; applied small animals, birds, or human figures; and geometric patterns such as appliquéd vertical rectangular stripes. Common to both are vessels with broad strap-handles and three slab feet, globular vessels with a restricted neck, and bowls. In addition, **Red Ware** has globular neckless vessels and plates.

Stone "barrels" often decorated with a monkey or an anthropomorphic figure carved in low relief on one end, realistic elongated representations of a "Man-on-slave" cut in the round from stone and known as Barriles-type statues, and four-legged large grinding stones elaborately carved with motifs related to the trophy-head cult are also associated with this phase.

The ceremonial center of Barriles is so named because of the barrel-shaped stones found there. Differing from those described above are barrel-shaped stones that have animals carved in low relief on the sides with the ends undecorated. The site, a fairly level elevation approximately 125 feet (38.1 m) long by 90 feet (27.43 m) wide, lies on the outskirts of Baru volcano. A mountain stream flows by one side. At the eastern end is a giant boulder carved with petroglyphs consisting of spirals and irregular lines ending in cup-shaped depressions. These may have been used to catch sacrificial blood. The western end of the site contained a transverse line of elongated figures cut in the round out of basalt on a pedestal base. They portray life-size nude males carrying on their shoulders personages who wear conical hats, have representations of gold jewelry or a trophy head dangling from the neck, and usually hold in each hand a ritual object such as a head or axe.

At the time of excavation, all the statues were on the ground partially destroyed. Except for these and the boulder with petroglyphs, the site was covered by a six-inch (15 cm) layer of dark gray sandy humus which rested on top of an equal amount of volcanic ash and pumice, indicating abandonment. The stratum serving as the base for the ceremonial center lay below the ash and consisted of 35 inches (90 cm) of fertile black soil. In this lower layer were several rectangular floors or foundations made of boulders and large stone slabs, as well as caches of pottery vessels.

Besides wares similar to Aguas Buenas pottery and monochrome vessels with red or black incised designs, the Barriles people made large globular flaring urns, some 36 inches (0.92 m) high, with deep necks incised with stylized animals and birds painted red and bright lemon yellow. Inverted bowls served as lids to these urns. The nearest counterpart to this style is seen in some of the pottery from Marajo, Brazil. Animals, birds, or human beings were fashioned in clay to form tripod legs for some vessels while

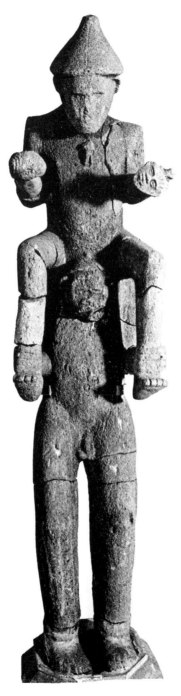

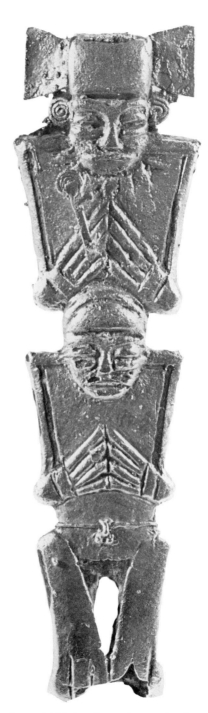

"Man-on-slave" figure from Barriles, Panama, Scarified or Late Preclassic. Note trophy head and stone weapon in hands; simulated gold ornament on neck and conical hat. Height 2.44 m.

Cast gold Muisca figure from Colombia portraying "Man-on-slave" motif.

frogs in high relief adorned the body of certain urns and appliquéd animals decorated the rim of others — all Aguas Buenas phase characteristics. Negative painted ware with bowl interior designs in red and black was also popular.

There was scant grave material at Barriles, however. The dead were buried in shaft tombs, sometimes with three stone-lined chambers. Usually the furnishings were confined to very large and elaborately carved grinding stones containing raised rims decorated with anthropomorphic or stylized human heads and four legs. Some supports have stylized human figures, singly or in pairs, carved in low relief as adornment.

One grinding stone of exceptional size probably did not come from a grave but was used ceremonially at the site, perhaps as an offering table or making a ritual drink like chicha. One leg represents a nude female with accentuated genitals and breasts. Her arms are doubled upward at the elbow and her hands sustain two human heads under the rim of the grinding plate. The only ornament is a pendant representing a gold image of a human being. Wearing apparel consists of a conical cap with diamond-shaped medallions in low relief. This is the only female figure known from Barriles. The remaining legs or atlantes on this stone are male figures, each with a pendant and hat and also wearing a thick belt between the navel and the genitals, both of which are exposed.

Barriles indicates that social stratification, a ritual center, and the trophy-head cult as well as the use of gold objects were to be found in Panama during the time of the Late Preclassic Period in Upper Central America. As part of the Aguas Buenas phase, Barriles may be the forerunner of the realistic stone sculpture so characteristic of the Atlantic watershed of Costa Rica. An indication of this is seen in the recent discovery at the headwaters of the Telire River in the Durika range, Alta Talamanca, Costa Rica, of a "Man-on-slave" figure similar to those from Panama.

Toward the end of the Scarified period, a widespread ceramic style consisting of black-line designs appears to have extended over Veraguas, Sitio Conte in Cocle, the Azuero Peninsula, and Venado Beach in the Canal Zone. It is known as Black-line Geometric Ware or Santa Maria Polychrome and has a radiocarbon date of approximately A.D. 227 at Venado Beach. As a ware it seems to have had little influence on other styles. It is found in

Urn burials from Barriles, Panama.

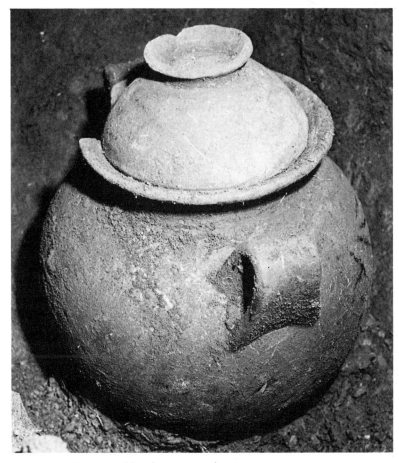
Burial urn with inverted bowl cover, Barriles, Panama.

deep shaft graves in Veraguas that often have a chamber at the bottom similar to tombs in parts of Colombia.

At Venado Beach the first radiocarbon date for gold figures is about A.D. 250, a date that is compatible with the Aguas Buenas phase. There is no suggestion, however, of the extension of gold or tumbaga objects farther west than Barriles until approximately A.D. 700. The reason for such a static condition cannot be answered at present.

SUMMARY OF THE PRECLASSIC PERIOD
The year 2130 B.C. marks the earliest evidence of sedentary man in the Preclassic Period in all of the Central American isthmus. It occurs in Lower Central America at Monagrillo, Panama, where

coiled and fired pottery, decorated by incising and punctate designs and by red paint, points to a relationship with South America. This antiquity is perplexing when we consider the quiescent nature of Lower Central American cultures. As yet there is no record of cultural change within this territory from 2130 B.C. until 300 B.C., the start of the Zoned Bichrome and Scarified periods, when different types of pottery decoration and distinct stone artifacts came into use. Perhaps in part heavy rainfall, with the subsequent dense forests, and volcanic activity were responsible for destruction of the evidence, but till now the archaeological spade has not found the answer.

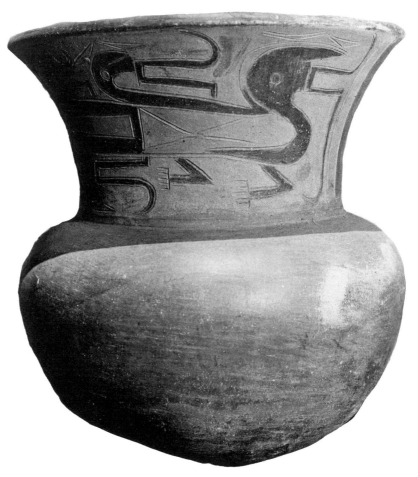

Large globular flaring vessel with deep neck incised with stylized birds and painted in red and bright lemon yellow, Barriles, Panama. Height 0.92 m.

The extension of these early phases west and north likewise is not clear. None of the ceramic periods in Upper Central America have left signs indicating the exact location of their cultural roots, but many show a relationship between certain traits which may be evidence of diffusion and interchange of ideas both among themselves and with the south.

It is significant that the oldest sites of Chiapas, Mexico, and Upper Central America, dating around 1500 B.C., the Barra phase at Altamira, Mexico, and the Ocos phase at La Victoria, Guatemala, also show more cultural connections with the southern hemisphere than with their immediate surroundings. There are other features that indicate a southern relationship for these Early Preclassic sites in Chiapas and Upper Central America — the use of tubers such as manioc and malanga or tiquisqui, as implied by the deep-trough grinding stones, a stirrup muller at Chiapa de Corzo, and the lack of rimless grinding stones associated with maize or of any other vestiges of this agricultural product. Coupled with the already recognized South American ceramic tradition that is completely without local antecedents, these features suggest that the earliest yet known cultures of Chiapas and northern Central America had their origins in the lower isthmian and northern South American regions. Their history in this northern territory is one of discontinuity and they seemingly disappeared before 1100 B.C.

It has been postulated that the break in the Ocos-Chiapa I ceramic tradition was due to Olmec culture-carriers from San Lorenzo and that others of this group went south into Soconusco, Pacific Guatemala, and probably introduced maize in this region. Certainly around 1000 B.C. the independent farming populations of Upper Central America showed a cultural continuity that bespeaks a trade relationship and a diffusion of ideas mostly stimulated by religion — for example, the distribution of the figurine cult. Perhaps the connection was based on the trade of ceremonial objects. Ritualistic and luxury items may have been among the first things desired by the small farming populace which had no ceremonial center.

Religion in this early period was probably a personalized one based on individual gods, perhaps household or cult images. The disappearance of the figurine cult with the beginning of religious architecture in the ceramic phases, even if it was revived

later, suggests a drastic introduction or penetration of new concepts with regard to the ritual and spiritual life of the people. Evidence of the Olmec art style at Kaminaljuyu, Guatemala, and El Salvador just at this time strengthens such a hypothesis. Northerners had reached Upper Central America and imposed at least a theological and ritual conquest. Formal ceremonialism with a standardized group of deities prevailed. Certainly oriented mound and pyramid architecture is conducive to pageantry and a controlled populace under the religious hierarchy.

Chiapas, lowland and highland Guatemala, and western Honduras give evidence of interrelations and Olmec cultural influences which helped to form the Maya civilization. The Olmecs or provincial Olmecs at the same time left many distinctive material traits such as large stone heads, basalt stelae, and boulder sculpture to mark their path or that of their culture.

In northwestern Honduras, the Playa de los Muertos phase was the first in the isthmian region with a stratified society and before it disappeared it also felt radiations of, if not actual contact with, the Olmecs. Playa de los Muertos people likewise played a part in the formation of lowland Maya culture.

Not only foreign influences spread during the Middle Preclassic Period, but also there was at least one local or Central American ceramic trend which was widely diffused. The distribution of the Usulutan technique is an example of the extent of intercommunication during this time. Perhaps through most of western Central America there were periods of trade when people of any tongue and inherent enemies could mingle freely. Such a condition existed in historic times among the Honduran and Salvadorian Lenca and in Lower Central America on the Costa Rican-Panamanian Caribbean coast. Whatever the answer, the Usulutan technique penetrated a wide area at a very ancient time.

Throughout the Preclassic Period, from 1500 B.C. to A.D. 300, there are signs of intercultural combinations until toward the end the Maya emerged with a complex civilization. It was based on an elaborate religion which turned small farming villages into large ceremonial centers. As these religious centers grew, the prevailing pottery types degenerated and disappeared.

Aside from architecture there is no connection between the Preclassic and the Classic eras. Again a social phenomenon must

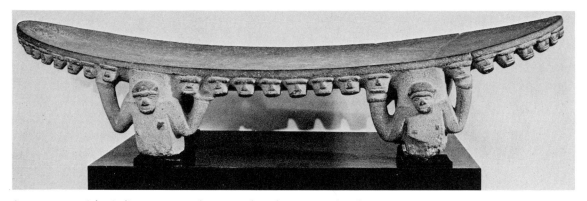

Large ceremonial grinding stone, southern type for tubers or peach palm nuts. The stylized human heads under the rim suggest the trophy-head cult, Barriles, Panama. Note the four Atlantean supports. Length 2.19 m.

have occurred. It could be that other peoples arrived to dominate culturally the erstwhile independent farming populations. Such groups must have come from Mexico and may have traveled in small immigrant or trading bands, not as an army because there are no signs of military struggle; contact and interchange had been gradually taking place over a long period of time. Extraneous pressure at home probably resulted in migrations to these areas that were already inhabited and were known through the reports of traders.

The end of the Preclassic and the start of the Classic Period in Upper Central America shows a cultural rather than an armed conquest of one group over another, even if in part arms were used. What definitely is present is evidence of a conquest in which ideology and a manner of living were utilized. Deliberate destruction of stone monuments and scattering them or discarding them in dumps, particularly at Kaminaljuyu, as well as their reuse as foundation or paving, offer some proof of such events.

Toward the end of the Preclassic Period in the lower isthmian region in the Greater Nicoya subarea, the static cultural phases gave their first signs of change. This is apparent in the predominately maize agriculture of Pacific Nicaragua, Palmar Ware, and the Usulutan technique. Rosales Bichrome Engraved Ware and Toya Zoned Incised likewise are shared by this subarea and indicate further extraterritorial cultural influences. These are influences that somehow skipped Panama and the Caribbean side of Costa Rica and Nicaragua, where the culture remained quiescent

until a later epoch, although items such as jade and pyrite mirrors on the Atlantic watershed of Costa Rica do indicate extraterritorial connections.

Panama, however, had its own distinctive development, Barriles — a ceremonial center showing southern, not northern, affinities. The gold cult is apparent in the ornaments portrayed on personages of the "man-on-slave" sculpture and may represent the first manifestations of the ceremonial offering tables and similar stones as well as the individualistic and portraitlike sculptures of later periods in Costa Rica. All form part of the enigma that characterizes the nonnorthern aspect of Lower Central American culture, an enigma involving both the basic roots and the sudden appearance of specially developed traits.

3

The Mexican Veneer

In northern Central America the Early Classic Period, A.D. 300–600, was the wide-open blossom of the Preclassic era with the Maya culturally coming into full reign. Maya groups extended north and east over the Guatemalan Peten, into British Honduras and Yucatan, south and east into western Honduras, and across the Guatemalan highlands into Chiapas and El Salvador.

In the highlands and the lowlands there were large unprotected ritual centers, some with cisterns to assure a water supply. The people from the outlying farmlands contributed their time to the glorification of the gods. Fields were terraced and irrigated, doubling production to feed the trained workmen and intellectuals. Artisans were needed to carve sacred monuments and fashion gala jewelry of jade, shell, and bone, while in the Maya lowlands, fantastic eccentric flints were also coveted. Beautiful ceremonial vessels were adorned with religious motifs painted in earthy colors like sepia and orange-reds and were used in rituals and as grave furnishings in the burial mounds and vaults. These constructions, along with temple mounds, enclosed paved courts forming acropolislike structures.

Scholars concerned themselves with the calendar and astronomy, which influenced agriculture, and hieroglyphic texts recording these vital events were painted on deerskin codices and perhaps cotton cloth and were also sculptured on lintels and stelae. The elite practiced artificial deformation of the head, elongating and slanting it so that the elaborate feathered headdresses worn at important functions would sit firmly. This lent dignity and an ethereal look which helped to impress the worshipers, both those of local origin and pilgrims from other centers.

TEOTIHUACAN INFLUENCE (A.D. 300)

Part of the artistic skill which produced many of these cultural developments may have been derived from artisans of Nahuat origin. As peaceful immigrants they arrived in Central America around A.D. 300 from the Mexican plateau. Their background reflected the culture of Teotihuacan but they had also received cultural traits from El Tajin in Veracruz. Known as the Izalco Pipil from their chief location in western El Salvador, they settled in territory which once probably belonged to the Xinca but was then inhabited by a Maya group, the Pokomam. The newcomers became the principal cultivators of cacao, a product that early enjoyed popularity as an item of commerce, particularly with Mexico. The growth of distant trade and the demand for luxury goods in the ceremonial centers made a form of currency necessary, and the cacao bean, besides its use as chocolate, served as a medium of exchange, particularly in the market places — an innovation during the Early Classic Period that may have been derived from Teotihuacan culture.

The civilization of Teotihuacan was the product of an ecclesiastical government whose primary interest was focused on religion and the glorification of the gods and the dead. This gave rise to the Priest-King or ruler and to his deification at death. It also fostered commercial organization — trader groups who ventured beyond the limits of the central plateau to collect the precious raw materials such as jade, quetzal feathers, and, most important, rubber for the ball game so closely associated with the ceremonial center. This second essential aspect of Teotihuacan culture, commerce, was supervised by the clergy, and trade served in more than one way its own religious impetus. Proselyting, the adaptation of new gods for the pantheon, and the diffusion of cults and cult images also took place. And as the trade routes spread south through the already religious-minded centers of Guatemala, the Nahuat culture infiltrated and in part dominated the people with whom it came in contact. Eventually more Nahuat-Pipil groups reached this area, but the second appearance of bearers of this fundamentally Teotihuacan culture may have been related to the historic Toltec. They followed the trade routes south and east from Tuxtla in Veracruz, through Tabasco, up the Usumacinta, across the Peten, into the Motagua Valley to southern Guatemala,

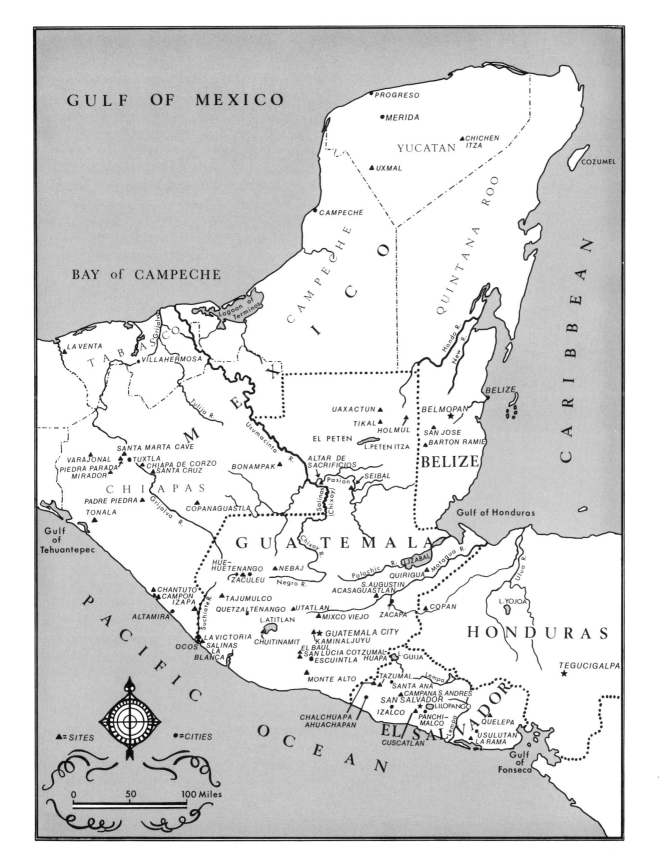

GULF OF MEXICO

BAY of CAMPECHE

●PROGRESO

●MERIDA

YUCATAN ▲CHICHEN ITZA

COZUMEL

▲UXMAL

M E X I C O

●CAMPECHE

C A M P E C H E

Q U I N T A N A R O O

C A R I B B E A N

Lagoon of Terminos

R. Grijalva

T A B A S C O

LA VENTA ▲

●VILLAHERMOSA

Tulija R.

Usumacinta R.

Hondo R.

New R.

BELIZE

▲UAXACTUN

UAXACTUN ▲

TIKAL ▲

HOLMUL ▲

EL PETEN

L.PETEN ITZA

BELMOPAN ★

SAN JOSE ▲

BARTON RAMIE ▲

BELIZE

SANTA MARTA CAVE ▲

VARAJONAL ▲ ●TUXTLA

PIEDRA PARADA ▲ ▲CHIAPA DE CORZO

MIRADOR ▲SANTA CRUZ

BONAMPAK ▲

ALTAR DE SACRIFICIOS ▲

Pasion R.

SEIBAL ▲

C H I A P A S

PADRE PIEDRA ▲

TONALA ▲

Grijalva R.

▲COPANAGUASTLA

Salinas (Chixoy)

Gulf of Tehuantepec

Chixoy R.

G U A T E M A L A

Gulf of Honduras

HUE-HUETENANGO ●

▲NEBAJ

ZACULEU ▲

Negro R.

IZABAL

L.IZABAL

Polochic R.

Motagua R.

QUIRIGUA ▲

S. AUGUSTIN ACASAGUASTLAN ▲

Ulua R.

L.YOJOA

CHANTUTO ▲

CAMPON ▲

IZAPA ▲

TAJUMULCO ▲

QUETZALTENANGO ●

▲UTATLAN

MIXCO VIEJO ▲

ZACAPA ●

▲COPAN

H O N D U R A S

ALTAMIRA ▲

Suchiate R.

L.ATITLAN

CHUITINAMIT ▲

KAMINALJUYU ▲

GUATEMALA CITY ●★

TEGUCIGALPA ★

LA VICTORIA ▲

OCOS ▲

SALINAS LA BLANCA ▲

EL BAUL ▲★

SAN LUCIA COTZUMAL- ▲

ESCUINTLA ●

HUAPA ▲

L.GUIJA

P A C I F I C

MONTE ALTO ▲

TAZUMAL ▲

Lempa R.

SANTA ANA ●

CAMPANA S.ANDRES ▲

SAN SALVADOR ★

LILOPANGO ⬡

CHALCHUAPA ▲

AHUACHAPAN ●

IZALCO ▲

PANCHI- MALCO ▲

QUELEPA ▲

USULUTAN ▲

LA RAMA ▲

E L S A L V A D O R

CUSCATLAN ▲

Lempa R.

Gulf of Fonseca

O C E A N

▲=SITES ●=CITIES

0 50 100 Miles

113

Cylindrical tripod vase with cover of polished black ware, plastered and painted, from Mound 2, Tomb II, Kaminaljuyu, Guatemala, Esperanza phase, Early Classic, Classic Teotihuacan tradition. Height 20.2 cm, diameter 15.25 cm.

Stela 23, Kaminaljuyu, Guatemala, Early Classic. Note the simplicity. The style of carving recalls that on jade ornaments. Height 85 cm.

Cream Ware gutter-spouted bowl with pink stucco, Kaminaljuyu, Guatemala, Esperanza phase, Early Classic. Rim motif has three pairs of birds (vultures?). Height 4 cm, diameter 25 cm, 28 cm with spout, diameter of bottom 15.5 cm.

Cuzcatan in El Salvador, and perhaps from the Motagua to Honduras and beyond.

NAHUAT VERSUS LOWLAND MAYA

Between A.D. 300 to 400 there is a notable change within the Maya region. In Chiapas the sweathouse, a ceremonial structure common in the Mexican plateau, appeared as early as A.D. 200–350 during the Jiquipilas phase connected with Chiapa VIII. Development at Chiapa de Corzo terminated, and only grave furnishings of three Teotihuacan-like vessels mark the Chiapa IX phase. Mirador and coastal Chiapas show strong Teotihuacan influence.

At Kaminaljuyu, Guatemala, during the Aurora and subsequent Esperanza phase that also extended into El Salvador, pottery was influenced by Teotihuacan art even though El Salvador kept its own characteristics throughout the entire Classic Period. During the Aurora phase the use of stucco on vessels painted in the Usulutan technique was common. In fact, there were two contenders for cultural dominance in Upper Central America: one, Teotihuacan Nahuat, and the other, the lowland Maya associated with the Tzakol phase at Uaxactun, Periods II–IV at Holmul, Guatemala, and Period II at San Jose, British Honduras. Polychrome ware, particularly basal-flanged bowls with naturalistic designs inspired by

Polychrome bowl and lid with spotted deer from San Miguel Uspantan, Quiche, Guatemala, Early Classic. Height 16 cm.

the Peten Maya, vied with Teotihuacan styles at Kaminaljuyu. There are numerous examples of stuccoed and painted tripod cylinders in both Mayoid and Teotihuacan styles, while tetrapod censers bespeak the lowland Maya. Ceramics of the Esperanza phase are distinguished by Esperanza Flesh-color Ware (a local product), polychrome vessels reminiscent of the Peten, and Thin Orange cylindrical tripods, a trade ware from Puebla, Mexico. A third ceramic tradition of unknown source appears in fine-paste black and ivory bowls.

Often the motifs on Early Classic vessels show the impact of new religious ideas and the conforming designs are mere symbols used to convey spiritual concepts. Indicative of the Maya are double nose ornaments, elements of the Serpent X, the kin cross somewhat resembling that of St. Andrew's and frequently associated with rain and the feathered snake, shell symbols, and bare feet. Diagnostic of Mexico or Teotihuacan are the cults of the rain god Tlaloc, the wind god Ehecatl, Xipe, god of spring, and the butterfly goddess; droplets; Tri-mountain and serpent-eye symbols; sandals; speech-scrolls beflowered or noded; and capes. Trade wares were present, such as Thin Orange already noted, low cylindrical vessels with openwork or round-bottomed feet from Teotihuacan, Tlaloc effigies, and "cream pitchers" and "candeleros." Other Teotihuacan items, not necessarily imported, were probably used for offerings. There is almost a total absence, however, of the Usulutan technique, and pottery figurines, whistles, and stamps disappeared in both highlands and lowlands.

But as new customs and people made their mark at Kaminaljuyu, earlier values changed. The carving on stelae and the construction of altars degenerated, many sculptures were destroyed, and hieroglyphic representations ceased. There was no need for a "written" language which the new religious leaders did not master, and perhaps this caused a marked deterioration in monumental lithic sculpture and stone jewelry. Iron pyrite mirrors encrusted on slate discs often beautifully carved with religious symbols or personages in El Tajin style are found so frequently, however, that they may have been the work of skilled artists brought from Veracruz to serve the elite of Kaminaljuyu and to fashion the stone yokes and thin stone heads used in the sacred Mexican-inspired ball game throughout the area.

At Uaxactun during the Tzakol phase and at many other low-

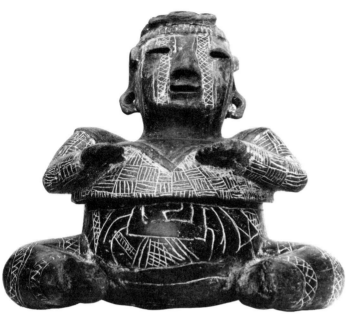

Effigy vessels with lids, Uaxactun, Guatemala, Tzakol 3 phase, end of Early Classic. Left: Black Ware from Burial 20A; height ca. 16.2 cm. Right: Monkey effigy vessel; height ca. 15.5 cm.

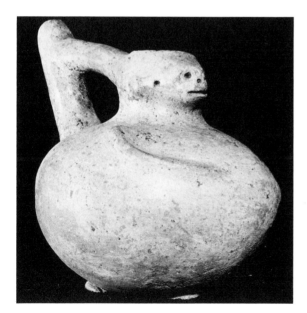
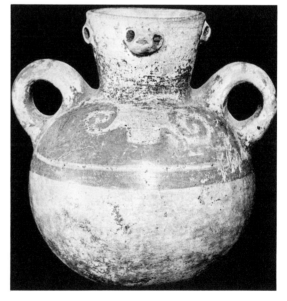

Small cantharo with effigy monkey face and arms on upper body and neck of vessel, Early Classic. This effigy may imply the cult of Ehecatl. Cream slip. From eastern El Salvador. Height 12.8 cm.

Small polychrome cantharo with effigy animal face on vessel neck, El Salvador. The slip is white with red designs on upper body curve and an orange wash over white on the lower half. This ceramic style belongs to the Oriente group and is typical of Late Classic central and eastern El Salvador. Height 13 cm, rim diameter 5.9 cm.

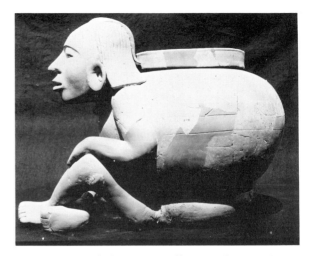

Restored Thin Orange effigy vessel, Kaminaljuyu, Guatemala, Early Classic.

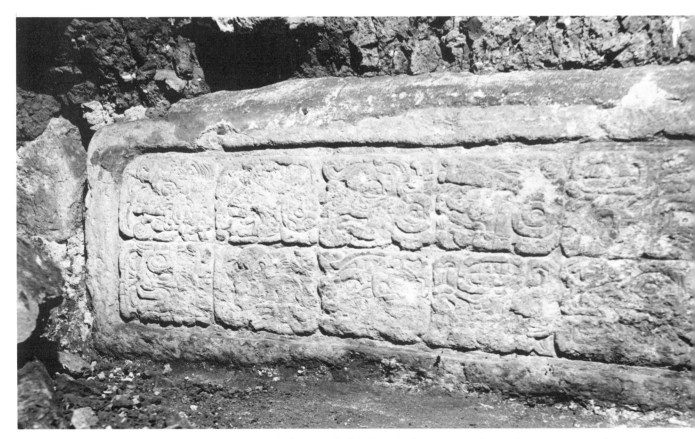

A rise carved with hieroglyphs, interior of Mound 11, Copan, Honduras.

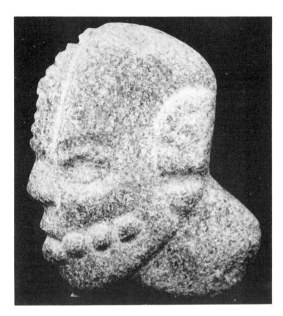

Hacha, Kaminaljuyu, Guatemala, Early Classic.

Slab-leg tripod vessel with cover from Burial A 22, Uaxactun. Height ca. 18 cm.

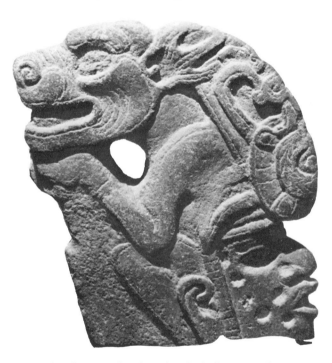

Clay cream pitcher from Burial A 22, Uaxactun, Guatemala, Tzakol 3 phase, end of the Early Classic. Height 8.5 cm.

Thin flat stone head used in the ball game and called an *hacha*, from Aguachapan, El Salvador, Early Classic.

119

land sites, the Maya culture continued intact — almost the reverse of what occurred at Kaminaljuyu and in the highland region. Common diagnostic lowland Maya traits included basal-flanged and annular-based vessels, polychrome pottery, tall tubular incense burners, eccentric flints, corbeled vaults, and elaborate stelae carved with hieroglyphs and placed in front of altars.

Popular deities were the rain god Chac (who may have developed from the Olmec concept of the big nose or *narigudo)*, the jaguar, the bat, and the long-nosed god. Some Teotihuacan influences appear but they are rare and mostly religious in nature. Thus Tlaloc, Quetzalcoatl, Ehecatl, and Xipe cults participated in the ceremonies. *"Candeleros,"* Thin Orange Ware, and occasional pyrite-encrusted slate plaques suggest traders from Mexico and the Guatemalan highlands.

TIKAL, GUATEMALA

Tikal, however, showed closer contact with Teotihuacan culture despite its essentially lowland Maya character and with its unique fantastic roof combs was something of an exception. Burial 10, for example, following the Maya custom of placing the body of a high-ranking personage in a chamber cut from bedrock, was below the North Terrace and underneath Structure 5D–34, a feat that must have taken considerable time and labor to accomplish. Teotihuacan-style stuccoed vessels painted with Tlaloc images were found in Burial 10, and other tombs of the late Early Classic Period yielded Teotihuacan designs on cylindrical tripods, objects of green obsidian including projectile points and flake blades, and clay earspools. Even some stelae and altars were not free from Nahuat religious motifs. The figure on Stela 4 has a scallop shell necklace; that on Stela 18 holds Tlaloc. Figures on the side of Stela 31 wear scallop shell necklaces and carry shields and spear-throwers, while Stela 32 has a full Tlaloc representation or a priest of the cult. Altar 19 is carved with a face showing Mexican features and Altar 12 has a seated figure with serpent jars, all traits associated with Teotihuacan.

COPAN, HONDURAS

It was during the Early Classic Period also that lowland or Peten Maya culture extended to one of its most beautiful religious centers, Copan, Honduras. About A.D. 400 ritual vessels of basal-

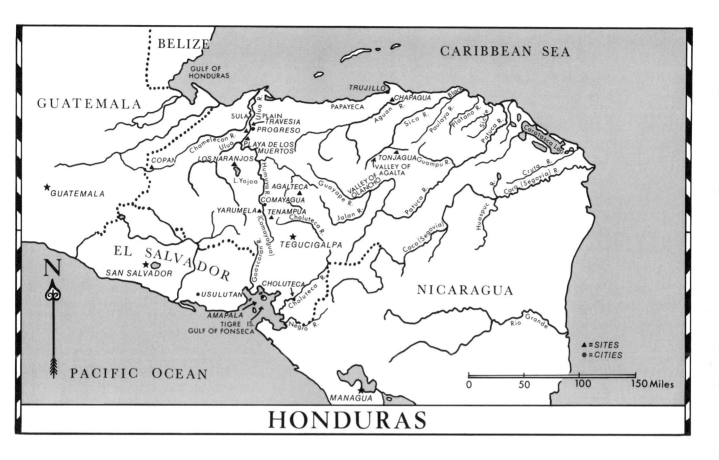

HONDURAS

flanged polychrome bowls and Black and White Ware slab-footed tripods belonging to the Tzakol phase were brought from the Peten for tomb furnishings, probably by Maya priests, along with the stela and ball game cults. Tetrapod hollow-leg bowls, crude effigy-legs on deep bowls, and the later Red-on-Orange Ware painted in Usulutan technique show contact with El Salvador. In fact in the Maya area this manner of decoration continued only at Copan and in El Salvador.

Ladle censers and Esperanza Flesh-color bowls indicate trade with Kaminaljuyu, as do deep, thin-walled, basal-flanged bowls with a ring base and naturalistic designs known as Type A. A similar style is also known from San Jose, British Honduras. Type B, a thicker-walled vessel with narrow protruding flange and geometric designs connects Copan, the lowland Maya territory, the Alta Verapaz, and Kaminaljuyu, while Thin Orange Ware suggests

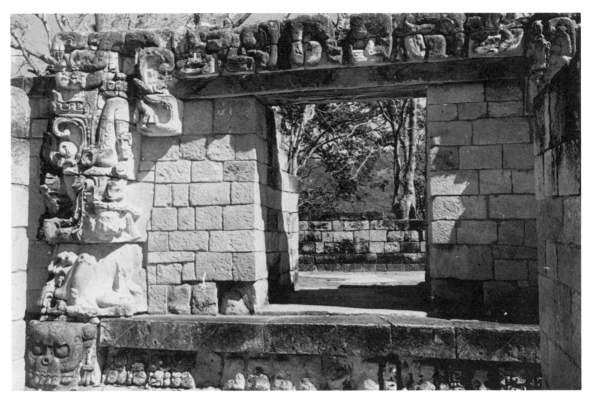

Entrance to room in Temple 22, Copan, Honduras, Late Classic.

trade with Mexico. Pottery unique to Copan includes horizontal loop-handled *comales* (flat pans) and later Black Ware pastel-tinted stuccoed tripod vessels with covers, although they show influences relating them to lowland and highland Maya sites as well as San Agustin Acasaguastlan in the Motagua Valley of Guatemala.

There may have been artisans among the Copan villagers, but experts trained in masonry and sculpture probably accompanied the priests in their peaceful crusade to establish another center of ritual and pilgrimage. Copan grew quickly, a fact which suggests imported technicians and craftsmen; perhaps they were members of the priesthood itself as in the early Christian monasteries.

At this time the Acropolis was started and where Temple Mound 26 stands today, a low terrace faced with a stucco-painted mask appeared, reminiscent of Uaxactun and Tikal. There was also a rise carved with hieroglyphics on steps leading up to a temple within

what is now Mound 11, the Temple of the Inscriptions. The first ball court with open ends, discovered so far, was constructed here and two stelae were erected. One, Stela 20, bears a probable date of A.D. 450, but the other, Stela 24, has a positive date of 470.

Maya religion now dominated and filled the valley with a zealot's fervor. This was further strengthened by the importance the priests gave to agriculture. The simple peasant society of pre-Maya Copan became the follower of a cult controlled by the theocratic authority's knowledge of astronomy and its effect on major agricultural undertakings, planting and harvesting, as well as the equinoxes, solstices, and eclipses. In connection with all these major events, the clergy regulated the vital steps concerned with food production through ritual and festivities which the uninitiated masses of people could conform to and appreciate.

Ball court, Copan, Honduras.

The Maya possessed three calendars — a solar, a liturgical, and a combination of the two, indicating their propensity to adopt, a trait also seen in their hieroglyphic writing. Their numerical system was vigesimal, using the unit 20, and their solar year was divided into 360 days or 18 months of 20 days each, with 5 additional days. When involved in calculating dates, however, 20 remained the unit count. All this contributed in making Copan significant, for the center was a privileged one and an important scientific capital of the Maya.

Influences from Honduras reached eastern El Salvador. At Quelepa massive terraces faced with large cut stone blocks and similarly faced terraced substructures with multiple stairways signify the start of a ceremonial center. In the west, ritual importance now began at Tazumal and Campana San Andres, reflecting Kamin-

Part of the west facade of Structure 1, Tazumal, department of Santa Ana, El Salvador. With the exception of the base, which dates from the Early Classic, this structure is Late Classic.

aljuyu and Copan in certain details of construction. Maya pottery types predominated. At Tazumal, in particular, hollow rattle feet were common on bowls decorated in the Usulutan technique with red paint added, as were knob feet on small Brown Ware incised bowls.

The same general type of construction, stone set in adobe, was used in the earliest levels at Travesia, a ceremonial site in the Sula Plain, Honduras. Unlike Tazumal and Campana San Andres, however, lime facing was not applied at Travesia until the Full or Late Classic Period.

INNOVATIONS IN LOWER CENTRAL AMERICA

During the Zoned Bichrome period in Lower Central America, the presence of northerners in Eastern Honduras and Nicaragua is suspected, particularly in the type of grinding stone. Both northern and southern influences can be seen in the pottery. At the beginning of the Linear Decorative phase, although some of the ceramic styles such as painting in multiple lines continued from Zoned Bichrome times, innovations again came from the north and south. White-on-Red Ware related to pottery of the Ecuadorian Guangala period appeared at the start of the Santa Elena phase which follows Chombo in northern Guanacaste, Costa Rica. Although disappearing toward the end of the phase, the ware indicates that the few good anchorages of northwestern Costa Rica were utilized by early traders in transcontinental journeys.

The shapes and designs of Urcuyo White-on-Red (at times called Nandaime) Ware from Pacific Nicaragua and Costa Rica and Lopez Trichrome Ware from the Nicoya Peninsula show northern influence. This pottery is similar to the San Martin style from Zacatenco, Mexico. Bowls decorated with side or basal molding, like those that characterize the Lavanderos and Guinea wares from the Tempisque Valley, also indicate inspiration from the north. The growing importance of maize is shown by the appearance in the Greater Nicoya region of rectangular grinding stones without a raised rim, a type long established in Upper Central America.

On the Atlantic watershed in the Reventazon Valley an Early Period B, A.D. 0–400, follows Early Period A. The predominant wares are monochrome decorated with rocker-stamping and some appliqué. However, Red-on-Buff painted pottery appears. Forms are mostly lugless globular vessels, but some are tripods.

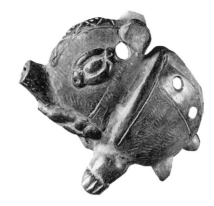

Pottery ocarina in the shape of a wild pig, Lagunilla, Nicoya Peninsula, Costa Rica. Width 8 cm, length 11.5 cm.

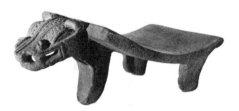

Carved metate from Nicaragua. Height 17.75 cm, length 52.10 cm, width 22.80 cm.

Head of stone figurine from Farm 5, Diquis delta, Costa Rica. Note the resemblance to the statues from Barriles, Panama (p. 102). Height 5.5 cm.

Around A.D. 300, two distinctive elements appear in the flood plain of the Rio Grande de Terraba or Diquis in southeastern Costa Rica, where traits are prone to be characterized by an attribute of largeness: stone figures reminiscent of Barriles heads, although some are small, approximately two inches (5.5 cm) high, and stone spheres which occur throughout the Diquis region. The biggest sphere known measures eight feet (2.44 m) in diameter. Some were supported in the delta silt by cobblestone platforms, indicating the engineering ability of their makers. These granite balls are in an area where such raw material is nonexistent. Their exact purpose remains a mystery, but many have been found in connection with cemeteries suggesting a ritual use. They are associated not only with the earliest pottery in the Diquis delta, Brown Ware and Fugitive Red Ware, but also with painted Red and Black Line Ware of Chiriqui type which has been found with iron tools of European manufacture.

Clay jars of Brown Ware Parallel-line Incised style form the second distinct trait of the Diquis culture complex. Some are two feet

Stone balls at Las Bolas on the Brujo Trail near Alto Cabagra, Costa Rica. Height ca. 1.75 m.

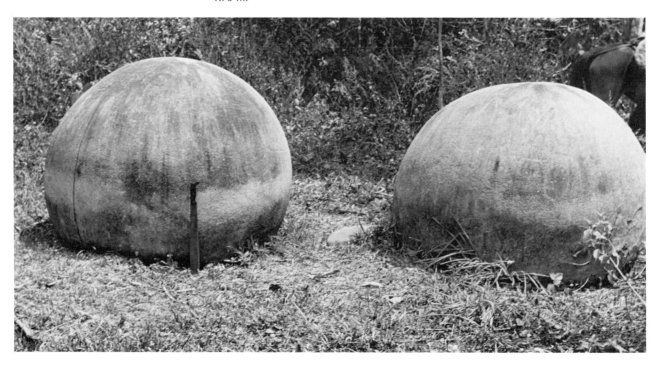

(60 cm) at the base and five feet (1.5 m) high; others have a diameter of about two feet (63 cm) at the rim. Among the speculations offered to explain the purpose of these extra large and heavy vessels are that they served for fermenting chicha (an intoxicating brew made from tubers or the fruit of the peach palm or maize), as storage jars, or as urns for secondary burial. The fact that some were broken and buried and others occurred in general refuse suggests a probable function as storage jars for fermented drinks. Today in Alta Talamanca, Costa Rica, the custom still exists of communal partaking of chicha from large earthen jars at a grave site or during rituals. The same type of vessel is also seen in dwellings for making and storing chicha.

The earliest Brown and Fugitive Red pottery was lugless and legless, but these appendages soon came into fashion. Fugitive Red was so named because its coloring is easily rubbed off and was probably applied after firing. Fugitive Red Ware has figurines corresponding in time to the Parallel-line Incised type of Brown Ware. Cleft feet are reminiscent of Preclassic figures in northern Central America, but the generally triangular faces, circular eyes, modeled breasts, and seated position of many figurines with the hands on the knees recall the later painted Red and Black Line Chiriqui-type figurines of the Diquis region and Panama.

This early Diquis delta pottery, Brown Ware and Fugitive Red, is contemporaneous with the first part of the Burica phase, A.D. 300–500, of the Gulf of Chiriqui, Panama. Diagnostic of the entire Burica period, A.D. 300–800, which was concentrated on the mainland between Punta Burica and the islands in the Chiriqui Gulf, is Isla Palenque Maroon Slipped Ware. This ware is composed principally of thick and thin globular handleless jars and bowls with a low annular base, although short and tall tripods also occur. The maroon or brick slip is often polished, and some bowls are decorated in addition with diagonal incised parallel lines above the shoulder and below the lip, with slightly raised diagonal parallel ridges, or with appliquéd curvilinear ridges and nodules. Large thick jars of this ware were used for secondary burials.

The people of the Burica phase apparently inhabited the islands in the Gulf of Chiriqui seasonally for fishing and hunting, not as permanent homesites. Trade with the Parita Bay area and beyond, however, occupied some of their time during these sojourns. Strangely enough, no stone artifacts have appeared in the

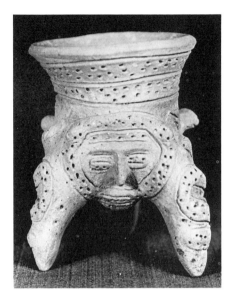

Monochrome tripod vessel, Chepillo, Chepo district, Panama province, Panama, decorated by incision and punctation, contemporary with the Early Polychrome period in Lower Central America. Human face is repeated on the opposite side.

Bichrome bridged and spouted vessel with bird effigy, Bayano, Chepo district, Panama province, Panama, contemporary with Early Polychrome phase in Lower Central America.

Burica phase though in Veraguas during this time and even earlier, oval, raised-rim grinding stones with birds and animals carved in relief on the base and three cylindrical legs were in use.

The ceremonial center of Sitio Conte in the province of Cocle probably began around this time. Pits dug in refuse piles yielded the oldest burial pottery found here, an almost all plain Red Ware.

The oldest ceramics with painted motifs from western Panama, including sites in the Canal Zone, the Azuero Peninsula, and Cocle, consisted of Black-line on Red Ware and Black-line Geometric Ware which started shortly before A.D. 300. Shallow bowls painted on the interior with zoomorphic and geometric designs compose the first group, while the other has large globular jars with flaring red neck, base, and a light slip on the upper half of the body which is decorated by sections of crosshatching in black. Both styles were found in Veraguas, and Black-line on Red was traded also to Venado Beach and the distant Pearl Islands. Shared

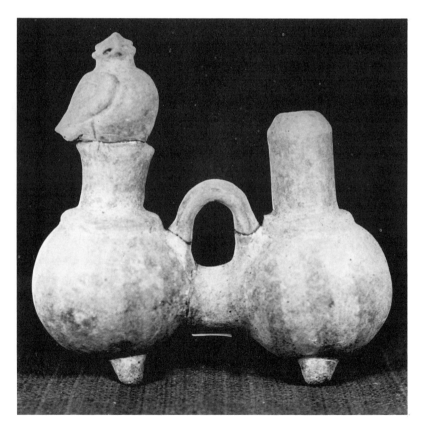

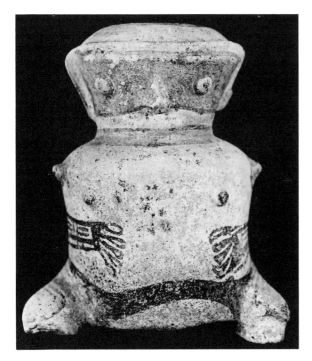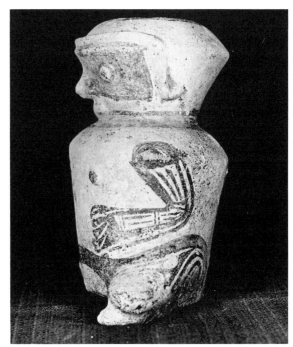

Hollow clay figure, Chepillo, Chepo district, Panama province, Panama.

by Venado Beach, Sitio Conte, some Azuero and Veraguas sites, and the Diquis delta refuse are vessels decorated by a black line bordered by white lines. The source of this style has not been determined.

Eastern Panama or the ancient province of Darien is very little known archaeologically. From the Canal Zone east there is less evidence of highly developed art or ritual sites. Among the better investigated parts of the adjacent territory are Bayano, Chepillo, and the Pearl Islands. Although there were secondary and extended interments, with some mutilation of the corpse at least at Venado Beach and Panama Viejo, burial in urns was typical. For food people depended on the sea, hunting, and limited agriculture. Incised spindle whorls indicate the use of cotton. Even though foreign wares reached Venado Beach and other sites, trade was at a minimum. The characteristic utilitarian pottery consisted of Incised Relief Brown with boldly executed zoomorphic patterns and Red and Brown combinations decorated by shell stamping, punctation, and reed markings. Human effigy vessels had only the modeled features of a face on the neck, a style familiar to basic

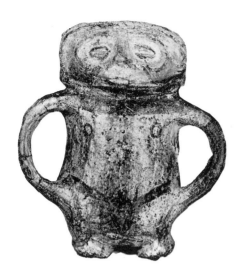

Polychrome hollow clay figure with open head from Chepillo, Chepo district, Panama province, Panama.

Central American cultures, or were vessels formed by a whole figure. Bridged and spouted vessels of some bichrome and monochrome pottery suggest Peruvian influence. An elaborate votive ware typical of Panama Viejo, characterized by animal, bird, and reptile effigies and ornamented also by incising and punctates, recalls certain styles from Santarem, Brazil. The eastern extension of the Pan American highway promises to open hitherto unavailable territory and to throw new light on the unwritten past.

THE FLORESCENCE OF THE CLASSIC PERIOD (A.D. 600–900)

During Chiapa X, A.D. 600–950, the florescence of the Classic Period occurred in Chiapas in the form of a population expansion with cultural traits which may have come partly from the Pacific coast, the Guatemalan highlands, and Mexico. Hillsides were terraced with stone walls placed to conserve soil and moisture for the intensive farming needed to meet the demands for an increased food supply. Three-pronged incense burner stands, open-ended ball courts, low temple mounds (some faced with stone blocks or slabs), and sweathouses indicate the spread of Maya religious customs. Even the corbeled vault tomb with horizontal passage, a combination of highland and lowland Maya traits, appeared at one ceremonial site, Varajonal, and in at least three places in the highlands stelae were sculptured in the style of the Peten. Tepeu 3 pottery types, such as carved Fine Orange Ware, were in Chiapas toward the end of the period.

Events in the valley of Mexico, however, were to change the culture and cause the appearance of new ethnic groups in Central America. The urban and religious center of Teotihuacan, fundamentally associated with Nahuat peoples from as early as Late Preclassic times, was burned during its third phase, around A.D. 650 and collapsed internally, and a general dispersion of its inhabitants took place. Some remained in the highlands settling in Cholula, while others scattered in all directions, carrying with them their dominant consuming religion and its focus on the rain deities: Tlaloc in combination with the Feathered Snake. We do not know who was responsible for the fall of this great metropolis, but its ruin spelled the disintegration of the Classic world in Mexico and was the cause of foreign cultural intrusions and a militaristic tendency in Upper Central America. In Mexico, many of the displaced people joined forces with other ethnic groups.

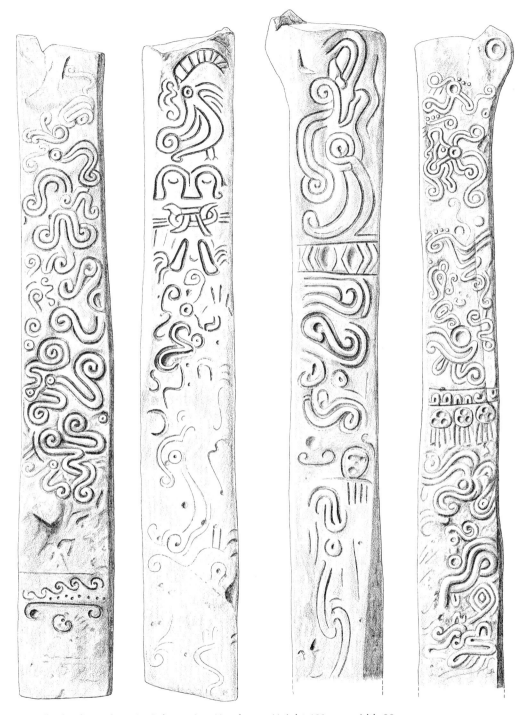

Inscribed column from La Paleta ruins, Honduras. Height 193 cm, width 28 cm.

131

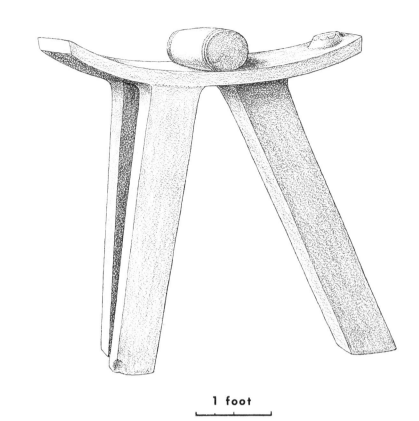

1 foot

Giant tripod metate with mano metate from La Paleta Site 1, near the head of the Klaura River, Honduras. 1′=25.4 cm.

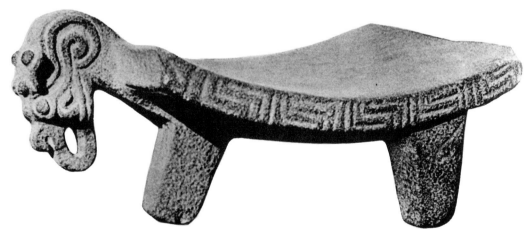

Grinding stone for maize, Tigre Island, Gulf of Fonseca, Honduras, with reptilian projecting head, stylistically eastern Honduras but also found in the Comayagua and the Choluteca Valleys and at Santa Lucia, Cotzumalhuapa, Honduras.

Serpents engraved on rock ledge at Santa Elena de Izopo, Honduras.

One result of such fusion became known as the historical Olmecs, Nahuat mixed with Mixtec and Chocho-Popoloca, who by A.D. 800 had complete possession of Cholula, that center of pyramids, a conquest which probably caused the departure south of Mangue-speaking people who had inhabited the mountains in the vicinity of this stronghold. Pushing through to Chiapas they settled in territory belonging to the Tzotzil, a Maya group that had taken over this land from the Mixe-Zoque. The Mangue-speakers forced the Tzotzil to the highlands and became known in their new home-land as Chiapanecas.

The Maya groups in Chiapas were continually hostile to the Chiapaneca and even joined forces with their kin from Tabasco. This may have been one of the reasons the branch of Chiapaneca called Chorotega-Mangue started south, forming colonies in Nequepio, El Salvador, and Choluteca Malalaca in southern Honduras by the Gulf of Fonseca in lands inhabited by the Ulva and Matagalpa, basically peoples from Lower Central America. They fringed on or usurped Lenca and Maya territory as well and left what might be traces of their path in eastern Honduras and western Nicaragua.

THE MOVEMENTS OF PEOPLES

More pressures from the north might have been responsible for the continued travel east of the Chorotega-Mangue to Nicaragua and Costa Rica, where they settled on the Pacific coast principally from Lake Managua to the Gulf of Nicoya. Part of their land was taken from the Corobici, an isthmian group of southern extraction.

Despite historical references, a Chorotega-Mangue ceramic complex has not yet been recognized. It is possible, nevertheless, that Modeled Alligator Ware and similar censers characteristic of Pacific Nicaragua and the Nicoya Peninsula in Costa Rica may have

133

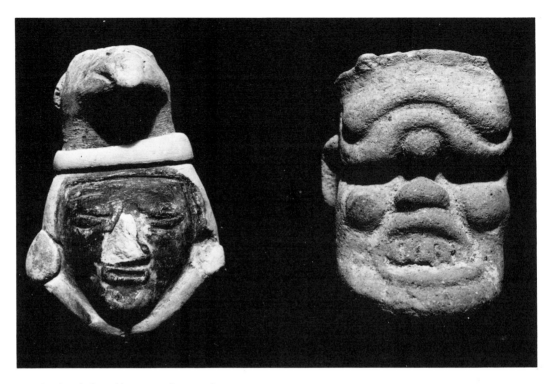

Figurine heads from Uaxactun, Guatemala.

evolved from the cylindrical smokestack decorated with clay nodules and fillets with punctates which rises from animal-effigy incense burners found in Chiapas. In Nicaragua and Costa Rica, Modeled Alligator Ware belongs to the Early Polychrome period, about A.D. 500–800.

In lower Nicaragua and Costa Rica it is possible that the Chorotega-Mangue took the idea of a vessel with a small modeled effigy animal or head from the local inhabitants such as the Corobici, part of whose territory they usurped, and created the jaguar, monkey, and similar vases so characteristic of the Greater Nicoya area during this period. In turn, this vessel style may have influenced the creation in the early Postclassic Period of that famous trade ware, Tohil Plumbate, discussed in Chapter 4.

Among the people affected by the unrest resulting from events which took place at Cholula were the Tlappaneca-Yopi in west Mexico. They followed close behind the Chorotega-Mangue to Pacific Nicaragua where they were known as the Maribio. Their

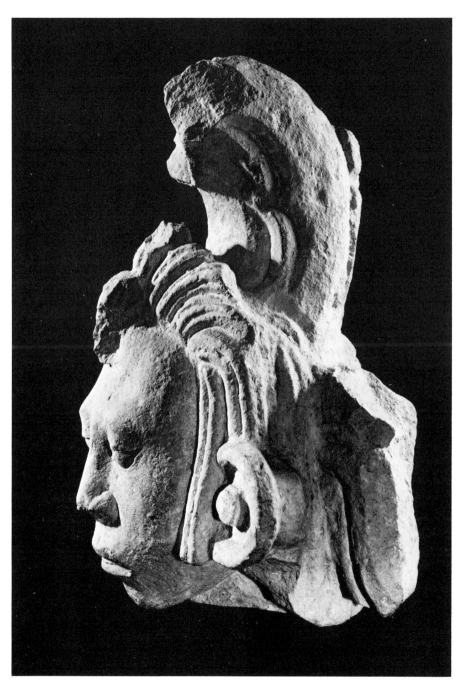

Head of the maize god carved in the round in stone, Copan, Honduras, Late Classic. This
was originally coated with painted plaster.

new territory around Leon may have belonged to people of the Tacacho tongue, whose affinity has been lost in time.

More Nahuat and Nahuatized peoples, in Central America called Pipiles ("princes" or "children"), also left the Mexican plateau and the Gulf coast region. The Cuzcatan Pipil of El Salvador reached the isthmus and affected a vast area. Nahuat-Pipil influence at the beginning was reflected principally in highland Maya territory where the culture and ritual had always been less elaborate and not so well defined as in the lowlands.

A change in village sites from open valleys to hilltops and the development of small compact ceremonial centers, seldom with acropoli, took place in the highlands. New customs appeared while some of the old were discontinued. Artificially elongated skulls, so necessary to orthodox Maya ritual, became almost extinct and stelae and altars completely disappeared outside the lowlands. Burials in urns became common and even the ball game showed signs of other influences. A closed-end court marked with horizontally tenoned stone heads served as a playing ground for men equipped with carved stone yokes worn as belts at the hips, often with a thin stone head or "hacha" attached to the opening and handstones to protect the knuckles — gear common to the region of Veracruz and the Nahuatized people inundated with the culture of Teotihuacan and Tajin. Tripod mushroom stones connected with an unknown ritual were also important, as well as mold-made clay vessels with modeled heads on the rim, a type known in the Mexican highlands.

In the Maya lowlands, however, the cultural life continued to flourish and expand. Growing centers were linked by cobblestone causeways to aid the pilgrims and merchants. Temples, often on tall acropoli, were fashioned with corbeled arches or housed corbeled burial vaults. At Uaxactun polychrome ceramics called Saxche began during the Tepeu I phase and included vessels with orange, cream, or red slips decorated with glyph-bands, geometric motifs, sky-band signs, figure painting, and reserve-space circle designs. The influence of Saxche and Tepeu 2 polychromes is reflected in the contemporaneous Ulua Polychrome and Copador wares of Honduras and El Salvador, for example at Tazumal, also in territory associated with the lowland Maya.

Stone head, Copan, Honduras, Late Classic. Note the hole probably used for an obsidian inlay. Height 85 cm.

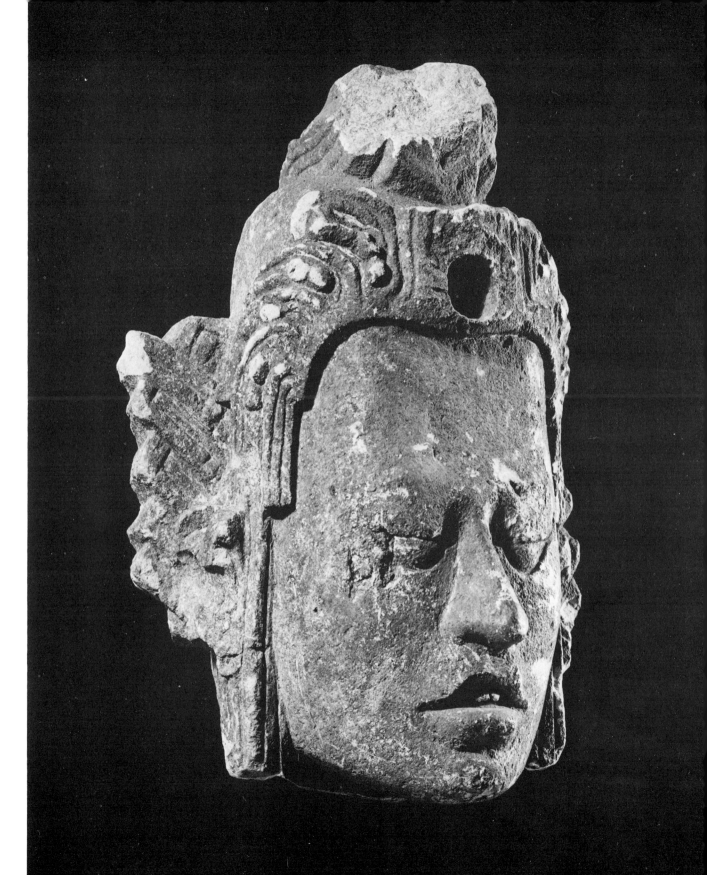

By around A.D. 800 some of the more important sites such as Uaxactun, Tikal, and Bonampak contained shrines adorned with frescoes, painted in blue, green, red, pink, yellow, and black, which depicted historical and religious themes and sometimes displayed a great sense of perspective. In the lowland Maya area, for example at Copan, elaborately sculptured stelae, usually placed relative to drum-shaped and carved altars, were erected to serve the ever-present spiritual needs, and beautifully sculptured figures adorned stairs and buildings. In fact, the importance of old customs survived. Even the open-ended ball court remained, although vertically tenoned stone heads decorated the sides and the players' equipment consisted of knee and elbow pads and wicker basket yokes.

In spite of the strength and efficiency of lowland Maya culture, it was not immune to alien influences. At Tikal in particular, and later at Copan and many other sites throughout the area, there is evidence of Nahuat religious penetration and the rise of militarism in the erstwhile peaceful centers. Possibly the militaristic trend was due to more than one cause. Overpopulation within the Maya area itself and the subsequent decline of an adequate food supply may have set one ceremonial city against another. Most certainly new-comers could have changed a nonchalant attitude into a defensive one. In any event, between the end of the Early Classic and the early Late Classic Period, an earthwork nearly six miles (9.5 km) long with causeways serving in part as gates was built about three miles (4.5 km) north of the Great Plaza of Tikal, and during the Late Classic there are signs of control by non-Mayas at Altar de Sacrificios and at Seibal.

Not only in the Guatemalan Peten but also at Copan, outsiders were present. Stela 6, bearing the date A.D. 682, has a personage wearing a Tlaloc headdress and sandals decorated with Teotihuacan hieroglyphs. At Travesia, Honduras, stones sculptured with Tlaloc faces were placed on the façade of the Temple of the Carvings. The famed marble vases characterized by stylized serpent scales, scrolls, projecting animal heads and their split counterparts on the vessel body appear to have been made at Santana Farm in the Sula Plain which borders on and is culturally an extension of Travesia. These vessels combine basic Central American and Nahuat or northern motifs and were carried to foreign ritual centers during

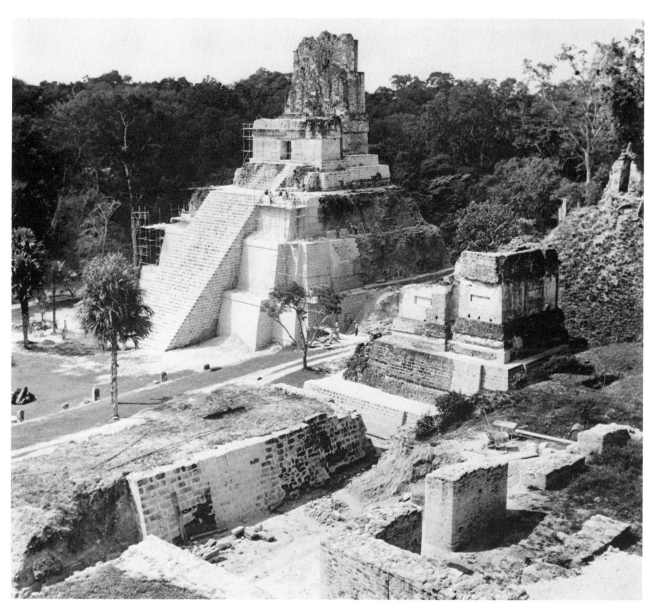

Temple II, Tikal, Guatemala.

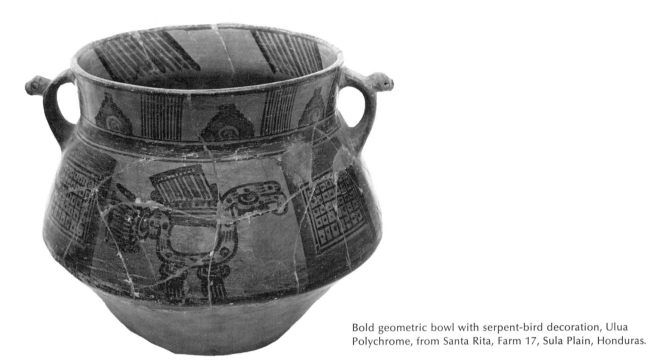

Bold geometric bowl with serpent-bird decoration, Ulua Polychrome, from Santa Rita, Farm 17, Sula Plain, Honduras.

Small marble vase from Playa de los Muertos, Sula Plain, Honduras. Height 8.3 cm, diameter 16.5 cm.

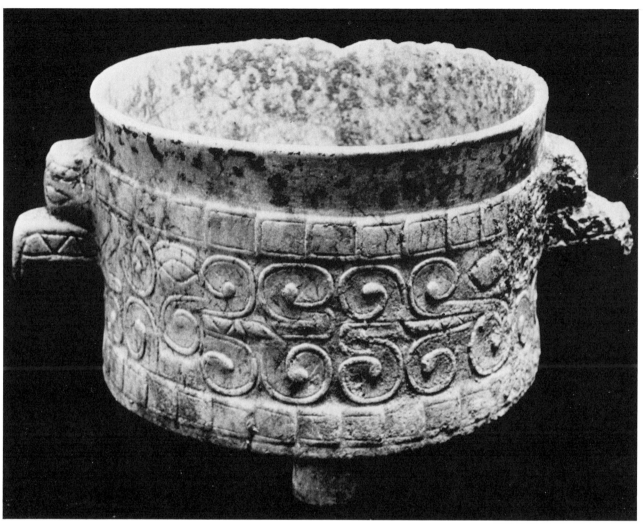

Marble vase with stylized serpent scale bands and projecting buzzard effigy head handles with their split counterparts framed partly with scrolls incised on the vessel body. The vase is from Peor es Nada at the southern end of the Sula Plain, Honduras, Late Classic. It was found with two Ulua Polychrome Ware Fine-line Mayoid vessels and jadeite pendants.

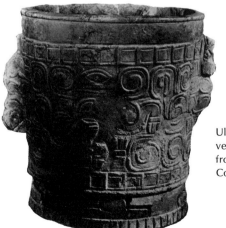

Ulua marble vessel with jaguar effigy handles and vestiges of stucco overlay painted in red and green from Ortega, near El Viejo, province of Guanacaste, Costa Rica.

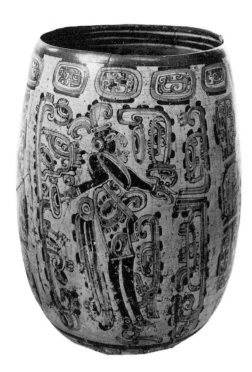

Ulua Polychrome pottery vase, dimpled base, Mayoid type, Lake Yojoa, Honduras. Height 26.10 cm, rim diameter 17.75 cm.

the Late Classic Period. Another local product covering the same period is known as Bold Geometric Ware and likewise shows primarily Central American, combined with northern, religious motifs.

The dominance of Nahuat culture and its steady infiltration of Maya and other cultures in the Late Classic era are documented by the ware known as Ulua Polychrome, a name derived from the Ulua River in northwestern Honduras. It is found throughout this river's drainage including Lake Yojoa, and appears in the departments of Copan, Morazan, Olancho, Choluteca, and some of the islands in the Gulf of Fonseca. On Lake Yojoa at Los Naranjos non-culinary pottery of the Yojoa phase also includes the Mayoid and Naturalistic styles of Ulua Polychrome and Fine Orange Ware. Ulua Polychrome occurs in El Salvador and examples have been found in Guatemala, western Honduras, and El Cauce near Managua, Nicaragua.

As previously noted, Ulua Polychrome Ware reflected the style of certain Tepeu ceramics from Uaxactun. The glossy finish, the manner of painting, and the design arrangement of the Mayoid portion of this ware suggest that it was the creation of Nahuatized Maya or Maya in the process of being Nahuatized. The other portion, the Naturalistic, shows the adoption or fusion of basic Central American deities with Nahuat and Nahuatized Maya gods. The religious character of Ulua Polychrome Ware is further emphasized by its close association with ceremonial centers, especially in western and central Honduras and El Salvador, all suggesting Nahuat-Pipil penetration. It is significant also that the presence of this ware at Copan coincides with the last period of the site, beginning around A.D. 700 when foreign influence is prominent. The site was abandoned around A.D. 810. Nahuat personages were sculptured in stone at Copan, for example, on Stela 6, and stone yokes connected with the Mexican ball game appeared after A.D. 800 when the last dated monument, Sculpture G, was erected.

I do not feel that trade was responsible for the presence of Ulua Polychrome Ware at Copan, but that it was due to a dominating religious group essentially Nahuatized. The typical late-period pottery at this site is Copador, a local development that, with few exceptions, is Maya in character. When it first appeared, Copador consisted of simple bowls and vases decorated with

Ulua Polychrome, Mayoid style sieve, Lake Yojoa, Honduras. Diameter 15.25 cm, handle 12.70 cm long. Note hole in handle for hanging.

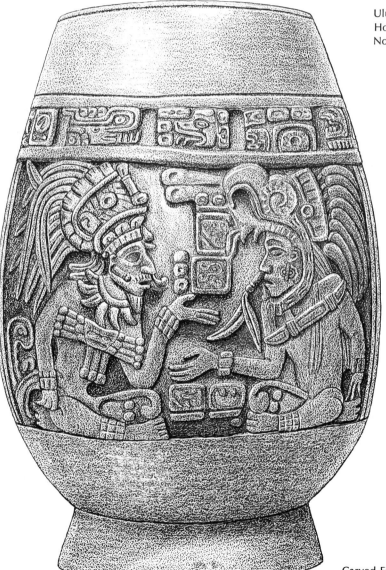

Carved Fine Orange Ware,
Uaxactun, Guatemala, Late Classic.

Two-handled Ulua Polychrome bowl, Mayoid type, Tlaloc effigy, Lake Yojoa, Honduras. Rim diameter 9.5 cm, vessel diameter 15 cm.

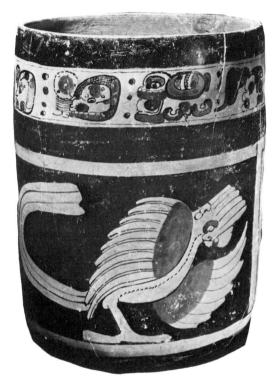

Copador and Ulua Polychrome Bold Animalistic styles combined on a vessel of the Late Classic Period from Tomb 2, Copan, Honduras. Height 18.5 cm.

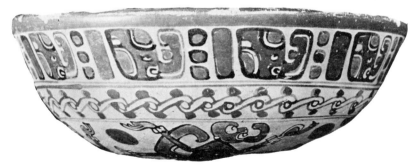

Copador vessel, Late Classic Period, typical of western El Salvador and Copan, Honduras. It came from Grave 10, Bolinas 1 cemetery, department of Santa Ana, El Salvador, and is painted with specular hematite, black, gray, and orange, on a thin orange wash over buff clay. Height 6.4 cm, rim diameter 7.5 cm.

144

Dog's head vessel from Tomb I, Copan, Honduras. It originally rested on three nubbin feet and may have been an incense burner.

Modeled Alligator Ware incense burner,
Ometepe Island, Nicaragua.

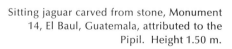

Sitting jaguar carved from stone, Monument
14, El Baul, Guatemala, attributed to the
Pipil. Height 1.50 m.

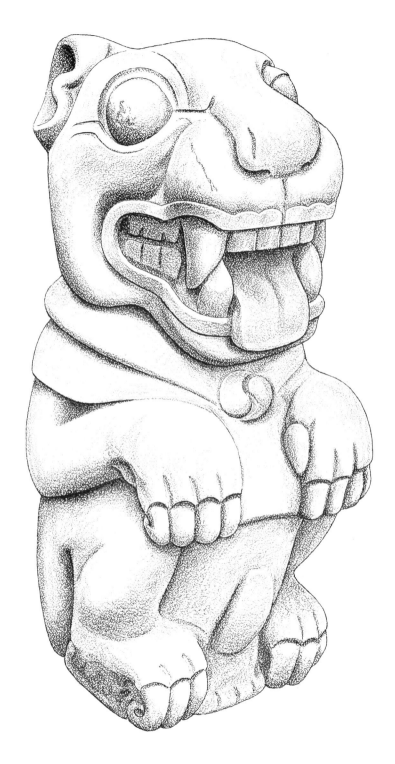

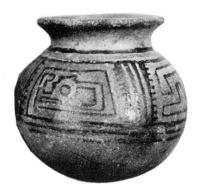

a

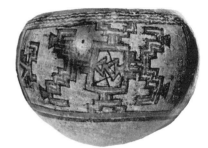

b

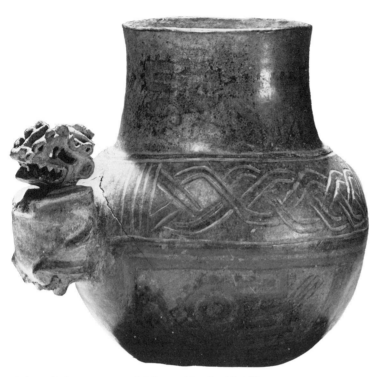

Galo Polychrome Ware finish combined with Alligator Type A motifs, Costa Rican style movable head, Guanacaste province, Costa Rica.

Nicoya Polychrome Ware vessels, Alligator Type A or Carrillo Polychrome, Early Polychrome B, Costa Rica. a. From La Fortuna. Height 9 cm. b. From Samara. Height 11.5 cm. c. From La Cueva. Height 30 cm.

c

147

Whistling type vessel, Nacascolo, province of Guanacaste, Costa Rica. The body is painted in dark and light red, green, and white with deer and human figures and rim and base bands of Feathered Serpent symbols on white stucco. It was found with an Ulua marble vessel, Alligator Type A or Carrillo Polychrome, Galo Polychrome, and other items of the Late Classic and Early Polychrome B periods from Upper and Lower Central America. Height 20 cm.

Human figure with animal alter ego, El Panama, province of Guanacaste, Costa Rica, now in Radio Fides, San Jose.

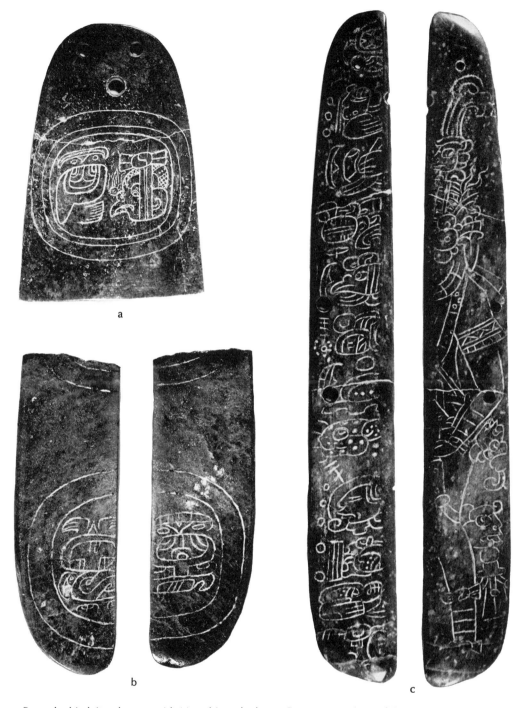

Reworked jadeite plaques, with Maya hieroglyphs. a. Bagaces, province of Guanacaste, Costa Rica. b. Taboga region, Guanacaste, Costa Rica. c. Split jadeite celt, Bagaces, Costa Rica, A.D. 300–500.

a

b

c

Stone effigy, probably Nicaragua. Height 61 cm.

Stone stela found with other stelae on Zapatera Island, Lake Nicaragua, Nicaragua. Height 1.207 m.

distinctive human figures and glyphlike motifs. Beyond Copan it is found at Tazumal in the Chalchuapa region and in central El Salvador, sites in former Maya territory taken over by Nahuat groups. Perhaps Copador Ware was the result of trade brought to El Salvador by the gradually conquering or infiltrating Nahuat from Copan.

Part of the Nahuatization of the Maya area may have received stimulus from the capital of Tajinized Teotihuacanos, the Cotzumalhuapa territory on the Pacific slopes of Guatemala. This area embraced a number of sites including El Baul and Bilbao; and during the period of its greatest development about A.D. 650–925, it included the San Juan and the contemporaneous Santa Lucia phases. Diagnostic of this period is San Juan Plumbate, a vitrified technically well-made ware with a uniform ferruginous paste. Cylindrical forms are common but basal molding on bowls and squat, collared jars decorated by incised designs, studs, and grooves occur on El Baul specimens. San Juan Plumbate Ware was traded to Kaminaljuyu, San Agustin Acasaguastlan, and Tajumulco in Guatemala, Tazumal in El Salvador, and south to Costa Rica.

Characteristic of the entire Cotzumalhuapa district are stelae, panels, and boulders carved with non-Maya hieroglyphs, speech-scrolls, ball game players in association with death manikins and human sacrifice, plus eagle-and-jaguar warriors, sky deities, and sun discs — all reflecting Teotihuacan and El Tajin cultures. Almost every god depicted is Mexican. The possible exception is the crab god. Although known in northern Veracruz, this deity is of great importance in southern Central America, particularly Panama, Pacific Costa Rica, and Pacific Nicaragua, places frequented by Mexican traders and colonizers from a very early period.

One result of the movement of peoples in the isthmian region, whether merchants or colonizers, was the appearance of objects made of copper and tumbaga (a copper-gold alloy) in Upper Central America. The art of working metal spread west from South America and reached Venado Beach, Panama, possibly around A.D. 250. Why it took five centuries for this art to arrive in Costa Rica, we cannot say. Once in Costa Rica, however, it was brought north, probably by Mexican peoples. The earliest-dated ornaments of gold or gold alloy which we have from Upper Central America are approximately A.D. 751, according to radiocarbon tests made in connection with three figures from Tazumal; their composition

suggests Costa Rica as their place of origin, although the style of one, a flying bird, is Quimbaya. The next dated metal object is a small pair of legs from a tumbaga figure found at Copan under Stela H which bears the inscription A.D. 782. Also Quimbaya in style, the analysis of the alloy indicates an origin in Panama or Costa Rica. Gold and copper pieces were generally scarce during the Late Classic Period in Upper Central America.

NORTHERN PENETRATION INTO LOWER CENTRAL AMERICA

Between A.D. 500 and 600 a change came over the entire Greater Nicoya archaeological subarea, much of it pointing to the upper isthmus. Communities on the Nicoya Peninsula increased in size. Salt water mollusks and maize became an integral part of the diet. Secondary and occasionally mass burials were placed in cemeteries and accompanied by pottery vessels, figurines, jades, and carved grinding stones, and some graves had stone coverings.

Although some Nicoya Polychrome Ware, called Type A, Alligator or Carrillo Polychrome, recalls Chiriqui Alligator motifs, most of the pottery reflects northern influence. Nandaime Ware in Nicaragua — specifically Tola Trichrome red slipped bowls, jars, and occasionally grater plates decorated with a wide black band around the rim with thin white linear designs on the band and vessel body, Urcuyo White-on-Red Ware which differs from Tola Trichrome in the absence of the band, Chavez White-on-Red, and Leon Punctate graters with mammiform legs reminiscent of forms connected with the Usulutan technique — has shapes and design motifs associated with the north, including symbols related to the monkey and the serpent. Modeled Alligator, mentioned previously, and Galo Polychrome Ware, prevalent at the end of the Early Polychrome and the start of the Middle Polychrome period (A.D. 800–1200), also suggest Upper Central America. Galo Polychrome Ware in particular seems to have been inspired by Ulua Polychrome in form, design, and glossy finish and could well be the product of Nahuat penetration by traders or even colonizers. Early Classic whistling-type vessels painted "al fresco," jadeite celts incised in Classic Maya motifs eventually reworked, marble vases from the Sula Plain in Honduras (one bearing vestiges of stucco overlay painted in red and green), ladle censers, and effigy-face pottery with a buff background also found their way south to the Nicoya Peninsula.

Located in the Greater Nicoya area is the largest group of

Stone stela, seated monkey on a stand, from Zapatera Island, Lake Nicaragua, Nicaragua. Height 1.4 m.

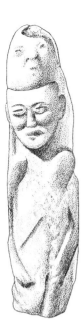

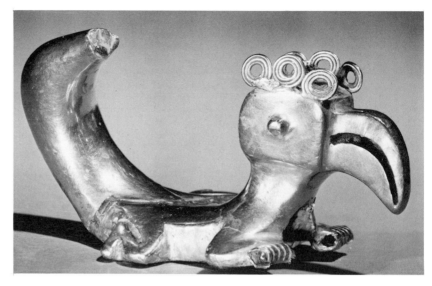

Cocle style gold curly-tail parrot, Guacimo, Linea Vieja. Costa Rica.

Stone stela, Momotombita Island, Lake Managua, Nicaragua. Height 133.20 cm.

Winged pendant in agate, Guacimo, Linea Vieja, Costa Rica. Length ca. 18 cm.

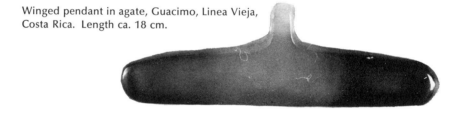

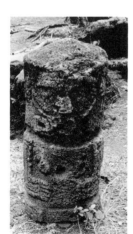

Chontales style monolithic figures from the base of Cordillera Amerrisque, department of Chontales, Nicaragua. They are now in Juigalpa, Nicaragua. 3.33 m high.

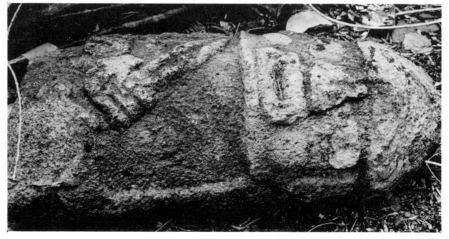

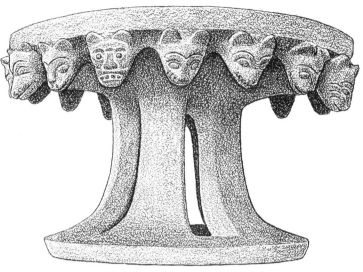

Effigy vessel, incised and negative painted (resist dye), Guapiles, Costa Rica. Width 17 cm, length 25 cm, height 17 cm.

Large offering table or grinding stone, Linea Vieja, Costa Rica.

Chontales style monolithic figure from El Salto at the base of the Cordillera Amerrisque, Nicaragua. Height 3.33 m.

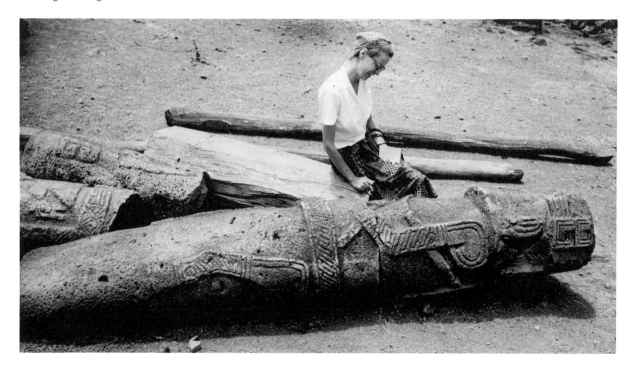

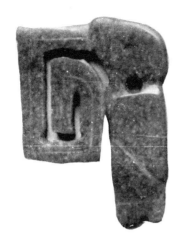

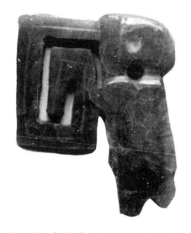

Jadeite beak-birds, Guacimo, Linea Vieja, Costa Rica, Early Period B phase. Height of larger 5.75 cm.

monumental sculptures in Lower Central America. Modeled Alligator Ware in a rock mound associated with two of these statues offers a clue to dating. Occasionally they represent animals but more often they depict realistic nude males. The "alter ego" or "second self," the guardian animal which supposedly forms part of each individual, is shown as a headdress or clinging to the back. Some figures have the appendage or mask of an aquatic bird and may reflect the ancient religious tradition of a bird-man, an Olmec concept absorbed by the Nahuat, who associated the idea with certain representations of Quetzalcoatl. The sculptures are carved either in the round or in high relief and rest on a column or pedestal base. Such statues are known from Momotombito Island in Lake Managua to Nacascolo on the Nicoya Peninsula, Costa Rica, but are particularly associated with Zapatera, Ometepe, and Pensacola Islands in Lake Nicaragua and the vicinity of Norome by the Lagoon of Apoyo, Nicaragua.

A second group of stone sculptures is limited to Nicaragua, especially the northern side of Lake Nicaragua in the department of Chontales. Many of these very stylized figures of human beings, both male and female, hold a scepter or spear on the torso with both hands and are carved in low relief around a column. Generally the legs are flexed and have geometric markings reminiscent of alligator or serpent symbols, designs that are sometimes also on the arms. A necklace or pendant decorates the neck and frequently a woven belt is indicated. The headdress is formed by a coronet or band with or without a miniature "alter ego" animal. These figures have been compared with sculptures from the Callejon de Huailas, Peru, and the province of Cocle, Panama, but they also show northern influence despite the southern appearance of some of the ornaments carved in low relief.

In the Central Plateau of Costa Rica, burials were placed directly in the earth along with grave furniture. The typical ware of this period is called Curridabat and is divided into two types. Type A consists of globular jars with a recurved rim and thickish lip and an encircling ridge at the shoulder. They are found with and without a low annular base and occasionally with short or conical tripod legs. There are also tripod broad bowls decorated with appliqué, modeling, incising, and paint. Designs generally show the alligator and are southern in character, associated with western

South America. Type B lacks the encircling ridge but the globular jars and bowls with annular base or tripod conical legs are similar to Type A. Painted motifs occur in vertical lines sometimes suggesting animals. Interior patterns recall negative painting.

On the Atlantic watershed, Middle Period A phase lasts from approximately A.D. 400 to 850 and is based on excavations in the Reventazon Valley. There was an increase in population and people lived in cane and pole houses built on low artificial mounds of earth and rock. They used heavy thick-walled jars, probably for making chicha, constricted neck jars, and bowls with a composite silhouette, or shallow bowls with outflaring sides. Some small openmouthed vessels had loop handles, and many were adorned with abstract and zoomorphic appliquéd figures. Anthropomorphic decoration appeared for the first time — a personalized animal or combination of human being and animal.

Innovations in ritual customs occurred. Incense burners and vessels with hollow legs containing rattles, a feature common in the north and associated with the cult of the rain god, are now present, as are large offering tables with human heads carved in bas-relief on the rim indicating the trophy-head cult.

Probable trade relations with Early Period Cocle in Panama are suggested by luxury or cult items such as winged pendants of agate and other stones, seashell beads, and curly-tailed animals of gold, a form copied in jadeite in the Linea Vieja area. The winged pendant and seashell beads are associated also with the Tairona, a people — possibly Arawak — of Santa Marta, Colombia. Other objects indicate influence from or trade with this South American culture and that of Linea Vieja — clay nasal snuffers probably for inhaling the drug *cojoba* or tobacco, jadeite frogs carved in a flat stylized manner, beak birds, anthropomorphic jadeite figures, and flat buttons of the same material. This last type of ornament is also known on the Nicoya Peninsula.

In the Diquis region of southern Costa Rica, Cocle pottery fragments from the Early Period and Middle Polychrome types of Nicoya Polychrome Ware indicate trade with Panama and the Greater Nicoya area respectively. Some unpainted and Brown Ware tall tripod vessels continued in vogue until the time of the Conquest and have been found with millefiore beads and iron articles representing Spanish trade pieces.

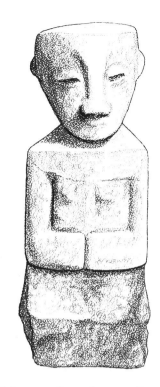

Villalba stone figure, human effigy with long tenon buried in cement. Height 58 cm.

SITIO CONTE, PANAMA

The Burica phase continued in Panama during this period. Secondary urn burials were common. There were contacts between the people responsible for this phase of Burica culture and those of Early Sitio Conte (Cocle), Parita Bay, or the Azuero Peninsula and Venado Beach. At a site on the Isla Villalba or Isla Muertos in the Gulf of Chiriqui, stone pillars ornamented on top by a small human or animal figure probably date from this time and may be related to pillars from Rio Caño, Cocle province, which are discussed later. They reflect a northern Preclassic tradition and hint of a cultural intrusion from Upper Central America.

Around Parita Bay a change in living patterns is suggested by the use of circular and rectangular earth mounds to support dwellings and to receive burials. The source of these innovations is not known. The burial practice, however, indicates a beginning of some kind of ritual.

The ceremonial character of Sitio Conte at this time is apparent in lines of crude stone columns, some six feet (2 m) high, in association with "altars" made of flat-topped boulders. One row extends from east to west and the other curves diagonally away from it. The "altars" face one another to the north and south of the columns. Sitio Conte differs fundamentally from the ceremonial centers of Upper Central America. Stone masonry was not used, only perishable materials such as wood or cane, with perhaps some adobe. It may have been a seasonal or summer settlement for ranking chieftains and their entourage, as the area is often flooded during the winter rains. Pottery types found in association with the columns date to the Early Classic Period in the upper isthmus.

The neighboring sites with stone columns, Sitio Hector Conte and Rio Caño, are contemporaneous with Sitio Conte. Rio Caño, however, has more artistically developed "altars" and megalithic pillars. Many columns are topped with figures of animals and men similar to figures at Villalba in the Burica culture area. They are reminiscent of Middle Preclassic shaft figures found near Tres Zapotes and Tonala, Mexico, western El Salvador, the Guatemalan highlands, and western Honduras. They may represent a northern vestigial trait that stopped with plain columns and "altars" at Sitio Conte. This impression of a northern source for such a cult is reinforced by a second style of column, probably later at Rio

Caño, associated with the end of the early phase, A.D. 800 or later.

The site was seemingly centered on the chieftains of a particular group. Burials of the Early Sitio Conte period emphasize its ceremonial importance. There are small, intermediate, and large size graves. The most impressive are large ones containing three or more bodies. These graves were about ten feet (3 m) deep, oriented toward the cardinal points, and had rounded corners. An incense burner, squared mirrors (in the earliest), and other grave furnishings were laid between a double floor in some of the large graves. Often sand was sprinkled on the floor. Stone slabs, which must have been hauled over water to the site usually show signs that they were cracked by fire, suggesting that they had been used during the process of desiccation to support the body before it

Gold Crocodile pendant with bifurcated tail, and other gold objects from Sitio Conte, Cocle, Panama. Length of crocodile 10.4 cm.

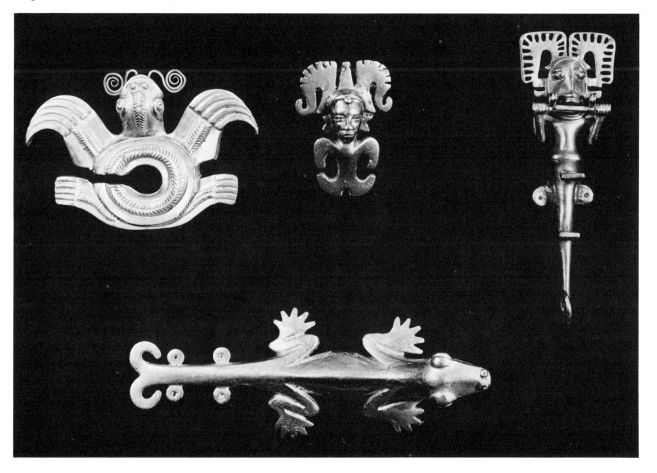

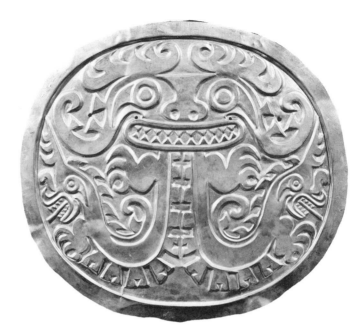

Gold disc or paten showing the Crocodile god, Cocle culture, Sitio Conte, Panama. Width 30 cm.

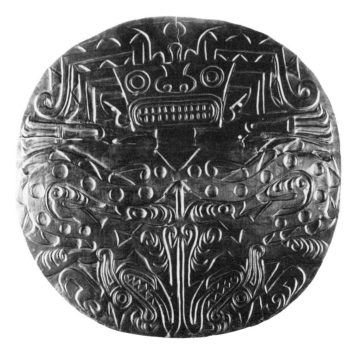

Gold disc representing the Crocodile god, Sitio Conte, Cocle, Panama. Diameter 26.3 cm.

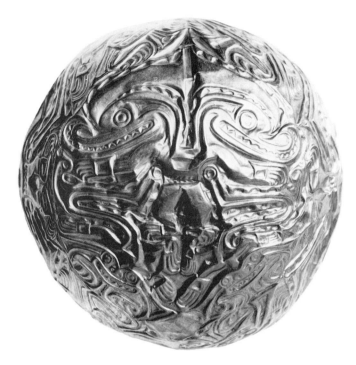

Gold helmet, Sitio Conte, Cocle, Panama.

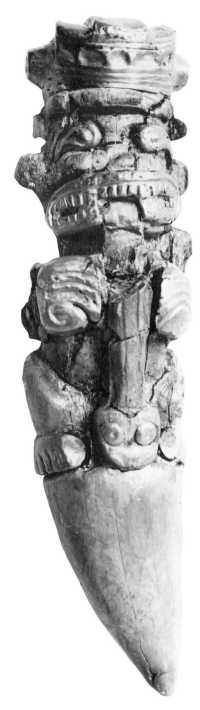

Andean motif of serpent emerging from the mouth of an anthropomorphic figure (Crocodile god) in gold over whale's tooth, Cocle culture, Sitio Conte, Panama. Height 16.5 cm.

was placed in the earth. The floor of the grave was then lined with cotton textiles or bark cloth on which the bodies were laid. Sometimes the principal personage was seated on a stool and protected by a shelter. Wives and servants were often buried with the chief in extended or unnatural positions as if forced to die in homage. Pottery, gold, agate, and serpentine jewelry formed part of the offerings. The sacred nature of Sitio Conte and a long dynasty of rulers there are also indicated by the destruction of older burials to make place for new ones and the transfer of furnishings from one grave to another. At times fires were made to destroy the objects.

Caches in pits contained piles of stone of unknown use, stone concretions probably for ceremonial use, pottery, stone tools, stone jewelry, or objects such as crystals and fossil shark teeth.

Sitio Conte has a well-deserved fame as a center for craftsmanship in gold, pure or alloyed with other metals, and precious

stones, for example, emeralds. Many techniques were used — casting over a clay and charcoal core with open back or hollow in the round, hammering, soldering, and welding. When copper was employed as an alloy, *mise-en-couleur* gilding, the process of bringing a golden hue to the surface by means of an acid, was used.

Special treasures from Cocle are gold bottles; earspools; lattice-type nose clips; pendants resembling curly-tailed animals; gold settings for emeralds, quartz, and carved whale's tooth ivory; filigree ornaments first built of wax threads and then cast; greaves; helmets; arm bands; beads; and N-shaped incisor teeth in gold. The teeth reflect the Andean art style of carving N-shaped incisors on stone statues. Peculiar to Cocle artisans were the use of sheet gold overlays on bone, stone, and probably wood; hollow figures cast in the round instead of with open backs; and resin-filled figures. This mastery in making ornamental artifacts continued with slight changes in style throughout the duration of Sitio Conte culture.

The ceramics of Early Sitio Conte included spouted effigy vessels; slightly curved plates and carafes, either angular or globular with tall flaring necks; and other forms. Patterns in parallel lines, face scrolls, curvilinear designs, zoomorphic motifs such as plumed serpents in fringed style, combinations of crocodile-headed birds, and turtle patterns are among the painted decorations. The face scrolls, parallel lines, and curvilinear designs recall the art of Marajo at the mouth of the Amazon River. All of these decorative elements, except the flat areas of color outlined in black, suggest South America. A white slip painted with green, purple, brown, black, and light and dark red was common; the vessel was then finished with a glossy resin varnish.

The same general style of pottery painting associated with Sitio Conte occurred also in the Alvina phase in the Parita Bay region. This ceramic group consists of Red, Plain, and Black-on-White painted wares with strap or loop handles. It has been suggested that the Alvina culture was a rural nucleus of Sitio Conte, perhaps in connection with sea fishing.

Venado Beach on the Pacific side of the Canal Zone also shows the florescence of Early Sitio Conte. Pottery found at this site included vessels belonging to the Early Period of Cocle along with some from the previous phase of Santa Maria. The latter is

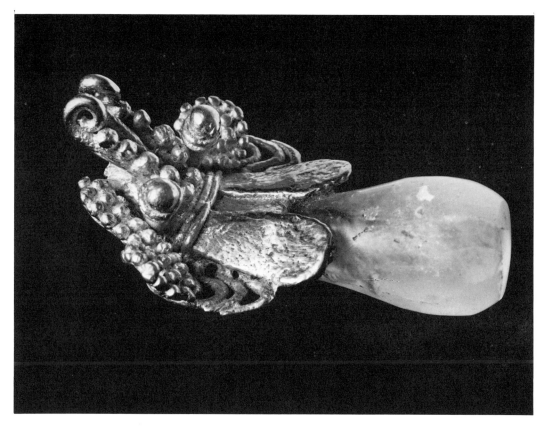

Gold pendant with a droplet of quartz, in the shape of an insect, Sitio Conte, Panama. Length 4.78 cm.

particularly associated with the Giron site and Escota styles of the Parita Bay region. Not much is known about Venado Beach people, but culturally they were advanced, especially in metal work. The change from single line designs to full polychrome is noticeable at Venado Beach, indicating the cultural dominance of Cocle during most of the Early Period.

Toward the end of the phase, however, something occurred which cannot be fully explained. There seems to have been a cultural decline. Graves at Sitio Conte were dug for one or two bodies and the furnishings were scant. Although ceramic styles persisted with almost no change until the close of the era, the start of Late Period characteristics is evident. Some economic pressure may have taken place either through tribal disturbances from without as a result of migrations, or through internal rebellion and disease.

SUMMARY OF THE CLASSIC WORLD

In Upper Central America, the Classic Period marked the Nahuatization of Maya culture and the dominance of Teotihuacan religious ideas. During this period the disintegration of urban ceremonial centers began in the north and ceremonial sites were started in the south. Foreign elements were present in both cultural spheres. In Upper Central America increasing militarism and the presence of foreign military groups led to a waning of religious activities on the part of the old priestly and ruling class. Outside pressures were felt at the ceremonial centers and there was a weakening of the "national" elite. There was a trend to abandon valley sites and move to hilltops that could be protected more easily. A cultural breakdown took place over the whole area.

In Lower Central America, where seasonal communities were common, settlements were temporarily deserted. Permanent construction of masonry was lacking. More than this, the Amazonian cultural background which these people inherited did not lend itself to a "ceremonial center" concept. Instead, there appears to have been a personalized religion, a chieftain cult that involved the tattooing and painting of a person's body with the leader's symbol. This custom was copied by northern immigrants in the Postclassic Period.

There were no large territories of tribal or national influence such as in the lowland and highland Maya regions or as among the later Nahuat groups. There were zones of influence in the south as reflected, for instance, at Cocle, which culturally extended into the Azuero Peninsula and Venado Beach. Local contacts farther west are only manifested through trade wares. Actual penetration from the north into eastern Central America, however, is suggested by the carved pillars of Villalba and the province of Cocle. Here at Sitio Conte it is possible that the idea of a ceremonial center came from the upper isthmus region. Disturbances caused by such intrusions may well have been responsible for the cultural decline at Sitio Conte.

4

Empire and Trade

THE IMPRINT OF THE NORTH

By Postclassic times (A.D. 900), Upper Central America and much of the lower portion had a slight veneer of Mexican culture manifested chiefly in religious concepts. The steady infiltration of peoples from the north many of whom were not content to live under the dominance of the historical Olmecs was in part responsible. But there were other changes in the Valley of Mexico which had their effect on and aided what might be termed the Mexicanization of the isthmian region as far east as the Greater Nicoya territory. They were reflected to a degree even in some cultures of western Panama. After 1100 Central Mexico was again to produce change in all of Upper and in western Lower Central America although in part this transformation was due to the reappearance of peoples of Nahuat culture from the isthmian region.

After the abandonment of Teotihuacan, if not somewhat earlier, Chichimec tribes invaded the Mexican plateau from the extreme northwest. A branch of these, the Toltec-Chichimec governed by warrior-priests, became discontented. Ce Acatl Topiltzin, the posthumous son of one of the most aggressive warrior-priests, left the plateau of Mexico with his followers and settled in the present state of Hidalgo, making Tula his capital. Here he was joined by a Nahuat-Pipil group, the "Nonoalca," a name applied to those who returned from the south. It is logical to assume that not everyone would be satisfied in a new environment, and a reverse migration of the Nahuat-Pipil cannot be considered unique. Some authorities believe that the presence of the Esquintla Pipil in Guatemala was the result of another group which returned from farther south. The newly arrived "Nonoalca" brought to Tula a heritage reflecting Teotihuacan combined with Tajin and the best qualities of Central American culture.

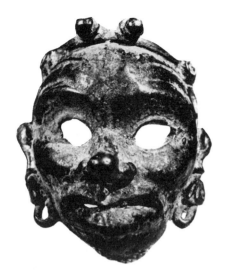

Copper mask or bell, San Mateo Ixtahua-
can, Huehuetenango, Guatemala, early
Postclassic. Height 4.6 cm.

Mold for front of pottery figurine, western El Salvador, very
late Classic or early Postclassic. Height 14.2 cm.

During their tenure in the Mexican plateau the Chichimec, mili-
tant in character, had absorbed to a certain degree some Nahuat
traits. Quetzalcoatl, the plumed serpent deity who probably orig-
inated on the eastern Gulf coast of Mexico, had long been incorpo-
rated by Nahuat-Pipil into their pantheon. The Chichimec ruler in
Tula made his tribal deity Tezcatlipoca, Smoking Mirror, subject
to the Feathered Snake, and he also took the name of Quetzalcoatl
as a title.

The arrival of the Nonoalca brought new life to Tula. Familiar
with the Gulf coast and the south, they were experts in carving jade
and working metal. These skills were responsible for the belief
that the Toltec of Tula were the first Mexican metallurgists.

Even the inherent characteristic Nahuat trait of religious devotion
had been strengthened by their journeys abroad. The Nahuat be-
came acquainted with several southern ideas — the crested alliga-
tor, a fertility and water deity brought west to Panama and Costa

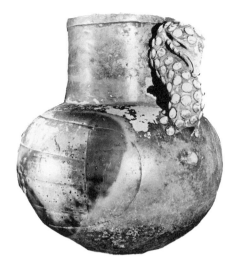

Turkey effigy Tohil Plumbate jar, El Salvador, early Postclassic. Height 23.4 cm, rim diameter 11.7 cm.

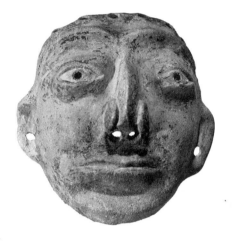

Clay mask with inset obsidian disc pupils, Siete Principes, El Congo area, department of Santa Ana, El Salvador, early Postclassic? Possibly originally slipped dark orange to brown. Height 11.5 cm, width 11.5 cm.

Rica from the Amazon-Orinoco basin, possibly by Arawak but certainly by Chibchan-speaking tribes; the large-beaked bird of the Arawak considered responsible for the creation of mankind; and the jaguar and snake gods of the tropical rain forests. These were concepts easy to accept and to blend into that great giver of essentials to man, the Feathered Serpent, Quetzalcoatl. Those essentials included in part the sun, the planet Venus, water, wind, and fertility, a juxtaposition of the vital things necessary for a good life. This mixture or conglomeration of ideas from the south with those of the north was the theological contribution of the returning Nahuat-Pipil to the Toltec-Chichimec and strengthened the multiple personalities already embodied in the Quetzal Snake. Southern crocodile, serpent, and bird images all were transformed into the plumed deity. Even Tlaloc, the rain god of the Mexican Gulf coast, blended into the multiple concept and took a secondary place at the Feathered Serpent's side. Tlaloc's roots reached into the Preclassic era and he was worshiped by the earliest Nahuat migrants.

And so Tula grew and flourished, a sacred shrine to the Bird-Snake, Quetzalcoatl. "Those who returned" carried north knowledge for making fine jewelry of greenstone, alabaster, gold, and copper, as well as religious concepts to whet the theologians' demand for cult images with emphasis on the Plumed One.

But inquietude and unrest rocked the shrines of Quetzalcoatl. The ancient Cholula, long a sacred stronghold of the omnipotent

deity, became a center of political tyranny against its neighbors. A 26-year drought combined with human elements caused other unhappy Nahuat-Pipil to push south; these were the Nicarao. They entered Central America through Chiapas where, it is said, one of their wise men foretold that they should travel until they found a site by a fresh water sea near an island containing two tall round mountains. The Nicarao spread over much of Guatemala and El Salvador and wedged their way into territory occupied by Xinca and southern Maya Pokomam and Mam. Some remained in already established colonies of Pipil; others formed new settlements such as Mita by Lake Guija. The main group, however, continued its journey south and east, stopping temporarily on the Pacific coast of Honduras where the last of their wise men died. His death only urged them forward more determinedly.

Around the time of Nicarao penetration into northern Central America, Tula started to decline. No place could grow so quickly, reach such importance, and not fall. Ce Acatl Topiltzin, he who had been so loved and respected, was blamed for degeneracy, incest, and drunkenness; any number of unpleasant grievances were remembered. No one is certain as to the exact events. Perhaps the old gods or the tribal ones of the Chichimec were jealous, but Tula fell; people left, and the elite, the priest-rulers, went south. They moved into Yucatan and around A.D. 999 apparently merged with the Putun Itza. Often called Chontal Maya, the Putun Itza were strongly Mexicanized and as early as 918 had established themselves in decadent Chichen Itza, in part rebuilding it.

Tula-Toltec presence at Chichen Itza is known through bas-relief figures on pilasters and painted figures on temple wall frescoes. The Toltec — with his mosaic crownlike headdress and breast ornament, a back shield around his waist, a bag in his left hand and a spear-thrower in his right — appeared in Yucatan, the militant missionary who spread Quetzalcoatl's fame.

The Toltec also penetrated Guatemala, some entering from highland Chiapas and others traversing the Usumacinta Valley, forcing their way not only into Mam and Pokomam regions but also into lands of the Kekchi, Pokonchi, Chol, and Chorti Maya. They were known as "Yaque" or "Yaqui," the emigrants. This name appears in the *Popul Vuh*, the sacred history of the Quiche Maya, and in fact, the Toltec were responsible for the present day Maya Quiche, Cakchiquel, and Zutuhil tribes.

With the Toltec came a new way of life and varied religious cults.

A cultural degeneration took place and it mattered little that metal craftsmanship was introduced into Upper Central America to fashion not only jewelry but also weapons, fish hooks, and other tools. Although some of the older settlements remained occupied, they were usually fortified. Bows, quantities of obsidian and chert points used as darts or arrows, clay vessels filled with wasps and hornets were weapons unknown until this period, and hilltop towns with military outposts reflected increased preoccupation with warfare.

Places of worship and ritual continued to be built, but they were Mexican in character. The ball court was occasionally open-ended but more often was enclosed by sinking the field into the earth. There were drains for water and at either end rose high walls and stairs. Almost vertical playing walls had vertical moldings on top. Mexican influence in architecture occurred in round temples and rectangular piers, masonry colonnades added to structures, and painting on stucco of the interior and exterior of buildings in red, green, yellow, blue, black, and gray.

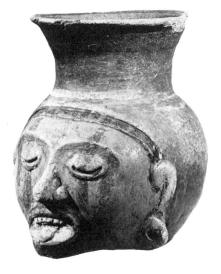

Effigy face jar, San Mateo Ixtahuacan, Huehuetenango, Guatemala, early Postclassic. Height 18.5 cm.

Northern innovations included arrow sacrifice of prisoners and cults of the war and sky gods. Idols of clay often made in molds, wood, and stone were offered incense, food, hearts, and blood. Incense was presented in tripod censers similar to those from the Mixteca-Puebla region, in covered ones with perforated bottoms, or in ladle-handled burners. But also part of the introduced rituals were phallic symbols and a renewal of the trophy-head cult, concepts probably brought by "those who returned" from Lower Central America.

Stone cist burials had flat stone or wooden roofs and depending on the area were with or without doors of large stone slabs. This type of interment was prevalent in the highland Maya region, while graves in dirt or under mounds were common in the lowlands; all had meager furnishings. At the end of the Early Postclassic, cremation appeared. The ashes were placed in jars with small objects such as bells and ornaments that could fit into the vessels.

Diagnostic of the era and the general cultural decadence was the popularity of "foreign" pottery. The exception to this was Tohil Plumbate Ware; made in the Guatemalan highlands, it was widely traded north to Yucatan and south to Panama. Like San Juan Plumbate in texture, it has a wider variety of shapes and decorative motifs. Forms include jars, pedestal-base and tripod vessels, cylindrical and barrel-shaped vases, and bowls decorated by incising, grooves, gadroons, and geometrical and curvilinear designs. Effigy

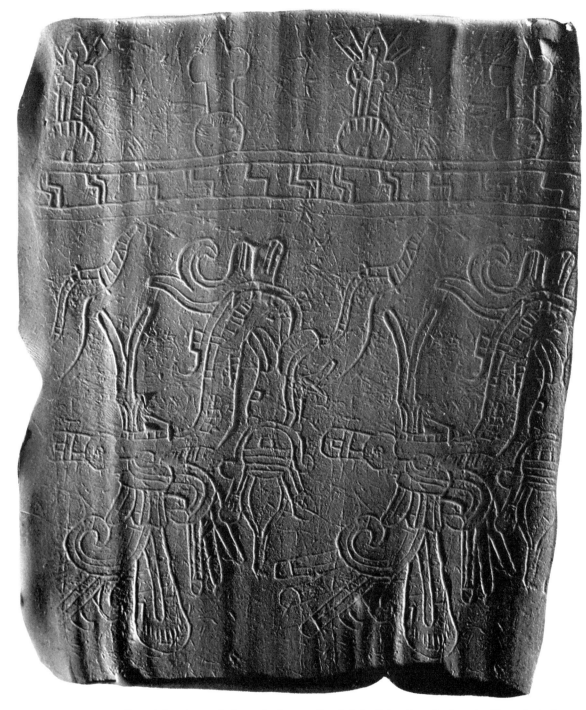

Carved deer bone photographed as a roll-out, Lake Peten Itza, Guatemala. The principal motif is a sky-serpent with a Mixtec star symbol on his back. Height of bone ca. 16 cm. Interpretation of Mixtec motif, Tatiana Proskouriakoff.

vessels are abundant. They represent zoomorphic and anthropomorphic figures as well as numerous Mexican deities, suggesting that Tohil Plumbate was the product of a non-Maya people.

X Fine Orange Ware, manufactured on the Mexican Gulf coast in Veracruz and Tabasco, shares the forms and designs of Tohil Plumbate, and although distributed over much of Upper Central America, only one sherd is known from Costa Rica at El Viejo, Guanacaste. Mixtec-Puebla-type tripod censers, with an elongated leg handle, and effigy-head tripods are also northern. These coveted objects probably reached the isthmian region by trade and were considered luxury goods in an otherwise meager culture.

But not all imported wares came from the north during this period. Certain types of Nicoya polychrome pottery came from the Greater Nicoya territory to Upper Central America, such as tripod effigy vessels and jicara- or gourd-shaped jars supported by a ring base. The resemblance between effigy jars of Nicoya Polychrome Ware and Plumbate has been noted by scholars. It is possible that the modeled effigy of the Nicoya polychrome vessels was adopted by the northern Chorotega-Mangue from their aboriginal Central American neighbors. Short-necked globular vessels, usually with modeled animal heads, were painted in red, black, and orange on a white background with symbols suggestive of Mexico. Found in El Salvador and Honduras, they are known as Las Vegas Polychrome Ware. Along with Tohil Plumbate, this ware forms part of the Rio Blanco complex recently discovered at Los Naranjos, Lake Yojoa. Las Vegas Polychrome and some of the tripod effigy vases may be the product of the latest Pipil group to arrive in the isthmian area, the Nicarao, who undoubtedly passed through much of this territory on their way south.

The Toltec remained, not only in Guatemala. Possibly these people entered northwestern Honduras. Near the present Puerto Cortes the fortress site of Tulian, at the edge of the Sula Plain, could have controlled the valley and served as a sentinel against approach from the sea. Tenampua, the practically unconquerable hilltop on the eastern side of the Comayagua Valley, and the Lenca site of Corquin in the present department of Lempira are two examples of the many evidences of outside pressures around this time. Certainly the Toltec trait of Chac Mool and Tohil Plumbate reached as far as Costa Rica. Chac Mools, the belly-indented sacrificial stone figures, are human and jaguar in Mexico and parts of

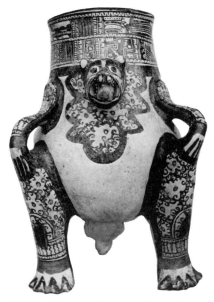

Modeled jaguar effigy tripod vessel, Nicoya, province of Guanacaste, Costa Rica, Middle Polychrome period. Height 40.5 cm.

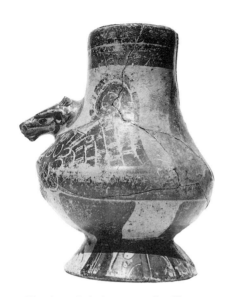

Ring-base Polychrome eagle effigy vessel gourd-shaped from Pacific Nicaragua, Middle Polychrome period.

Central America, but bird and jaguar in the south, another instance of cultural fusion. Tohil Plumbate, with its emphasis on religious themes, reached western Panama, and with it always was the hope, the dream, that Quetzalcoatl, the bird-snake god, would return and Tula and its people would triumph once more.

Perhaps pressure from the Toltec caused the eastern push of the Nicarao. At any rate, they moved into the territory of the Maribio and then went north to Desaguadero, the start of the San Juan River. Here they traveled through lands belonging to the Voto and Suerre, a Talamancan group, and reached the Caribbean Sea. The observations of the chroniclers indicate that some of the Nicarao journeyed to the southern continent. For instance, they were the only people in the isthmian region to cultivate a cactus called *dactos* (*Lemaireocereus griseus* [Haworth] Britton and Rose), which grew wild in Venezuela and Peru. The Nicarao, like the inhabitants of Veraguas, Panama, raised coca, a plant also grown in Venezuela and Peru.

But like other groups, not all the Nicarao were content, and remembering the old prophecy, some returned to Nicaragua to search for the mystical isle on the fresh water sea. These voyagers passed through Chorotega-Mangue territory, where they were not well received, and pushed on to lands of the Maribio. Continual wars with their "Chontal" neighbors caused them to move east once more toward the end of this period. The ambiguous term "Chontales" is a corruption of the Nahuatl word meaning "strangers"; they were probably Matagalpa or Ulva and perhaps Lenca in the west.

The Nicarao invaded the land of the Chorotega-Mangue in the Isthmus of Rivas. Here they decided to remain because the landscape corresponded to their old prophecy and they could see the island Ometepe with its two tall cones. When the Nicarao saw that their "hosts" tired of their presence, it did not worry them, because had not the ancient prophecy indicated that this land was theirs by right? They took recourse in a trick. Asking for porters to carry their belongings to another site, they moved a short distance and during the night slaughtered the helpers. Then they returned immediately to the village where they liquidated the rest of the Chorotega-Mangue who dwelt there. Thus began a war which ended around A.D. 1200 with the establishment of the Nicarao on the Isthmus of Rivas from Granada and Ometepe Island, Nicaragua,

to Cape Santa Elena and Bagaces; they also occupied a wedge of land along the Tempisque River to the Gulf of Nicoya, Costa Rica. The Chorotega-Mangue kept the rest of the islands in Lake Nicaragua and its northern shore, as well as Masaya and Nindiri in the south and Orosi and Nicoya in Costa Rica.

The Corobici, of Chibchan tongue, inhabited the Nicoya Peninsula and many of the Nicaraguan islands, including the bordering lands to the east and the Pacific or Rivas side of Lake Nicaragua, before the advent of the Chorotega-Mangue. They now retained only a narrow strip along the eastern bank of the Tempisque Basin over to the Volcanic Range where they met the Voto, also of southern extraction.

It was not only land that the Nicarao possessed, but also cacao trees, a cultivation they probably brought from the upper isthmus. Not all the other tribes of Lower Central America were ignorant

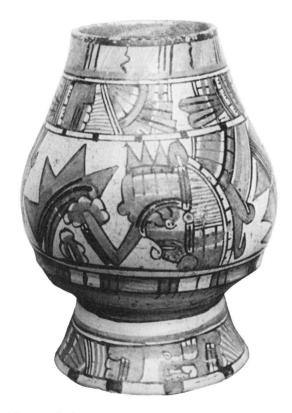

Nicoya Polychrome Ware, Papagayao style, with hooked nose Quetzalcoatl-Ehecatl representations from Nicoya, province of Guanacaste, Costa Rica, Middle Polychrome period.

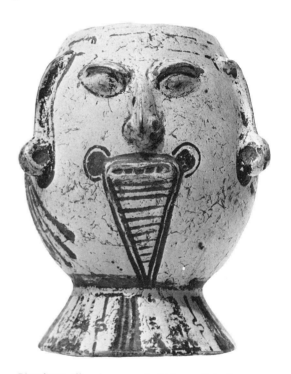

Ring-base effigy face vessel of Nicoya Polychrome Ware, Santa Elena, Ometepe Island, Nicaragua, decorated with a Silhouette Jaguar pattern and Feathered Serpent motifs, Middle Polychrome period. Height 30 cm.

171

of this tree, which originated in the Amazon-Orinoco area; they had cacao but did not cultivate it as did the Mexican people. Instead, the fruit was esteemed for religious purposes, not as a medium of currency or as a sign of wealth and nobility. The Nicarao irrigated their plantations and shaded the cacao trees with *Madera Negra* (*Gliricidia maculata* H. B. & K.), pruning it to grow straight and tall. The Chorotega-Mangue had a monopoly on nispero, a fruit native to tropical America; although it grew wild in Panama and Venezuela, it was cultivated in Tehuantepec and parts of eastern Mexico.

Both the Nicarao and the Chorotega-Mangue had towns with plazas, market places, and mounds used as a base for the chieftain's house and for religious purposes. Although the Maribio built mounds, they lacked the other features.

Pottery wares testify most strongly, perhaps, to the arrival of Nahuat-Pipil in this area. A style of Nicoya Polychrome Ware called Papagayo Polychrome is painted with representations of Quetzalcoatl-Ehecatl, with his prominent hooked nose. Mora Polychrome, or Geometric Nicoya Polychrome Ware, bears symbolism associated with the Feathered Serpent in Mesoamerica — the kan cross and the checkerboard motif. This pottery is confined to the years 800 to 1200 and it helps to orient the sequence of events described above. Some students think that the Nicarao appeared in Nicaragua at the beginning of the 15th century. Monochrome modeled figures on vessels are southern in origin. During this period negative painted vessels, also southern, appear on the Atlantic watershed and in the Diquis region of Costa Rica. Polychrome pottery figurines in the Greater Nicoya area show influences from both north and south, although the south predominates.

This fusion of cultures, often with indications of local development, is also evident in other pottery styles. Wares with engraved and incised lines (Maroon, Chocolate, and Red) are seen in Guanacaste and the Atlantic watershed of Costa Rica. Their presence in the latter region at this time is based on five radiocarbon dates ranging from A.D. 917±240 to A.D. 1237±210. In addition to the last date only one other is later than A.D. 1000 and that is A.D. 1007±430. The design elements depict the Plumed Serpent or the Crested Alligator which by now have the same interpretation. Chocolate Ware vessels in particular sometimes have articulated modeled heads of birds, animals, or men as decoration. The heads

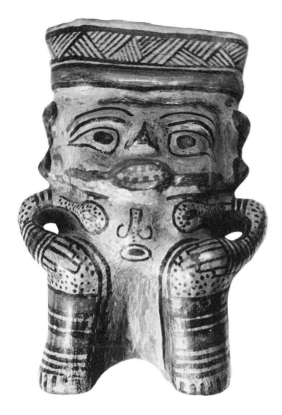

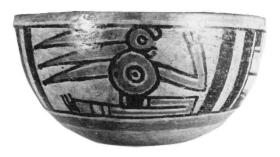

Mora Polychrome style of Nicoya Polychrome Ware from the Meseta Central, Costa Rica, contemporaneous with the Middle Polychrome period.

Nicoya Polychrome Ware figurine, Alta Gracia, Ometepe Island, Lake Nicaragua, Nicaragua, Middle Polychrome period. Note the serpent heads emerging from each shoulder toward the breast and the basket-weave design of the headdress which is associated with the serpent. Height 19 cm.

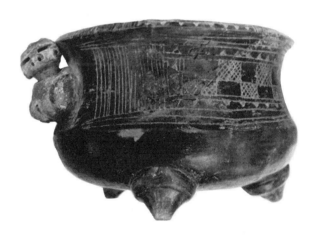

Chocolate Ware vessel with articulated effigy head, province of Guanacaste, Costa Rica, Middle Polychrome period. Height 14 cm.

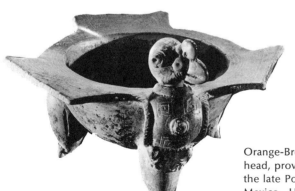

Orange-Brown Ware vessel with articulated effigy bird head, province of Guanacaste. This type was copied in the late Postclassic on the Isla de Sacrificios, Veracruz, Mexico. Height from bird's head to foot of vessel 9.1 cm, diameter 10.5 cm.

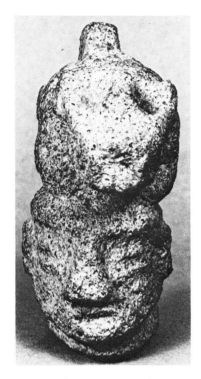

Stone effigy head with alter ego animal from slopes of Irazu volcano, Costa Rica. Height 7.75 cm.

are often set in a socket, an independent Costa Rican invention. In the late Postclassic this idea was copied on ritual vessels for a shrine dedicated to Quetzalcoatl at Isla de Sacrificios, Veracruz, Mexico.

SOUTH AMERICAN INFLUENCES

During Middle Period B, A.D. 850–1400, the Atlantic watershed abounded in large ceremonial and burial sites but had smaller habitation areas. Earth-and-stone-filled mounds, some encircled by stone retaining walls, stone walkways, stone house rings, and semicircles for rituals, culturally relate to northern South America, partly to Tairona and partly to Chibcha.

Burials in stone cist graves predominated during this period in the Atlantic watershed and southeastern Costa Rica. They are also of southern derivation and they were common around 500 B.C. at San Agustin, Colombia, and around A.D. 500 in Chiriqui, Panama. Some of the Costa Rican graves had giant stone slabs with personalized animal figures carved in the round, which represent the guardians or *naguals* of the group. The slabs were used as covers for secondary burials, presumably of matrilineal clan members, a feature in Costa Rica characteristic of the Atlantic watershed.

A curious regional style of sculpture known as Capellades was blocklike, had a tendency to realism, and was limited to a site of the same name in the Reventazon Valley. Common to all the Atlantic watershed, however, and indicative of the increasing demand for objects dedicated to religious ritual, were stone heads carved in the round, offering tables, and oversized grinding stones that often bore a flying panel representing animals or birds. The rims of these last two types of artifacts were sculptured with stylized human or animal effigy heads. These formed part of the trophy-head cult derived in this region from the south. Typical also were men, nude or wearing belts, many carrying a trophy head and a battle axe, and unclothed female figures holding their breasts or with hands resting on the abdomen. Others clutch a long plait of their own hair or have both a bird and a vessel or rattles (*maracas*) in the hands carved in the round from stone. Figures of sitting medicine men (*sukias*) in stone or clay, knees doubled up and held together by the hands or holding a flute or pipe in the mouth, have a stylized spinal column. They may have influenced the concept appearing later in the images of the Aztec god of song and dance.

174

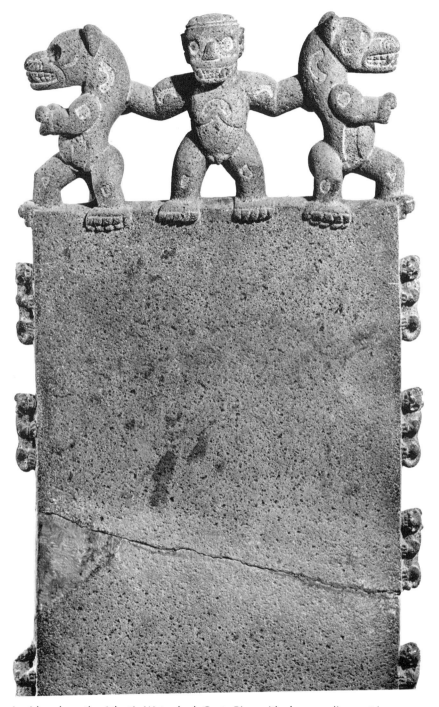

Lapidary from the Atlantic Watershed, Costa Rica, with clan guardians cut in the round on the border, Middle Period B. Width 56 cm.

Stone figure of a medicine man *(sukia)* from Williamsburg, Linea Vieja, Costa Rica, Middle Period B. Height 17.5 cm.

The importance of ritual during this time is emphasized by a cache preserved under a stratum of gray volcanic sand on the slopes of Irazu volcano by Las Pavas creek at Retes. More than four hundred objects made of lava or volcanic stone and more than one hundred wooden items were found. The stone objects included male and female figures ranging in height from a few inches to three feet, individual heads, grinding stones, offering tables, seats, and a single disc representing a gold paten. Most images resemble the types described previously, although some anthropomorphic figures occur — human beings carrying a drum or rattles, even a few not cut in the round but slab-shaped with hands on hips, a style common to the Diquis region. One curious two-headed person with genital organs portrayed on both front and back of the single body has the hands holding the breasts on one side and arms akimbo on the other.

Other lithic items were jaguar effigy and trough grinding stones, the latter decorated on the rim with conventionalized human heads interspersed by bird heads carved in slightly higher relief, the beak pointing toward the center; circular offering tables with stylized human or animal effigy heads on the rim and with a solid cylindrical base often slightly indented at the center or a hollow base and openwork decoration; and stools with a ring base and atlantes in the form of humanized jaguars.

Because of the protective layer of volcanic sand the wooden articles were preserved and have withstood the inclement tropical rains, insects, and general ravages of the centuries. Pieces from some of these objects yielded a radiocarbon date of approximately A.D. 960. The lot included many ceremonial artifacts. In greatest quantity were staffs with a rattle top, some with alligator or serpent symbols in low relief and ending in an animal carved in the round or an anthropomorphic figure. They resemble staffs used by the chieftains and medicine men in Talamanca as late as the beginning of the twentieth century. Similar rods still form part of the equipment of the Choco shamen of Colombia and the tribes of the Amazon. The cult images atop these staffs and the symbols carved on them have been found in bone at Jalaca in the Diquis region, indicating the extension of a common religion.

Among the other wooden items were tablets with symbols carved in low relief, reminiscent of present day Cuna song tablets from Panama; one circular offering table supported by a hollow

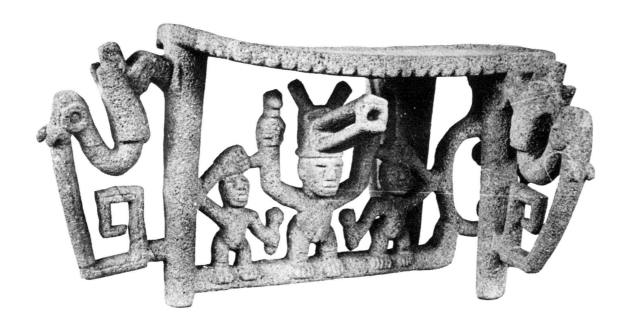

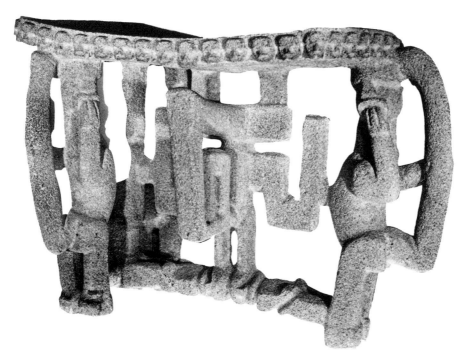

Two oversize grinding stones from the Reventazon Valley, Costa Rica, Middle Period B.

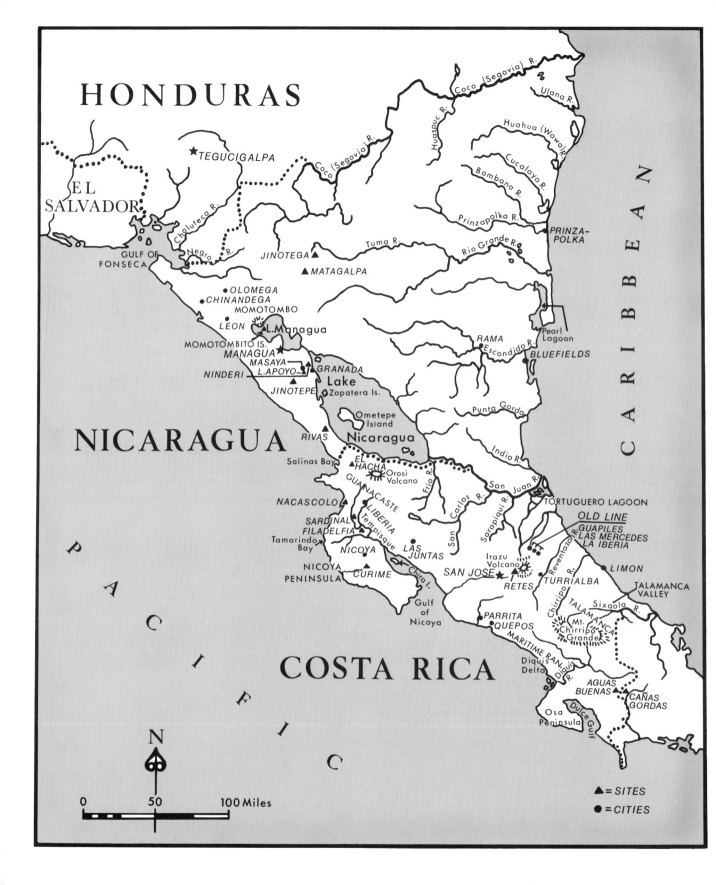

HONDURAS

EL
SALVADOR

★ *TEGUCIGALPA*

Coco (Segovia) R.

Coco (Segovia) R.

Choluteca R.

GULF OF
FONSECA

Negro R.

Huaspuc R.

Coco (Segovia) R.

Ulana R.

Huahua (Wawa) R.

Cucalaya R.

Bambana R.

Tuma R.

JINOTEGA ▲

▲ *MATAGALPA*

Prinzapolka R.

Rio Grande R.

● *PRINZA-
POLKA*

● *OLOMEGA*
● *CHINANDEGA*
MOMOTOMBO
● *LEON* ☼L. Managua

MOMOTOMBITO IS. ★
MANAGUA
MASAYA
NINDERI L. APOYO ●
JINOTEPE ▲

▲ *GRANADA*
Lake
Zapatera Is.

RAMA
● *Escondido R.*

*Pearl
Lagoon*

BLUEFIELDS

CARIBBEAN

Ometepe
Island

RIVAS ▲

Nicaragua

Punta Gorda

NICARAGUA

Salinas Bay

▲ *EL
HACHA* ☼*Orosi Volcano*

Indio R.

GUANACASTE

NACASCOLO ▲

SARDINAL
FILADELFIA
Tamarindo
Bay

LIBERIA
Tempisque

NICOYA

*NICOYA
PENINSULA*

CURIME

Chira I.

Gulf
of
Nicoya

Frio R.

*San
Carlos R.*

Sarapiqui R.

San Juan R.

TORTUGUERO LAGOON

OLD LINE
● *GUAPILES*
LAS MERCEDES
LA IBERIA

Reventazón R.

● *LIMON*

*Irazu
Volcano*
▲ ☼
SAN JOSE ★ ●
RETES

TURRIALBA

Sixaola R.

TALAMANCA
VALLEY

*LAS
JUNTAS*

● *PARRITA*
● *QUEPOS*

Chirripo
TALAMANCA
Mt.
*Chirripo
Grande*

MARITIME RAN.

Diquis
Delta

Diquis R.

*AGUAS
BUENAS* ▲
★ *CAÑAS
GORDAS*

COSTA RICA

Osa
Peninsula

Dulce Gulf

P
A
C
I
F
I
C

N

0 50 100 Miles

▲ = *SITES*
● = *CITIES*

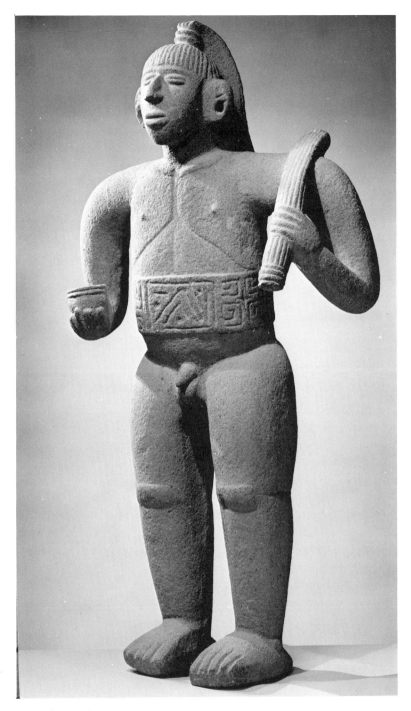

Stone figure of a man wearing an elaborate belt with cult artifacts in his hands, Las Mercedes, Linea Vieja, Costa Rica, Middle Period B. Height 1.29 m.

Teponaztli type wooden drum, Retes, Costa Rica, Middle Period B. Note the jaguar and the serpent cut in the round at one end.

cylindrical openwork base with conventionalized heads cut on the rim; one double-headed alligator effigy; and two types of drums — the northern kind with a tongue or wedge cut free on three sides similar to the Mexican *teponaztli* or Mayan *tunkul*, and the oblique cylindrical kind that has one end covered with hide. The latter type is still used in Talamanca and is also characteristic of the Cuna Indians, the Amazon Basin, and Indonesia. Serpent, alligator, or bird symbols and human beings were incised on the body of the drums; animals, some personified, were carved in the round at one end or, in the case of the southern type, on one side.

No whole vessels were found, but sherds were of two styles — brownish-red or brown hollow tripods with a long slit and globular body, and bowls with a cream slip inside and out with a red border. The interior was painted in dark brown squarish motifs with a brown eye in the center. The exterior had three thin red lines alternating with a single wavy dark brown line. A fragment of handwoven cotton cloth preserved on the underpart of the plate of a grinding stone completes the find.

Northwestern Costa Rica was not isolated from the rest of the country either. Trade is evidenced by Highland or Mora Polychrome Ware in the Meseta Central, Linea Vieja, and the Reventazon Valley and by Red, Yellow, White, and Black Line wares characteristic of the Atlantic watershed but occurring at this time in Guanacaste. Peg-base figures and some stone balls are evidence of contact between the Atlantic watershed and the Diquis region. Two kinds of peg-base figures, animal and stylized elongated or slablike human figures, appeared at Retes.

In Panama, the San Lorenzo phase, A.D. 800–1100, followed the Burica phase in the lands around the Gulf of Chiriqui. There was a slight change in the living patterns among the people in this area. In particular, besides mollusks, fish, and game, agricultural products became important in the diet. Although not numerous, trough and tripod grinding stones with mullers appeared at sites where during the previous phase no stone artifacts were found. This culture also had pounding-anvil stones, perhaps used for cracking the pit of the peach palm, and celts to clear the land. Other lithic objects were fishing weights, pebble polishers for pottery, pecking stones, and projectile points.

These people were copious users of pottery, which except for the plain wares was characterized by painted linear decoration. Two

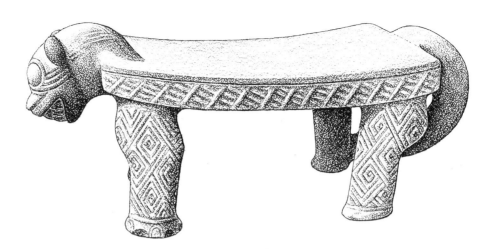

Jaguar effigy grinding stone from Guapiles, Linea Vieja, Costa Rica. Stones like this first appeared during Middle Period A, contemporaneous with the Late Classic Period.

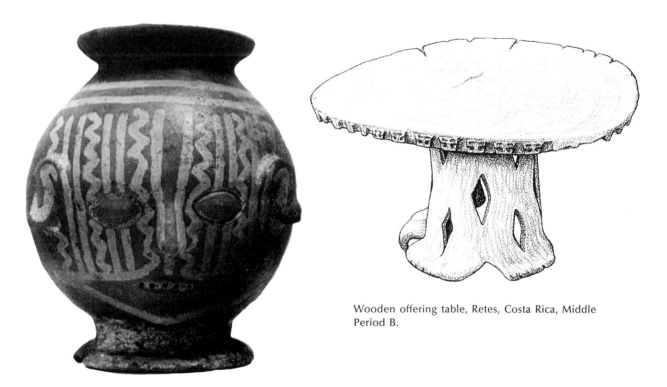

Wooden offering table, Retes, Costa Rica, Middle Period B.

Yellow-line Ware effigy vessel, Las Mercedes, Linea Vieja, Costa Rica, Middle Period B. Height 19.5 cm.

Stone effigy of a jaguar, Palmar, Diquis region.

Peg-base stone figure holding a trophy head, Palmar, Diquis region, Costa Rica.

local products were Banco Red Line and Castrellon Red Slipped. Banco Red Line consists of globular jars with strap handles. They are painted between the neck and shoulder in thin red lines and red pendant dots or a triangular motif of thin lines with connecting transverse lines and red splotches. The design is similar to the crocodile symbol associated with Classic Chiriqui wares. Castrellon Red Slipped Ware is composed of bowls, some with a ring or low pedestal base. The lip varies between fairly rounded and rounded and flat depending on the rim. A bright red slip applied on the polished surface of the interior extends over the lip, except when it is beveled, to form a band on the exterior. A few vessels of this ware were slipped on both surfaces. Other styles such as Arayo Polished Line and Linarte Zoned Red Line are equally unpretentious but continued to be made in Classic Chiriqui times.

Cultural influence and perhaps trade with people of the Late Cocle era is suggested by the resemblance of Zapote Red Banded vessels from the San Lorenzo phase and Cocle bowls of the Late and possibly Early periods, although the polychrome technique of Cocle is not present. Influences from Veraguas — effigy pots, loop legs or handles, and tall pedestal bases — also appear.

Inland Chiriqui was not isolated from contact with other regions. Cultural extensions, more likely due to the actual penetration of people than to trade, occurred at this time between the Atlantic watershed of Costa Rica and the Chiriqui highlands. Stone cist graves, characteristic of the Reventazon Valley during Middle

Period B (850–1400), were common in this section of Panama and appliquéd animals on vessel legs and handles appeared in both places. Red Line, White Line, Maroon, Chocolate, Handled, and Tripod wares also were shared by Costa Rica and Chiriqui toward the end of Middle Period B and the beginning of the late Post-classic in Panama.

The province of Veraguas borders on Chiriqui but identification of the people responsible for Veraguas culture remains a mystery. It cannot be placed in time except on a comparative basis, that is, the association of foreign artifacts in their graves or the lack of them. It is quite possible that this culture developed during the period of the Late Classic in Upper Central America, but as yet there is no evidence of its origins.

Veraguas cemeteries were built on high ridges, similar to many in eastern Costa Rica. Carbonized material and partly melted jewelry in the varied types of shaft graves indicate that fire was employed as a ritual in burials. The shafts, ten to more than twenty feet (3 m to 7 m) deep, are straight or slanting, with or without a lateral chamber. Some graves have several floors, the bottom one made with grinding stones, river rock, or sand; the shafts were earth or stone filled.

That Veraguas subsistence was mainly agricultural is inferred from the quantity of grinding stones. The earliest ones were decorated with stylized birds or animals carved in high relief under the mealing plate or had flying panels carved with similar figures — a trait also present in the Atlantic watershed of Costa Rica.

These people were expert craftsmen at casting open-backed tumbaga figures of birds, animals, frogs, crocodiles, men, and anthropomorphic creatures which they gilded with the *mise-en-couleur* technique. A characteristic of Veraguas metal work is the protruding eyes, frequently in the form of bells, on many of the figures. These objects were exported to Chiriqui, Cocle, Costa Rica, and beyond. Strangely enough, no stone jewelry was made by these people, but agate ornaments were imported from Cocle, particularly during the Late Period.

There are very few painted designs on Veraguas pottery. Almost all vessels were decorated by incising and filleting or the potters simply relied on form and lugs to give esthetic appeal. The influence of Veraguas styles — the tall pedestal base, tripod supports, and flaring strap handles — penetrated Chiriqui and northern Costa

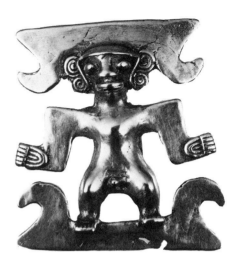

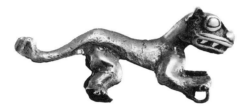

Pendant in the form of a crouching jaguar, Veraguas culture, Panama. Length 8.65 cm.

Pendant in the form of a male figure, Veraguas, Panama. Height 5.2 cm. Both photos courtesy of The Art Institute of Chicago.

Rica. The bottle shape is also characteristic of the ceramics. Other pottery types diagnostic of the culture but not yet placed in time are effigy bowls with gutter rims (double walls), a typical Amazon trait; jars that look like half vessels; jars with twin necks; slab tripods; and barrel-shaped vessels with a tall tubular neck coming from one side. The barrel vessels may indicate Peruvian influence and possibly are late. Some polychrome wares from Late Cocle were imported, for example, "coral snake" banded lip and effigy vessels with a decorated spout.

The Macaracas culture of the Azuero Peninsula showed close connections with the early Late Period at Cocle, an era of economic expansion indicating a sudden rebirth of prosperity and culture. Once again there were multiple bodies in a single grave and objects from far away places implying vigorous trade.

COCLE CULTURE, PANAMA

At Cocle the pottery associated with the Early Period almost totally disappeared. New styles were tried, many showing cultural influences from distant lands. Some of the vessels found in burials appear to be the work of a single potter, so craftsmanship was probably understood and appreciated. Among patterns char-

acterizing the beginning of Late Period ceramics are the dragon tongue, dragon belt, crab, dancing animals, double-profile heads, division of the field into parallel panels, and effigy vessels fashioned as fish, turtle, and human being — all indicative of Peruvian influence.

Other typical early Late Period styles are heavy but forceful curvilinear patterns, crocodile and bird motifs, and Red, White, and Purple Banded vessels that reveal a combination of cultural sources. The manner of color application is northern and suggests the Chorotega area; the symbolism involves both the Nicoya region and Peru. Characteristic pottery forms are plates decorated on the lower side only, with or without a pedestal base; cylindrical polychrome bowls; carafes with zoomorphic patterns; pot stands with a long cylindrical tube; and polychrome jars with and without a spout, the latter a favorite Peruvian type. Loop-leg vessels imply connections with Veraguas, and a style of Black Line Ware with

Clay replica of offering table with stylized eagles such as those seen in gold pendants, Veraguas, Panama.

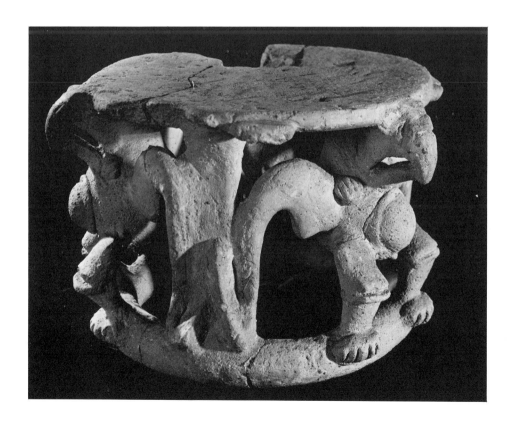

a

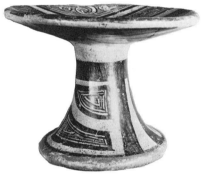

b

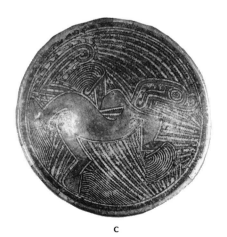

c

appliquéd nodules and figures suggests Chiriqui. Cocle pottery has been found in the Diquis region and the Nicoya Peninsula of Costa Rica. Clay drums, manganese pigment, and tripod grinding stones appear at Sitio Conte and in Nicoya. Whether these last items were due to trade or were local copies has not been confirmed.

Solid metal noseclips and ear rods are unique to the Late Period. Jewelry of all kinds, however, formed a particularly important article of commerce not only from Sitio Conte to the exterior, but also vice versa. Gold ornaments, for example, were imported from the Chibcha, Sinu, and Quimbaya peoples of Colombia. Emeralds and gold were sent from Ecuador to Cocle. Agate pendants from this site went north to Oaxaca, Mexico. Gold discs and other ornaments reached the Sacred Cenote at Chichen Itza, Yucatan, at least in the declining Cocle phase but probably toward the end of the early Late Period.

So it is not surprising that during this time at Rio Caño we find stone figures carved from columns that are slightly different in style from those of the Early Period. The figures are bas-relief images of nude men with arms bent at the elbow, one hand resting on the opposite shoulder and the other touching or covering the navel. They are present but rare in the Diquis region and relate to figures reflecting the Preclassic Period from Momotombito Island in Lake Managua, Nicaragua. More similarities are noted, though, with figures from Los Naranjos, Lake Yojoa, Honduras, which although late, follow the same artistic tradition.

THE LAST STAGES OF MESOAMERICANIZATION

Knowledge of the late Postclassic Period (A.D. 1200–1524) in Chiapas is limited mostly to small isolated sites along the Grijalva River. Although communities like Chiapa de Corzo continued to be inhabited, the Spaniards and the subsequent colonial era erased the archaeological evidence. The available data reconfirm activity that started in Early Postclassic times — a cultural take-over by Mexican peoples. Throughout the highlands of Upper Central America defensive sites appear on artificially leveled hilltops or mountain spurs protected by deep ravines. They are similar to sites constructed at the beginning of the period and occur either singly or in clusters containing up to eight settlements. An exception is the Chiapan

Cocle Late Polychrome pedestal plates with purple paint, Sitio Conte, Panama. a and b. Bird motif, height 11 cm, width of plate 14.5 cm, a whole vessel. c. Crocodile god motif. The pedestal is plain except for a red encircling band at the base, height 14.5 cm, width of plate 25 cm.

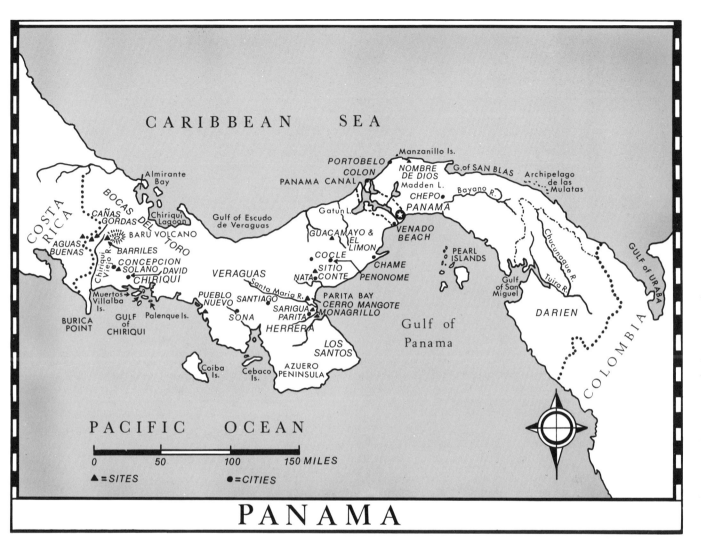

PANAMA

ceremonial center of Copanaguastla on the San Vicinte River, probably because the Central Plateau of Chiapas had so little to offer the merchant that no fortification was necessary.

Through this area of the isthmus, farmers stayed in the lowlands near the ancient settlements in times of peace. The fortified hilltops with their Mexican-inspired central temple structures, altar platforms, and plazas were used for marketplaces and folk-ceremonial dances. They also served as a place of refuge in time of strife. Even the ball courts changed. Shaped like an I, they had side benches, making them better suited for entertainment in contrast to their

187

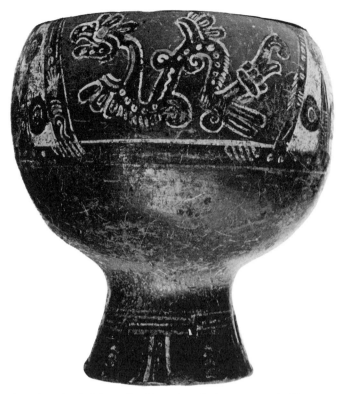

Late Postclassic Mixtec-Puebla style polychrome vessel with annular base that is closed and has cut outs with rattle inside, from a cemetery in coastal Ahuachapan, El Salvador. The principal motif is a sky-serpent. Highly polished surface. Height 15.3 cm, rim diameter 12.2 cm, thickness 0.75 cm.

earlier fundamentally religious purpose. Tula-Toltec culture had inspired nationalistic governments with a militant warrior class and lords. Capitals such as Mixco Viejo, Chuitinamit, Utatlan, and Zaculeu replaced ceremonial centers in highland Guatemala, a pattern copied extensively in the north. Newly formed nations like the Quiche, Zutuhil, Mam, and Cakchiquel began a program of expansion and aggrandizement with emphasis on secular, not religious, living.

New arrivals from the north also contributed to a change in pottery styles. Mixtec-Puebla wares were fashioned into tripod censers with effigy or bulbous supports, anthropomorphic effigy incense burners usually representing Mexican gods, ladle censers with hollow, plain, or effigy handles, and tall-necked jars adorned on neck or handles with small moldmade jaguar or human heads

with a long upturned nose. Increased metal work included copper axes, pins, and needles.

In El Salvador there are Tlaloc and large vase-shaped censers, ladle incense burners with serpent head handles, and small blue painted jars. Life-sized images of frogs and wheeled animal figures were probably used as offerings. Such items are evidence of Mexican cultures during this period and may indicate actual migrations instead of trade.

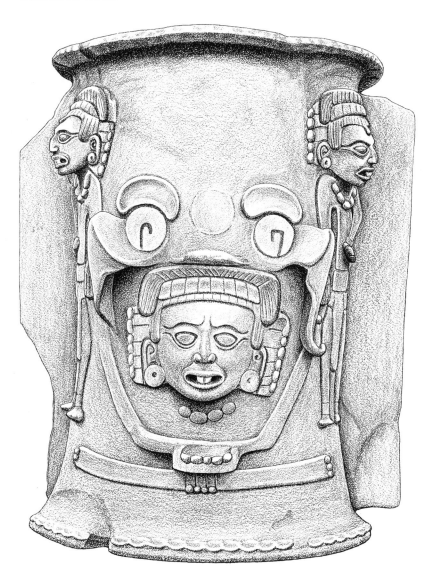

Effigy censer from Nebaj, Guatemala, representing Tlaloc and other deities, Late Postclassic. Height ca. 90 cm.

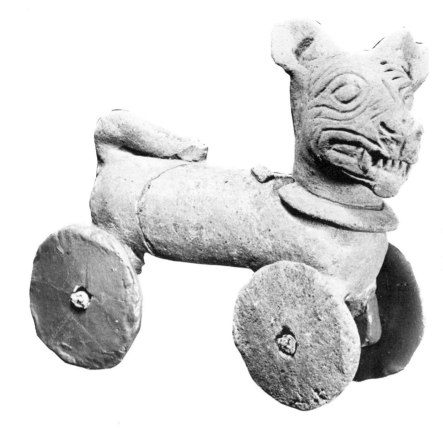

Fragmentary wheeled dog figure with hollow body and head, from East Group, Cihuatan, department of the San Salvador, El Salvador, probably late Postclassic. One wheel is original, others restored. Thin white slip over brown clay. Maximum length 15 cm, height less wheels ca. 12 cm.

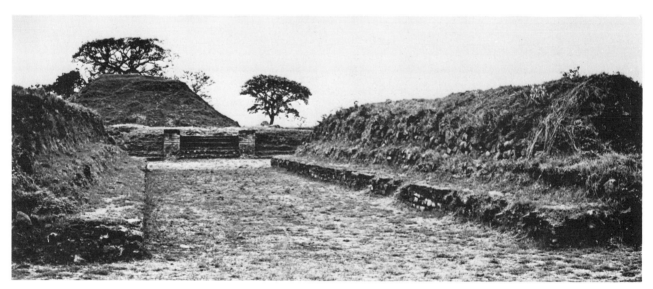

North ball court, looking south, with Structure 1 in the background, West Ceremonial Group, Cihuatan ruins, department of San Salvador, El Salvador, probably late Postclassic.

Pottery associated with late Postclassic in Honduras is known from Naco, a site in a lateral valley of the Chamelecon River, and Agalteca in the department of Morazan. Naco, apparently inhabited only during this last period, was reportedly settled by people who "came from the Southern Sea," a statement strongly suggesting the Pipil of El Salvador or Soconusco although it has been claimed that Naco was Aztec. The ware diagnostic of these two places is Naco Red or Black-on-White and it has linear patterns at times combined with scrolls and dots generally characteristic of serpent symbols in Middle America. Typical are shallow bowls with three semi-pointed feet, each with three lateral spurs near its base, and ladle censers with the handle hollow only to the vessel wall. Some of the bowls have complicated designs carved on the interior in a plano-relief technique. The same pottery types have been found in the Sula Plain, Honduras, and a related but not identical style occurs on certain vessels of Managua Ware in Nicaragua.

Another trait shared by Naco and Agalteca is a dark red plaster floor in certain mounds. No ball court has been discovered at Agalteca, but very little work has been done there. Naco, however, had a court with a ring.

Probably belonging also to the late Postclassic are the artifacts from a cave near Naco. Over 800 copper bells, cast in effigies or plain and varying in size from minute to approximately 2¾ inches (7 cm) in diameter, were hidden there along with a mask of the Mexican god, Ehecatl, bearing the remains of a turquoise inlay. In the Maya region where Naco is located, copper bells were used as money, their value depending on their size. The mask, of course, was a ceremonial object.

The farther east we go in Central America, the clearer the role of the merchant becomes. In late Postclassic times from the northwestern side of the Yucatan Peninsula, or more precisely from the ancient Cupilco Zaqualco River (the present Copilco) to the Ulua in Honduras the same language was spoken and people not only traded with one another but also regarded themselves as similar. The northwest section in particular and probably the entire territory were Chontal Maya — Putun Maya who, in the early Postclassic era, intermarried with Mexicans and were in part Mexicanized. Their ability as seamen and masters of large trading canoes, some carrying a crew of twenty-five, attracted the attention of Columbus on his first and last voyage to Central America.

Copper eagle ornament which probably topped a ceremonial staff, from Quimistan Bell Cave, Honduras. Length 9.85 cm.

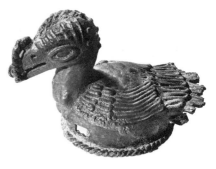

Copper bird effigy bell, Quimistan Bell Cave. Diameter 5.2 cm.

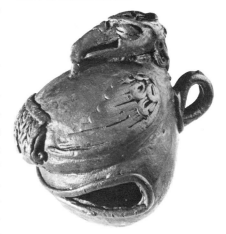

Copper bird effigy bell, Quimistan Bell Cave. Diameter 5.2 cm.

191

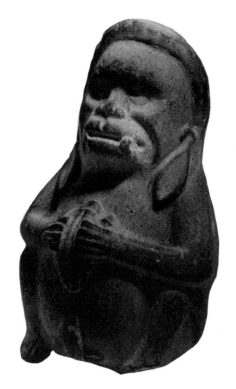

Clay image of the cacao god? Sula Plain, Honduras, Late Classic. *Cacao del mico,* monkey's chocolate, was the term used for the best cacao during the colonial period.

Commerce dominated the life of the isthmus. Although the Maya used the cacao bean for money just as the Pipil did, he also had as currency green and red beads that he carried in net bags at his belt. The green beads were stone; the red were probably shell. Copper axes and bells were also mediums of exchange, the size of the bell determining its value. The Maya traders were not daunted by swamps or mountain passes. There was trade over water in canoes and over land on roads that led through wet bogs by being raised above them. Bridges were built in the shape of the Maya, or corbel arch, and logs were laid on stone buttresses throughout the coastal region of Campeche and the Usumacinta Valley south and east. Special road signs were placed on trees on the islands of Terminos Lagoon in the manner of lighthouses to facilitate the passage of heavily laden cargo canoes with their merchant masters.

In the early part of the late Postclassic, Mexican peoples established themselves at key spots on the trading routes or where raw materials were available — cacao, feathers, greenstone, salt, and even gold. One of these important passages led from Xicalango by the Lagoon of Terminos to Nito in Guatemala and over to Naco in Honduras. Many of the towns on the merchants' route had special *barrios* or quarters allotted to traders who generally were of Nahuat speech. Toward the end of the period, those of Nahuatl tongue (people who pronounced the "l" after the "t" and were known by the general term *Nahuatlacas*) also used some of the roads. Three names are associated with this group — the Aztecs, famed traders and empire builders, and their close relatives the Alcohuaca and Tlaxcalteca.

One of the fundamental categories of Aztec society was the pochteca, the guild of traveling merchants who dealt only in foreign trade and who, in some degree, served as bankers in their communities. Membership in the guild was hereditary. Members married within the guild and had their own courts, distinct living quarters in their towns, and equipment, as well as a special god, Yiacatecutli. Within Aztec stratified society the pochteca were equal to warriors and nobles and were governed by a small group of elderly merchants too old to travel but well experienced. Some Aztec kings, for example, Ahuitzotl who reigned between 1486 and 1502, participated in their commercial ventures by sending merchandise to foreign lands and thereby making money.

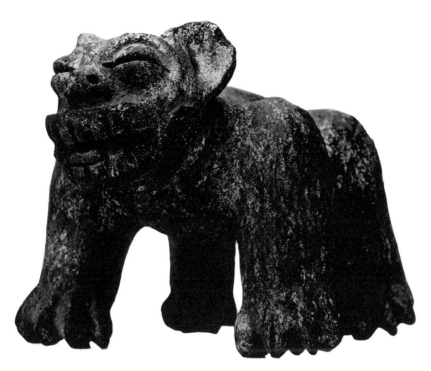

Clay effigy of an animal, Nicaragua, probably late Postclassic.

The pochteca functioned as an army, as spies, and as vanguard of the Aztec empire. They collected for the Emperor and waged war if necessary to induce unwilling communities to trade. Their presence in the isthmian area has been doubted by some scholars, but historical documentation reveals that by the beginning of the fifteenth century the Aztecs, represented by the pochteca, had colonies in Soconusco. During the years 1440 to 1470, King Montezuma I equipped a punitive army and sent it south to Oaxaca and beyond to control vassals who rebelled against paying tribute. A little later Emperor Ahuitzotl sent men to Guatemala in an attempt to form an alliance with the now powerful Maya-Toltec groups. Failing in this, the Aztecs spread to El Salvador. Archaeological evidence shows in bowl censers with cylindrical handles ending in a serpent head, large moldmade clay frogs bearing traces of black paint and sometimes a bow or knot on the back, and spindle whorls. The Aztecs undoubtedly followed trade routes of the Pipil and Maya.

Mexican people who were probably Aztec traders kept law and

order among the Paya, Sumu, and other aboriginal tribes of eastern Honduras. This area was the province of Taguzgalpa, a large tract of land with rivers rich in gold, ending at the Segovia River, the boundary between Honduras and Nicaragua. This province should not be confused with the district of Tegucigalpa, seat of the capital of the Republic of Honduras. The presence of Aztecs in this region before the Spanish arrival is implied in a report on the Bishoprics of Honduras and Nicaragua in 1629. The report stated that at the time of writing "there is a tradition that on account of the wealth of that country, Montezuma used to send down a delegation every year for his tribute in gold and other valuables; and when these Mexican ambassadors who happened at that time to be in these provinces received word of the arrival of the Spaniards and that they had overthrown their King and taken the stronghold of Mexico City and all its territory, they stayed in these provinces after learning this, and have maintained them in good government and normal growth ever since." Possibly some of these Mexicans were the Chuchures, who went by canoe from Honduras to join people of their own tongue near Nombre de Dios in Panama. They remained there until the arrival in 1510 of Diego de Nicuesa who wiped out the colony. Some students, however, think that the Chuchures were Pipil.

The Pipil were well established in parts of eastern Honduras during this late period. The large communities of Papayeca and Chapagua, not far from Trujillo, were probably inhabited by Nahuat-speakers, for Cortez noted that their pronunciation was not as clear as the "Mexicans," that is the Aztecs. The very rich province Hueitapalan, also called Xucutaco, was situated on the route to Olomega in Nicaragua and might have been Olancho, where Nahuat was spoken.

Nevertheless, some scholars believe that Aztec traders had a small colony in Nicaragua, near the mouth of the San Juan River where tribute of gold, jade, and green feathers was collected for Montezuma II. It is certain that a Royal Cedula of 1535 ordered the exploration of this waterway because of consistent reports that gold was being sent by the Indians north to Mexico, an action the Spanish conquerors could not tolerate.

Archaeologically certain polychrome vessels dating from the late Postclassic Period in Nicaragua and the Nicoya Peninsula in Costa Rica were found with painted representations of the Aztec Earth

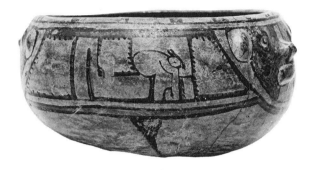

Luna Ware vessel, Rivas, Nicaragua, late Postclassic.

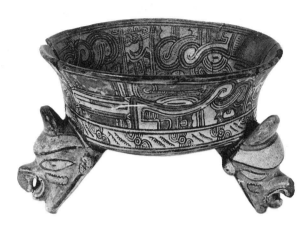

Luna Ware tripod vessel, Ometepe Island, Lake Nicaragua, Nicaragua. Height 11 cm, diameter 19 cm.

Monster, Tlaltecutli, and the Man and Jaguar motif which is also associated with these people. Clay vessels resembling Aztec chile graters form an important part of Managua Ware. Given the historical data above, such items suggest a significance beyond individual trade pieces.

Several wares associated with the Greater Nicoya area reveal cultural affinities. Luna Ware has been found with European objects, for example, a bronze image of a saint. The commonest form is a bowl with tubular or effigy head supports, both characteristic of the north. Decoration of modeled animal or human heads may be the influence of non-Mexican neighbors with southern affiliation, or perhaps the Chorotega-Mangue. The outstanding feature of Luna Ware, however, is the manner in which it is painted. The background is white and motifs associated with the Feathered Serpent, figures painted in silhouette style with black or brown outlines, dots, stepped frets, and pompons reflect the artistic tradition of Cholula and Tlaxcala, home of the Nicarao.

Another pottery type associated with European artifacts is Black Ware, found on Ometepe Island in Lake Nicaragua and on the mainland from the Isthmus of Rivas through the Nicoya Peninsula. Modeled and incised decoration occasionally filled in with white paint on a solid black background is characteristic. Forms include

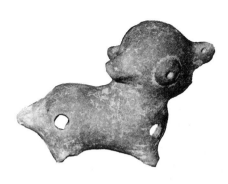

Sula Plain type of whistle from the vicinity of Bagaces, Guanacaste province, Costa Rica, Late Polychrome (late Postclassic).

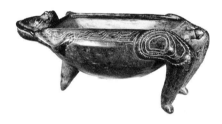

Marron Ware vessel, Linea Vieja, Costa Rica, late Middle Period B–Late Period (late Postclassic).

spouted sub-globular vessels, shoe-shaped vessels, and cylindrical jars. Spouted pots and modeled adornment in high relief recall Peru; cylindrical shapes are associated more with Mexico and the Maya area.

A special type of whistle common to the Sula Plain of Honduras consists of a birdlike or human face with two bulbs forming the body. In Nicaragua and Costa Rica similar whistles are sometimes found. Probably trade pieces, they may have had a religious significance.

The Chorotega-Mangue, the Nicarao, and the Aztecs continued their movements east. The Spaniards noted that the Chorotega-Mangue were equipped to "do what they wanted by land and by sea." The route of their journey can be traced through a name that persists today — the Rio de los Mangues or Mangue River in southern Costa Rica near Quepos. That they went farther east than this and established a militant colony, perhaps in search of slaves and gold, is suggested by a Spanish report. It recorded an event that took place two years before the arrival of the Europeans in the region of the Azuero Peninsula. A great army came from the direction of Nicaragua and settled in land bordering that of Chieftain Cutatara, who reigned over the province of Parita, or Paris, in Panama. The newcomers were eaters of human flesh and they carried off young boys for this purpose. Suddenly they were plagued by an unknown disease and retreated to the seacoast. Ill and off guard, they fell easy prey to Cutatara and his men who killed them all and seized their booty containing much gold.

Even the Nicarao, though well established in their new home, continued to journey back and forth to Panama and perhaps beyond, undoubtedly on trading expeditions and possibly lured by the cult of gold. By the time of the Spanish Conquest, they had placed such value on this metal that the goldsmith was given the rank of a noble.

The first Spaniard to reach the valley of Talamanca in northeastern Costa Rica near the border of Panama was Sanchez de Badahoz in 1540. He found ruling there a chieftain named Coaca (Coaza) who used a Nahuatl (Aztec) word in his conversation with the Spaniards. He had more than seventy chieftains subject to him; most Costa Rican aborigines had fled to the hills. A chieftain named Yztolin was described as Mexican, leader of the Chichimec.

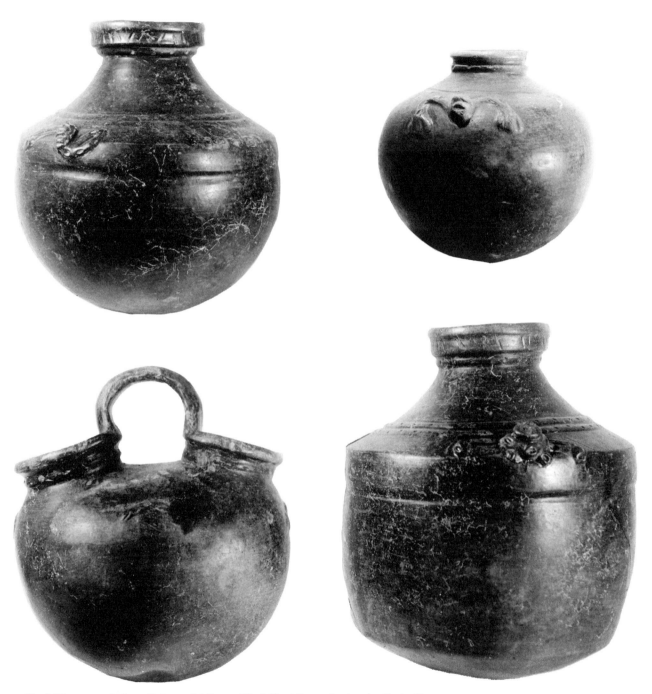

Black Ware vessels from Potrero del Burro, Filadelfia, Nicoya Peninsula, Costa Rica,
Late Polychrome (late Postclassic).

Polychrome penis effigy of clay painted with symbols of the serpent or alligator from the vicinity of Bagaces, Guanacaste province, Costa Rica. Length 15.75 cm.

In other instances he is called Ystoli or Estuli, although always he is considered Mexican.

Bordering on this region on the Panamanian side were the "sigua" or "strangers." These "foreigners" were well installed before the Spanish arrival. They were Mexican warrior traders and of such a turbulent nature that they had been forced to leave Talamanca. The Sigua apparently were the latest group of Aztecs in the isthmus and they probably remained in their new location for the same reason their counterparts stayed in Taguzgalpa, Honduras.

No archaeological artifacts are associated with these peoples. It has been said that they were brought by the Spaniards as mercenaries from Mexico to be used against the local inhabitants, a supposition hard to validate as historical documentation shows they were present in the land when the first Europeans arrived.

POSTCLASSIC AFFINITIES IN COSTA RICA AND PANAMA

The late Postclassic Period was a time of religious ceremonialism among the inhabitants of the Atlantic watershed of Costa Rica. Phallic symbols and the "mamita" figures at Las Mercedes suggest influences or even movements from the south. Walled mounds and stone-walled enclosures with several entrances and moat-like depressions surrounding ceremonial and burial areas appear. Among the sites of ritual importance are La Fortuna, El Guayabo, Germania, Najerra, and Las Mercedes. There were aqueducts and

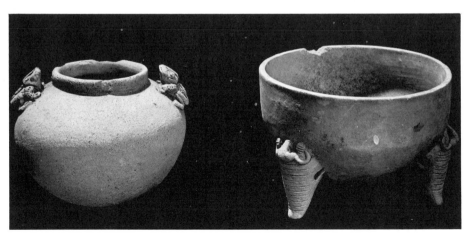

Biscuit or Armadillo Ware vessel, Classic Chiriqui (late Postclassic).

cobblestone roads. The scars of vine bridges can still be seen on ancient trees. At El Guayabo water was channeled from a subterranean source through the village in an aqueduct partly lined with stone slabs. Cane and wood houses were built on mounds of stone and earth with stone stairways on one or more sides. When this site was first inhabited has not yet been determined, but its cultural apex seemingly was achieved during the late Postclassic. The increase of Chocolate and Nicoya Polychrome wares indicates extensive trade with northwestern Costa Rica. The prevalent grinding stone was the same jaguar effigy with handle tail as was popular at Retes; it is typical also of the Diquis region and of Classic Chiriqui culture at this time.

There is a close affinity between Chiriqui and the Diquis territory. Common to both areas are Red and Black Line or Alligator Ware, including triangular-faced female figurines painted with alligator symbols; beautifully modeled Biscuit or Armadillo Ware

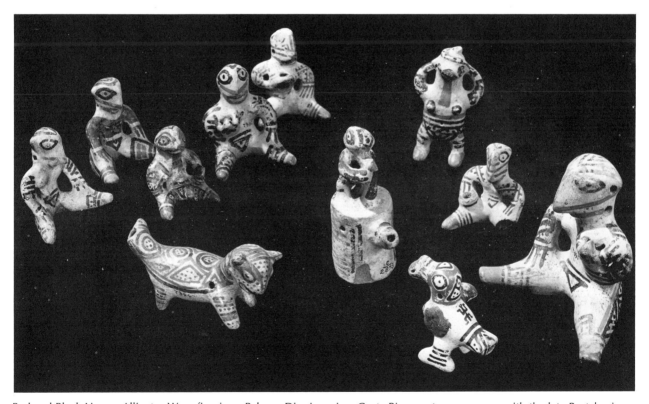

Red and Black Line or Alligator Ware figurines, Palmar, Diquis region, Costa Rica, contemporaneous with the late Postclassic.

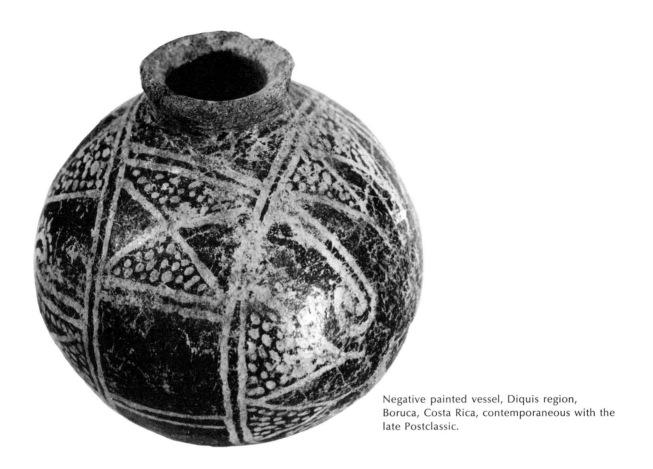

Negative painted vessel, Diquis region, Boruca, Costa Rica, contemporaneous with the late Postclassic.

noted for its simplicity of form and minute appliquéd details; negative painted pottery; Chocolate Ware related to or inspired by Nicoya; and Fish or Appliqué Tripod Ware. They appear either as local variants or, in the case of Red and Black Line pottery for example, are actually identical types. In the Diquis region both Fish Tripod and Effigy Appliqué as well as Red and Black Line wares have been found with iron artifacts of European manufacture.

Gold "eagle" pendants continue in fashion in the cultures of the Atlantic watershed, Diquis and Chiriqui. According to the modern tribes of Talamanca and Boruca, they represent the turkey buzzard, a form taken by God, *Sibu*, when he came to earth to show man how to dance. This type of pendant was also made by the Veraguans. In Diquis, Chiriqui, and Veraguas, the "eagle" motif was often combined with the crocodile and sometimes the jaguar, implying the dual personality or fusion of both gods and a common

Massive stones bridging aqueduct at El Guayabo, Costa Rica, contemporaneous with the late Postclassic.

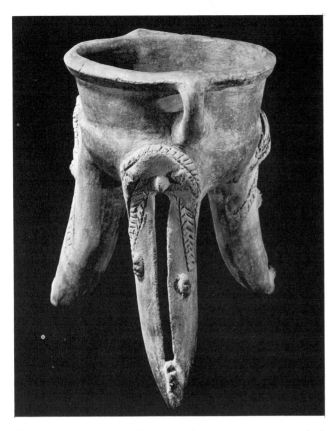

Fish or Appliqué Tripod Ware vessel, contemporaneous with the late Postclassic.

religious background. Other deities apparently reverenced and portrayed in gold by these people were the Winged Jaguar, the Jaguar, the Bat, the Crocodile, and the Frog — all were occasionally interpreted anthropomorphically. Many of these subjects were likewise fashioned in metal in South America. Their presence in the isthmian area marks the western advance of the cult of gold that the chroniclers describe so vividly as being of religious significance in Panama and Colombia.

The latter part of the Chiriqui phase, 1200–1500, is coeval with the Herrera phase in the Azuero region of Panama and extends into Veraguas and Chiriqui. The people of the Herrera phase cremated their dead and placed the ashes in urns. Necklaces of human teeth, one composed of eight hundred incisors, and beautifully carved manatee bones used as batons served as grave furnishings. El Hatillo Polychrome pottery is characterized by modeled forms

of flying birds and animals. Short pedestal and ring bases and bottle shapes are common. A red-brown slip usually occurs on the undecorated portion of the vessel and the design is on an orange to dark orange or cream background. Narrow black outlines enclose red geometric and natural motifs. Some life patterns such as triangular faces are reminiscent of the Winged Heads of Nicoya Polychrome Ware; other patterns are stylized crocodiles or pelicanlike birds characterized by boldness and angularness of design. Also contemporary with this ware but not as widespread is Parita Polychrome. Pedestal bowls and plates and large collared jars are common. The designs include birds, in particular the buzzard, fish, turtles, and frogs, and are often curvilinear. They are painted in black, red, and purple, the last two colors outlined in black. The painted motifs characterizing these two wares represent much the same pantheon as is displayed by the gold pendants and reflect the ceremonial nature of these vessels.

The culture of Veraguas remained static during the late Postclassic Period. Chieftains governed a highly stratified society living in small well-fortified towns. Thorny thistle plants closely interwoven served as walls for added protection. Exportation of gold jewelry continued to form the basis of Veraguas economy. Inferior unpainted heavy vessels with loop legs or double rims composed the typical pottery. When decorated they had small appliquéd

Stairway made of river stones at El Guayabo, Costa Rica, contemporaneous with the late Postclassic.

203

figures of women, animals, crocodiles, frogs, and birds. There was only minor interchange with the Azuero Peninsula but it enabled some Azuero painted ware to be enjoyed by the Veraguans. No ceramics were traded with Chiriqui.

Very little is known of Cocle during this so-called period of decline. Cultural waning was such that a burial contained only one body and very little grave furniture. Although some local pottery is found in the graves, there is a higher percentage of foreign wares associated with Parita or the Azuero Peninsula region. The only historical reference concerning this territory was given by the conqueror Gaspar de Espinoza, who noted that the ball court of the chieftain Jabraba was similar to ball courts in Haiti. This suggests that the South American Arawak, or at least some of their customs, had reached Panama before the Spanish arrival.

Some scholars think that the Arawak never entered the Central American isthmus. Their reasoning is based on the scarcity of archaeological remains. As noted here, however, as early as the Late Classic Period certain luxury and cult objects associated with the Arawak reached the Atlantic watershed of Costa Rica and to a lesser degree, Cocle. These occurrences I have attributed to trade. At the time of the Spanish Conquest, though, there are historical references to people who spoke the "language of Cuba" in Panamanian territory.

Arawak homelands were apparently located in the Amazon basin. These famous seamen migrated south to Chile and east and north to the Antilles as far as Florida in North America. They were in Cuba and Hispaniola, which included Haiti. Their neighbors on Haiti were the Caribs who were also aborigines of South America but at the time of the Spanish arrival the Caribs had not reached Cuba. The Arawak people were divided into many different groups under distinct names. It is significant, therefore, that the chroniclers referred not to a tribal appellation (of which they had no conception nor interest), but to the similarity in language.

The places where Arawak was spoken when Panama was discovered by Europeans were Chame (Chiama), Coyba (Coiba), and the province of Purulata. It was reported by Herrera, the Spanish chronicler, that the language of these places did not differ from Cuba but was "more refined and the people more presumptuous."

Chame, Coyba, and the province of Purulata were under the jurisdiction of the Spanish settlement of Panama and were not

distant from Nata and Cocle. As a boy of fourteen, Ferdinand Columbus accompanied his father, Christopher, on his last voyage and referring to the north coast of this territory, he noticed that the "customs of the Indians at Belen were like those of Hispaniola, and the Neighboring islands" and were different from those of the present province of Veraguas. The same implication more explicitly worded is gathered from the chronicler Lopez de Gomara: "They dress, talk and walk in Panama like in Darien and in the land of Culua, which they call Castilla del Oro. The dances, rites and religion are somewhat different, and are very similar to those of Haiti and Cuba."

Observations like these suggest that the South American Arawak had colonies in the lower isthmus. The ball court mentioned in connection with Chief Jabraba is diagnostic of the Arawak and not of the Chibchan or Carib. Perhaps merchant groups were responsible for these isolated and small concentrations. Historical evidence in the lower isthmus in late Postclassic times points to multiple peoples with mutually unintelligible languages.

SUMMARY OF THE POSTCLASSIC PERIOD

Empire and trade — this summarizes the Postclassic world in Upper Central America. Nationalistic groups appeared in Guatemala. The Quiche, the Cakchiquel, and the Mam are a few who represented the combination of local Maya nuclei with Tula-Toltec. The Tula-Toltec intermarried or conquered and imposed their own kin as rulers and their own deities as the gods to be worshiped. Mixed Maya and Nahuat descendants controlled a cultural zone formerly rich in artistic genius and able artisans. The warrior and merchant class developed in Upper Central America while the influence of the clergy declined. Ceremonial vessels were important, however, and served as objects of trade, helping the Nahuat religion to infiltrate alien peoples and their beliefs. The "Eagle" and "Jaguar" orders of the Toltec flourished. On commercial routes rest stations and small shrines were developed for the itinerant trader and the god associated with his profession.

Not only the Maya territory but also most of the isthmian region was overrun with those other Nahuat — the Pipil. They pushed farther and farther south and east, leaving their imprint on all the land in which they settled and through which they passed. Since their first appearance in Central America, their religious concepts

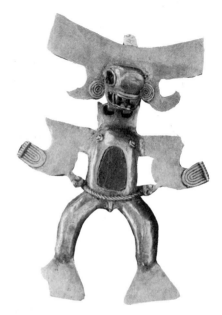

Gold pendant with iron pyrite inlay, La Vaca, Diquis region, Costa Rica, contemporaneous with the late Postclassic.

Monolithic stone axe found on the Nicaraguan Caribbean coast. Related types are known in the Antilles. Length 31.7 cm.

had infiltrated the peoples with whom they came in contact, but now, because of the Tula-Toltec, those ideas found firm footing in most of the isthmus.

The age of the ceremonial center had passed. Trade, which had long been important, realized a new impetus. Three ceramic wares are diagnostic of the early Postclassic Period in northern Central America — X Fine Orange from the Mexican Gulf coast, Tohil Plumbate, and effigy vessels of Nicoya Polychrome Ware. All three wares were traded in the upper isthmus, and Plumbate vessels were in demand as far east as Panama and north to the Mexican plateau. Except for the trophy-head cult, traits such as certain painted motifs on pottery, human sacrifice by removing the heart, and the use of idols mark a religious conquest that took place principally from the north, and Maya culture and creativity were reduced to mediocrity or totally disappeared.

In Lower Central America, both the Chorotega-Mangue and the Nicarao were in control of the Greater Nicoya area. Their cultural traditions dominated the art as well as the economy. They had a medium of exchange (the chocolate bean), markets with commerce conducted by an organized group, a highly stratified society, and a Mexican pantheon. At least in the periphery of Greater Nicoya religion was diffused with the concepts of southern or Lower Central America.

In the rest of this territory, northern and southern Costa Rica, and Panama, there was an upsurge of the artisan. On the Atlantic watershed of Costa Rica a realistic tendency appears in stone carvings and clay effigy vessels. Many stone figures have portrait characteristics, not only with regard to the individual aspect of the face but also in posture and position. In the southeast conventionalized lithic figures were cut in the round and in low relief with a peg base, or slablike elongated figures without the limbs cut free. The subjects were motivated by religion, as the personified alligator or crocodile testify.

Both on the Atlantic watershed and in the Diquis region, the cult of gold became significant. Small pendants were cast or hammered in the Atlantic watershed, where metal itself was scarce and mostly imported. Helmets, pendants of multiple figures within a frame, headbands, cuffs, fish hooks, buttons, and noseclips — that is, the greater part of the gold inventory occurring in Cocle and Veraguas — were also produced in southern Costa Rica. Local characteristics

distinguish certain Costa Rican objects from those of other places. Examples of such pieces are bells from Linea Vieja that have an elongated neck and sometimes an additional loop at the end of the already perforated shaft. Such bells have been found as far north as the Cenote at Chichen Itza in Yucatan. Articulated figures from the Diquis region are also unique. Some have movable heads and limbs while others have bangles or are combined with jade. Characteristic, too, is jewelry made especially for grave offerings. It is often unfinished with no hole for suspension and no sign that it was worn.

In Lower Central America the Postclassic continued to be a time of cultural extensions. Northwestern Costa Rica and Pacific Nicaragua shared many traits. The Atlantic watershed and the Costa Rican Diquis region had close affinities with Classic Chiriqui culture and, to a certain degree, with the Veraguas culture in Panama. Items common to these last four regions include grinding stones, framed ornaments of cast gold, and tripod vessels with appliquéd figures. At least trade connections existed between the Diquis territory and the Nicoya Peninsula, as Red and Black Line or Alligator Ware has been found near Bolson, and some Nicoya Polychrome appears in the Delta at Farms 2 and 7 outside of Palmar.

Trade was important throughout this period and earlier in Lower Central America. Although when it actually reached Veraguas is not known, an Olmec-style dancing figure was found there. Indeed, the people of Veraguas seemingly exported more gold ornaments than any other group in the New World. During this Postclassic Period, Cocle agate jewelry spread to Oaxaca, and Nicoya jades reached Chiriqui. The pochteca, engaged in well-organized foreign trade, were involved in extending Aztec boundaries, thus enlarging both their empire and their tribute lists. Although since Preclassic times the isthmian area had bowed to the power of the trader, now in the Postclassic Period the merchant assumed an even more crucial and important role. An eyewitness and Crown's historian, Gonzalo Fernandez de Oviedo y Valdes, made the following observation concerning the eastern reaches of the isthmus at the time of the conquest. It sums up the way of life of the nonnorthern peoples and partly explains the ease with which the Nahuat and the Nahuatl advanced nearer and nearer to the southern continent. ''When the Indians are not at war, their sole occupation is to negociate and barter what they have with others, and in this manner

from some parts to other [parts] those who live on the sea coasts or by rivers, go in canoes to sell what they have as surplus and abundant, and to buy what they lack. And in like manner they negociate by land, and the cargoes are carried on the backs of slaves: some carry salt, others maize, others cloth, others hammacs, others spun cotton or [cotton] to spin, others salted fish, others carry gold. . . In short, that which the Indians lack is what they most esteem, and some even sell their own children. And all these things and others they barter some for others."

Northerners penetrated the southern continent during the Postclassic Period probably in search of gold. The association of the Nicarao with Venezuela has already been examined. A report of a Mixtec hieroglyph in British Guiana, carved on a rock in a style common to A.D. 1350, suggests that those of Nahuatl speech went even farther south and may indicate an exploratory mission. It is interesting that toward the end of the Postclassic era the term "Tlailotlaque" came into use. It is a word of Nahuatl origin meaning "those who returned from the south" and indicates that tribal movements continued among the Mexican peoples. Had the discovery of the New World been delayed a hundred years, perhaps Aztec territory would have stretched from Mexico to northern South America and two of the continent's higher cultures, Aztec and Inca, would have shared a common frontier east of the Central American isthmus.

Credits

OWNERS

Permission has been granted by the following museums and individuals to reproduce the art in their collections:

Objects not listed above are in private collections.

PHOTOGRAPHERS

ARTISTS

Drawings by Symme Burstein

Charts by Symme Burstein

Maps by Barbara Westman

Chronology of Cultures

Bibliography

Index

A chronological chart of Upper and Lower Central America.

UPPER CENTRAL AMERICA | LOWER

RELATIVE CHRONOLOGY	GUATEMALA COASTAL	GUATEMALA HIGHLANDS	GUATEMALA LOWLANDS	EL SALVADOR	HONDURAS WESTERN	HONDURAS SOUTHERN	HONDURAS EASTERN	NICARAGUA

POSTCLASSIC
- 1500 — Chinautla (Highlands)
- 1200 — Naco (W. Honduras); Malalaca (S. Honduras); Late Polychrome (Nicaragua)
- Las Vegas; Rio Blanco; Amapala (S. Honduras)
- 900 — Peor es Nada (Coastal); Tohil (Highlands); Plumbate (El Salvador); Cocal (E. Honduras)

CLASSIC — LATE / EARLY
- Pamplona (Highlands); Tepeu 3, Tepeu 2, Tepeu 1 (Lowlands)
- Ulua Polychrome; Copador (El Salvador); Ulua Polychrome; Copador (at Copan) (W. Honduras)
- San Juan; Santa Lucia (Coastal); Amatle (Highlands)
- Fonseca (S. Honduras); Mid. Polychrome (Nicaragua)
- Yojoa (W. Honduras); San Lorenzo (S. Honduras); Selin (E. Honduras)
- 600
- Laguneta (Coastal); Tzakol 3 (Lowlands); Tazumal; Quelepa Esperanza (El Salvador); "Classic" Copan?; Travesia? (W. Honduras); Chiamuyo (S. Honduras); Early Polychrome (Nicaragua)
- Esperanza Aurora (Highlands); Tzakol 2 (Lowlands)
- 300

PRECLASSIC — LATE
- Santa Clara (Highlands); Tzakol 1, Matzanel (Lowlands); Zoned Bichrome (Nicaragua)
- Mejor es Algo (Coastal)
- A.D. / B.C.
- Arenal (Highlands); Lo de Vaca II; Eden (W. Honduras)
- 300 — Crucero, Illusiones (Coastal); Cerro Zapote (El Salvador); Ulua Bichrome (W. Honduras)
- Lo de Vaca I (W. Honduras)

PRECLASSIC — MIDDLE
- Conchas II (Coastal); Miraflores, Providencia, Majadas (Highlands); Chicanel (Lowlands); Jaral (W. Honduras)
- Yojoa Monochrome? / Playa de los Muertos II (W. Honduras)
- 600
- Algo es Algo, Conchas I, Jocotal (Coastal)
- "Archaic" Copan? / Playa de los Muertos I (W. Honduras)
- 900 — Cuadros (Coastal); Las Charcas (Highlands); Mamom (Lowlands)

PRECLASSIC — EARLY
- 1200 — "Archaic" Chalchuapa? (El Salvador)
- 1500 — Ocos (Coastal); Arevalo (Highlands); Yarumela I (W. Honduras)

212

COSTA RICA / PANAMA chronological chart

	COSTA RICA			PANAMA					
NICOYA PENINSULA	HIGHLANDS	ATLANTIC WATERSHED	SOUTHEAST	CHIRIQUI GULF	MAINLAND CHIRIQUI	VERAGUAS	COCLE	PARITA BAY	VENADO BEACH
								La Arena Phase	
								El Tigre Phase	
	Late Period (Orosi)	Late Period					Herrera Phase		
Late Polychrome			Late Per. Diquis	Chiriqui Phase	Classic Chiriqui	Class. Veraguas			
	Middle Period B (Chircot; El Guayabo)								
Mid. Polychrome	Middle Period A (El Guayabo)	Middle Period B	Middle Per. Diquis	San Lorenzo Ph.			Late Cocle	Late Cocle (Maracas Phase)	
Early Polychr. B						Mariato Phase			
Early Polychr. A	Curridabat						Early Cocle	Early Cocle	Venado Beach 2
		Middle Period A							
Linear Decoration			Early Per. Diquis B	Burica Phase	Burica Phase		Santa Maria	Santa Maria	
		Early Period B			Barriles; Aguas Buenas				
Zoned Bichrome		Early Period A	Early Per. Diquis A		(La Concepcion)	Scarified Period	Scarified Per.		Venado Beach 1

Time scale (right margin, top to bottom): 1500, 1200, 900, 600, 300, A.D. / B.C., 300, 600, 900, 1200, 1500

213

CHIAPAS, MEXICO

	CHIAPA de CORZO PHASES	CERAMIC PHASES

Period			CHIAPA de CORZO PHASES	CERAMIC PHASES
CLASSIC	EARLY	600	Maravillas	Chiapa X
		300	Laguna	Chiapa IX
PRECLASSIC	LATE		Jiquipilas	Chiapa VIII
			Istmo	Chiapa VII
		A.D. 0 / B.C.		
			Horcones	Chiapa VI
		300	Guanacaste	Chiapa V
			Francesa	Chiapa IV
			Izapa	
	MIDDLE	600	Escalera	Chiapa III
		900	Dili	Chiapa II
		1200		
	EARLY	1500	Cotorra	Chiapa I
			Barra	

Bibliography

CHAPTER 1. THE MINGLING OF PEOPLES

Bird, Junius B.
 1969 "A Comparison of South Chilean and Ecua-
 dorian 'Fishtail' Projectile Points," *The
 Kroeber Anthropological Society Papers*,
 no. 40, pp. 52–71. Berkeley, California.

Bosch-Gimpera, Pedro
 1959 "La prehistoria del nuevo mundo y Centro
 América," *Actas del 33 Congreso Inter-
 nacional de Americanistas*, vol. 1, pp. 137–
 151. San José, Costa Rica.

Coe, Michael D.
 1960 "A Fluted Point from Highland Guatemala,"
 American Antiquity, vol. 25, no. 3, pp.
 412–413. Salt Lake City, Utah.

Drucker, Philip
 1948 "Preliminary Notes on an Archaeological
 Survey of the Chiapas Coast," *Middle
 American Research Records*, vol. 1, no. 11,
 pp. 151–169. Tulane University, New Or-
 leans, Louisiana.

Haberland, Wolfgang
 1960a "Ceramic Sequences in El Salvador,"
 American Antiquity, vol. 26, no. 1, pp. 21–
 29. Salt Lake City, Utah.

Haberland, Wolfgang, and Willi-Herbert Grebe
 1957 "Prehistoric Footprints from El Salvador,"
 American Antiquity, vol. 22, pp. 282–285.
 Salt Lake City, Utah.

Lange, Frederick W.
 1969 *An Archaeological Survey of the Rio Sapoa
 Valley*. Interim Report on a Preliminary
 Season of Archaeological Research in
 Northwestern Guanacaste Province, Repub-
 lic of Costa Rica. Field Research conducted
 as part of the Central American Field Pro-
 gram of the Associated Colleges of the
 Midwest. Ibero-American Studies Program,
 University of Wisconsin, Madison, Wis-
 consin.

Longyear, John M., III
 1948 "A Sub-pottery Deposit at Copan, Hon-
 duras," *American Antiquity*, vol. 13, no. 3,
 pp. 248–249. Menasha, Wisconsin.

Lorenzo, J. L.
 1955 "Los concheros de la costa de Chiapas,"
 *Anales Instituto Nacional de Antropología e
 Historia*, vol. 7, pp. 41–50. Mexico.

Lothrop, Samuel K.
 1926 *Pottery of Costa Rica and Nicaragua*. Con-
 tributions from the Museum of the Amer-
 ican Indian, Heye Foundation, vol. 8. 2
 vols. New York, New York.

 1937 *Coclé: An Archaeological Study of Central
 Panama*, Part 1. Memoirs of the Peabody
 Museum, Harvard University, vol. 7. Cam-
 bridge, Massachusetts.

McGimsey, Charles R., III
 1956 "Cerro Mangote: A Preceramic Site in Pan-
 ama," *American Antiquity*, vol. 22, no. 2,
 pp. 151–161. Salt Lake City, Utah.

MacNeish, Richard S., and Frederick A. Peterson
 1962 *The Santa Marta Rock Shelter, Ocozo-
 coautla, Chiapas, Mexico*. Papers of the
 New World Archaeological Foundation, no.
 14. Publication no. 10. Brigham Young Uni-
 versity, Provo, Utah.

Oviedo y Valdés, Gonzalo Fernández de
 1851–55 *Historia general y natural de las Indias,
 islas y tierra-firme del mar océano*. J. Am-
 ador de los Ríos, editor. 4 vols. Madrid.

Richardson, Francis B.
 1944 "Las huellas de Cahualinca," *Cuadernos del
 Taller San Lucas*, no. 4, pp. 23–30. Granada,
 Nicaragua.

Sander, Dan
 1959 "Fluted Points from Madden Lake," *Pan-
 ama Archaeologist*, vol. 2, no. 1, pp. 39–51.
 Canal Zone.

Schuchert, Charles
 1935 *Historical Geology of the Antillean-Caribbean Region.* New York, New York.
Shook, Edwin M.
 1951 "The Present Status of Research on the Pre-Classic Horizons in Guatemala," *The Civilizations of Ancient America.* Selected Papers of the 29th International Congress of Americanists, pp. 93–100. Chicago, Illinois.
Stewart, Robert H.
 1968 "Geological Evidences of Ancient Man in Panama," *Boletin del Museo Chiricano, Colegio Felix Olivares,* pp. 20–25. David, Panama.
Stone, Doris
 1941 *Archaeology of the North Coast of Honduras.* Memoirs of the Peabody Museum, Harvard University, vol. 9, no. 1. Cambridge, Massachusetts.
 1957 *The Archaeology of Central and Southern Honduras.* Papers of the Peabody Museum, Harvard University, vol. 49, no. 3. Cambridge, Massachusetts.

Swauger, J. L., and W. J. Mayer-Oakes
 1952 "A Fluted Point from Costa Rica," *American Antiquity,* vol. 17, no. 3, pp. 264–265. Salt Lake City, Utah.
Tschiffley, A. F.
 1933 *Tschiffley's Ride. Ten Thousand Miles in the Saddle from Southern Cross to Polar Star.* New York, New York.
West, Robert C.
 1964 "Surface Configuration and Associated Geology of Middle America," *Handbook of Middle American Indians,* vol. 1, pp. 33–83. University of Texas Press, Austin.
Willey, Gordon R.
 1958 "Estimated Correlations and Dating of South and Central American Culture Sequences," *American Antiquity,* vol. 23, no. 4, pp. 353–378. Salt Lake City, Utah.
Williams, Howel
 1952 "Geologic Observations on the Ancient Human Footprints near Managua, Nicaragua," *Contributions to American Anthropology and History,* pp. 1–31. Carnegie Institution of Washington, Publication 596. Washington, D.C.

CHAPTER 2. THE EARLIEST VILLAGERS

Balser, Carlos
 1971 "Una extensión de la cultura de 'Los Barriles' de Panamá en territorio costarricense," *La Nación,* Monday, Nov. 8, p. 59. San José, Costa Rica.
Baudez, Claude F.
 1967 "Recherches archéologiques dans la vallée du Tempisque, Guanacaste, Costa Rica," *Travaux et Mémoires de l'Institut des Hautes Etudes de l'Amérique Latine,* 18. Paris.
 1970 *Central America.* Barrie and Jenkins, London.
Baudez, Claude F., and Pierre Becquelin
 1969 "La séquence céramique de Los Naranjos, Honduras," *Verhandlungen des 38 Internationalen Amerikanistenkongresses,* vol. 1, pp. 221–227. Stuttgart-Munich.
Baudez, Claude F., and Michael D. Coe
 1962 "Archaeological Sequences in Northwestern Costa Rica," *Akten des 34 Internationalen Amerikanistenkongresses,* pp. 366–373. Vienna.
Bernal, Ignacio
 1969 *The Olmec World,* translated by D. Heyden and F. Horcasitas. University of California Press, Berkeley and Los Angeles.
Boggs, Stanley H.
 1950 *"Olmec" Pictographs in the Las Victorias Group, Chalchuapa Archaeological Zone, El Salvador.* Notes on Middle American Archaeology and Ethnology, vol. 4, no. 99. Carnegie Institution of Washington, Washington, D.C.
Borhegyi, Stephan F. de
 1965a "Archaeological Synthesis of the Guatemalan Highlands," *Handbook of Middle American Indians,* vol. 2, pp. 3–58. University of Texas Press, Austin.
 1965b "Settlement Patterns of the Guatemalan Highlands," *Handbook of Middle American Indians,* vol. 2, pp. 59–75.
Bronson, Bennet
 1966 "Roots and the Subsistence of the Ancient Maya," *Southwestern Journal of Anthropology,* vol. 22, pp. 251–279. Albuquerque, New Mexico.
Bullard, William R., Jr.
 1964 "Settlement Pattern and Social Structure in the Southern Maya Lowlands during the

Classic Period," *Actas y Memorias del 34 Congreso Internacional de Americanistas*, vol. 1, pp. 279–287. Mexico.

Canby, Joel S.
1951 "Possible Chronological Implications of the Long Ceramic Sequence Recovered at Yarumela, Spanish Honduras," *Selected Papers of the 29th International Congress of Americanists*, pp. 79–85. University of Chicago Press, Chicago, Illinois.

Coe, Michael D.
1959 "Archaeological Research on the Pacific Coast of Guatemala, "*Actas del 33 Congreso Internacional de Americanistas*, vol. 2, pp. 241–249. San José, Costa Rica.
1961 *La Victoria, An Early Site on the Pacific Coast of Guatemala*. Papers of the Peabody Museum, Harvard University, vol. 53. Cambridge, Massachusetts.
1965 "The Olmec Style and its Distributions," *Handbook of Middle American Indians*, vol. 3, pp. 739–775. University of Texas Press, Austin.

Coe, Michael D., and Claude F. Baudez
1961 "The Zoned Bichrome Period in Northwestern Costa Rica," *American Antiquity*, vol. 26, no. 4, pp. 505–515. Salt Lake City, Utah.

Coe, Michael D., and Kent V. Flannery
1967 *Early Cultures and Human Ecology in South Coastal Guatemala*. Smithsonian Contributions to Anthropology, vol. 3. Washington, D.C.

Covarrubias, Miguel
1946 "El Arte 'Olmeca' o de la Venta," *Cuadernos Americanos*, Año V, no. 4, pp. 153–179. Mexico.

Dixon, Keith A.
1959 *Ceramics from Two Preclassic Periods at Chiapa de Corzo, Chiapas, Mexico*. Papers of the New World Archaeological Foundation, no. 5. Publication no. 4. Orinda, California.

Drucker, Philip
1943 *Ceramic Stratigraphy at Cerro de las Mesas, Veracruz, Mexico*. Bureau of American Ethnology, Bulletin 141. Smithsonian Institution, Washington, D.C.
1948 "Preliminary Notes on an Archaeological Survey of the Chiapas Coast," *Middle American Research Records*, vol. 1, no. 11, pp. 151–169. Tulane University, New Orleans, Louisiana.

Easby, Elizabeth Kennedy
1968 *Pre-Columbian Jade from Costa Rica*, André Emmerich Inc., New York, New York.

Ekholm, Gordon F., and Clifford Evans
1962 "The Interrelationships of New World Cultures: A Co-ordinated Research Program of the Institute of Andean Research," *Akten des 34 Internationalen Amerikanistenkongresses*, pp. 253–278. Vienna.

Evans, Clifford, and B. J. Meggers
1957 "Formative Period Cultures in the Guayas Basin, Coastal Ecuador," *American Antiquity*, vol. 22, pp. 235–247. Salt Lake City, Utah.

Glass, John B.
1966 "Archaeological Survey of Western Honduras," *Handbook of Middle American Indians*, vol. 4, pp. 157–179. University of Texas Press, Austin.

Gordon, G. B.
1898 *Researches in the Uloa Valley, Honduras*. Memoirs of the Peabody Museum, Harvard University, vol. 1, no. 4. Cambridge, Massachusetts.

Green, Dee F., and Gareth W. Lowe
1967 *Altamira and Padre Piedra, Early Preclassic Sites in Chiapas, Mexico*. Papers of the New World Archaeological Foundation, no. 20. Publication no. 15. Brigham Young University, Provo, Utah.

Haberland, Wolfgang
1955 "Preliminary Report on the Aguas Buenas Complex, Costa Rica," *Ethnos*, vol. 20, no. 4, pp. 224–230. Stockholm.
1959 "A Re-appraisal of Chiriquian Pottery Types," *Actas del 33 Congreso Internacional de Americanistas*, vol. 2, pp. 339–346. San José, Costa Rica.
1960a "Ceramic Sequences in El Salvador," *American Antiquity*, vol. 26, no 1, pp. 21–29. Salt Lake City, Utah.
1962 "The Scarified Ware and the Early Cultures of Chiriqui (Panama)," *Akten des 34 Internationalen Amerikanistenkongresses*, pp. 381–389. Vienna.
1969 "Early Phases and their Relationship in Southern Central America," *Verhandlungen des 38 Internationalen Amerikanistenkongresses*, vol. 1, pp. 229–242. Stuttgart-Munich.

Harte, Eva M.
1958 *Guacamaya Indian Culture*. Panama.

Kidder, Alfred V., Jesse D. Jennings, and Edwin M. Shook
1946 *Excavations at Kaminaljuyu, Guatemala*. Carnegie Institution of Washington, Publication 561. Washington, D.C.

Ladd, John
1964 *Archeological Investigations in the Parita and Santa María Zones of Panamá.* Bureau of American Ethnology, Bulletin 193. Smithsonian Institution, Washington, D.C.

Lange, Frederick W.
1969 *An Archaeological Survey of the Rio Sapoa Valley.* Interim Report on a Preliminary Season of Archaeological Research in Northwestern Guanacaste Province, Republic of Costa Rica. Field Research conducted as part of the Central American Field Program of the Associated Colleges of the Midwest. Ibero-American Studies Program, University of Wisconsin, Madison, Wisconsin.

Linares de Sapir, Olga
1968 *Cultural Chronology of the Gulf of Chiriquí, Panama.* Smithsonian Contributions to Anthropology, vol. 8. Washington, D.C.

Longyear, John M., III
1951 "A Historical Interpretation of Copan Archeology," *Selected Papers of the 29th International Congress of Americanists,* pp. 86–92. University of Chicago Press, Chicago, Illinois.

Lothrop, Samuel K.
1927a "Pottery Types and their Sequence in El Salvador," *Indian Notes and Monographs,* vol. 1, no. 4, pp. 165–200. Museum of the American Indian, Heye Foundation, New York, New York.

1933 *Atitlan: An Archaeological Study of Ancient Remains on the Borders of Lake Atitlan, Guatemala.* Carnegie Institution of Washington, Publication 444. Washington, D.C.

1950 *Archaeology of Southern Veraguas, Panama.* Memoirs of the Peabody Museum, Harvard University, vol. 9, no. 3. Cambridge, Massachusetts.

1959a "A Re-appraisal of Isthmian Archaeology," *Amerikanistische Miszellen, Mitteilungen aus dem Museum für Völkerkunde und Vorgeschichte,* vol. 25, pp. 87–91. Hamburg.

1959b "The Archaeological Picture in Southern Central America," *Actas del 33 Congreso Internacional de Americanistas,* vol. 1, pp. 165–172. San José, Costa Rica.

1966 "Archaeology of Lower Central America," *Handbook of Middle American Indians,* vol. 4, pp. 180–208. University of Texas Press, Austin.

Lowe, Gareth W.
1960 "Brief Archaeological History of the Southwest Quadrant," *Excavations at Chiapa de Corzo, Chiapas, Mexico,* by Gareth W. Lowe and Pierre Agrinier. Papers of the New World Archaeological Foundation, no. 8, pp. 7–12. Publication no. 7. Brigham Young University, Provo, Utah.

Lowe, Gareth W., and J. Alden Mason
1965 "Archaeological Survey of the Chiapas Coast, Highlands, and Upper Grijalva Basin," *Handbook of Middle American Indians,* vol. 2, pp. 195–236. University of Texas Press, Austin.

Miles, S. W.
1965 "Sculpture of the Guatemala-Chiapas Highlands and Pacific Slopes, and Associated Hieroglyphs," *Handbook of Middle American Indians,* vol. 2, pp. 237–275. University of Texas Press, Austin.

Navarrete, Carlos
1960 *Archeological Explorations in the Region of the Frailesca, Chiapas, Mexico.* Papers of the New World Archaeological Foundation, no. 7. Publication no. 6. Orinda, California.

1972 "Fechamiento para un tipo de esculturas del sur de Mesoamérica," *Anales de Antropología.* Instituto de Investigaciones Históricas, Universidad Nacional Autónoma de México, vol. 9, pp. 45–52. Mexico.

Norweb, Albert Holden
1964 "Ceramic Stratigraphy in Southwestern Nicaragua," *Actas y Memorias del 35 Congreso Internacional de Americanistas,* vol. 1, pp. 551–561. Mexico.

Parsons, Lee A.
1967 *Bilbao, Guatemala.* Milwaukee Public Museum Publications in Anthropology, vol. 1. Milwaukee, Wisconsin

1969a "A Report on Archaeological Research in Western Guatemala," *News About the Peabody Museum and Department of Anthropology, Harvard University,* Summer, p. 4. Cambridge, Massachusetts.

1969b "Summary Report on the First Season of Excavation at Monte Alto, Escuintla, Guatemala: 1968–1969," *Informal Newsletter from the Peabody Museum-National Geographic Society Monte Alto Project,*

July 10, p. 4. Cambridge, Massachusetts.

Pollock, Harry E. D.
1965 "Architecture of the Maya Lowlands," *Handbook of Middle American Indians*, vol. 2, pp. 378–440. University of Texas Press, Austin.

Popenoe, Dorothy Hughes
1934 "Some Excavations at Playa de los Muertos, Ulua River, Honduras," *Maya Research, Alma Egan Hyatt Foundation*, vol. 1, no. 2, pp. 61–81. New York, New York.

Ricketson, Oliver G., and Edith Bayles Ricketson
1937 *Uaxactun, Guatemala, Group E, 1926–1931*. Carnegie Institution of Washington, Publication 477. Washington, D.C.

Root, William C.
1961 "Pre-Columbian Metalwork of Colombia and its Neighbors," *Essays in Pre-Columbian Art and Archaeology* by Samuel K. Lothrop and others, pp. 242–257. Harvard University Press, Cambridge, Massachusetts.

Ruz Lhuillier, Alberto
1965 "Tombs and Funerary Practices in the Maya Lowlands," *Handbook of Middle American Indians*, vol. 2, pp. 441–461. University of Texas Press, Austin.

Sander, Dan
1961 "An Archaeological Discovery: Rio Negro," *Panama Archaeologist*, vol. 4, pp. 1–3. Canal Zone.

Shook, Edwin M.
1951 "The Present Status of Research on the Pre-Classic Horizons in Guatemala," *The Civilizations of Ancient America*. Selected Papers of the 29th International Congress of Americanists, pp. 93–100. Chicago, Illinois.
1965 "Archaeological Survey of the Pacific Coast of Guatemala," *Handbook of Middle American Indians*, vol. 2, pp. 180–194. University of Texas Press, Austin.

Shook, Edwin M., and Alfred V. Kidder
1952 "Mound E–III–3, Kaminaljuyu, Guatemala," *Contributions to American Anthropology and History*, vol. 9, no. 53, pp. 33–129. Carnegie Institution of Washington, Publication 596. Washington, D.C.

Smith, A. Ledyard
1950 *Uaxactun, Guatemala: Excavations of 1931–1937*. Carnegie Institution of Washington, Publication 588. Washington, D.C.

1961 "Types of Ball Courts in the Highlands of Guatemala," *Essays in Pre-Columbian Art and Archaeology* by Samuel K. Lothrop and others, pp. 100–125. Harvard University Press, Cambridge, Massachusetts.

Smith, Robert E.
1955 *Ceramic Sequence at Uaxactun, Guatemala*. Middle American Research Institute, Publication 20. 2 vols. Tulane University, New Orleans, Louisiana.

Spinden, Herbert J.
1915 "Notes on the Archeology of Salvador," *American Anthropologist*, vol. 17, pp. 446–487. Lancaster, Pennsylvania.

Stirling, Matthew W.
1943 *Stone Monuments of Southern Mexico*. Bureau of American Ethnology, Bulletin 138. Smithsonian Institution, Washington, D.C.
1950 "Exploring Ancient Panama by Helicopter," *National Geographic Magazine*, vol. 97, no. 2, pp. 227–246. Washington, D.C.
1961 "The Olmecs, Artists in Jade," *Essays in Pre-Columbian Art and Archaeology* by Samuel K. Lothrop and others, pp. 43–59. Harvard University Press, Cambridge, Massachusetts.
1964 "Archeological Investigations in Costa Rica," *National Geographic Society Research Reports, 1964 Projects*, pp. 239–247. Washington, D.C.

Stirling, Matthew W., and Marion Stirling
1964 "El Limón, an Early Tomb Site in Coclé Province, Panama," *Anthropological Paper*, no. 71, pp. 251–254, Bureau of American Ethnology, Bulletin 191. Smithsonian Institution, Washington, D.C.

Stone, Doris
1956a "Breve esbozo etnológico de los pueblos indígenas costarricenses," *Estudios Antropológicos*, pp. 503–511. Mexico.
1956b "Date of Maize in Talamanca, Costa Rica: An Hypothesis," *Journal de la Société des Américanistes*, new series, vol. 45, pp. 189–194. Paris.
1962 *The Talamancan Tribes of Costa Rica*. Papers of the Peabody Museum, Harvard University, vol. 43, no. 2. Cambridge, Massachusetts.
1966a "Synthesis of Lower Central American Ethnohistory," *Handbook of Middle Amer-*

ican Indians, vol. 4, pp. 209–233. University of Texas Press, Austin.

1966b *Introduction to the Archaeology of Costa Rica*, revised edition. Museo Nacional, San José, Costa Rica.

In Press "Las figuras articuladas de arcilla en Mesoamérica," *Actas del 39 Congreso Internacional de Americanistas*. Lima.

Stromsvik, Gustav
1947 *Guide Book to the Ruins of Copan.* Carnegie Institution of Washington, Publication 577. Washington, D.C. (Reprinted in 1952.)

Strong, William Duncan
1948 "The Archeology of Honduras," *Handbook of South American Indians*, vol. 4. Bureau of American Ethnology, Bulletin 143, pp. 71–120. Washington, D.C.

Strong, William, Alfred Kidder, II, and A. J. Drexel Paul, Jr.
1938 *Preliminary Report on the Smithsonian Institution-Harvard University Archeological Expedition to Northwestern Honduras, 1936.* Smithsonian Miscellaneous Collections, vol. 97, no. 1. Washington, D.C.

Thompson, J. Eric S.
1965 "Archaeological Synthesis of the Southern Maya Lowlands," *Handbook of Middle American Indians*, vol. 2, pp. 331–359. University of Texas Press, Austin.

Torres de Araúz, Reina
1966 *Arte precolombino de Panamá.* Panama.

Vaillant, George C.
1930 *Excavations at Zacatenco.* American Museum of Natural History, Anthropological Papers, vol. 32, pt. 1. New York, New York.

1934 "The Archaeological Setting of the Playa de los Muertos Culture," *Maya Research*, vol. 1, no. 2, pp. 87–100. New York, New York.

Warren, Bruce W.
1959 "New Discoveries in Chiapas, Southern Mexico," *Archaeology*, vol. 12, pp. 98–105.

Willey, Gordon R.
1959 "The 'Intermediate Area' of Nuclear America: Its Prehistoric Relationships to Middle America and Peru," *Actas del 33 Congreso Internacional de Americanistas*, vol. 1, pp. 184–194. San José, Costa Rica.

Willey, Gordon R., and William R. Bullard, Jr.
1965 "Prehistoric Settlement Patterns in the Maya Lowlands," *Handbook of Middle American Indians*, vol. 2, pp. 360–377. University of Texas Press, Austin.

Willey, Gordon R., and Charles R. McGimsey
1954 *The Monagrillo Culture of Panama.* Papers of the Peabody Museum, Harvard University, vol. 49, no. 2. Cambridge, Massachusetts.

Willey, Gordon R., Gordon F. Ekholm, and René F. Millon
1964 "The Patterns of Farming Life and Civilization," *Handbook of Middle American Indians*, vol. 1, pp. 446–498. University of Texas Press, Austin.

CHAPTER 3. THE MEXICAN VENEER

Adams, Richard E. W.
1969 "Maya Archaeology 1958–1968, A Review," *Latin American Research Review*, vol. 4, no. 2, pp. 3–45. University of Texas Press, Austin.

Andrews, E. Wyllys, V
1969 "Excavations at Quelepa, Eastern El Salvador," a paper read before the 68th Annual Meeting of the American Anthropological Association, November 20. Manuscript.

Baudez, Claude E.
1962 "Rapport préliminaire sur les recherches archéologiques entreprises dans la vallée du Tempisque-Guanacaste-Costa Rica," *Akten*

des 34 Internationalen Amerikanistenkongresses, pp. 348–357. Vienna.

1967 "Recherches archéologiques dans la vallée du Tempisque, Guanacaste, Costa Rica," *Travaux et Mémoires de l'Institut des Hautes Etudes de l'Amérique Latine*, 18. Paris.

Baudez, Claude F., and Pierre Becquelin
1969 "La séquence céramique de Los Naranjos, Honduras," *Verhandlungen des 38 Internationalen Amerikanistenkongresses*, vol. 1, pp. 221–227. Stuttgart-Munich.

Baudez, Claude F., and Michael D. Coe
1962 "Archaeological Sequences in Northwestern

Costa Rica," *Akten des 34 Internationalen Amerikanistenkongresses*, pp. 366–375. Vienna.

Biese, Leo P.
1964 "The Prehistory of Panamá Viejo," *Anthropological Papers*, no. 68, pp. 1–51. Bureau of American Ethnology, Bulletin 191. Smithsonian Institution, Washington, D.C.

Bischof, Henning
1969 "La cultura Tairona en el area intermedio," *Verhandlungen des 38 Internationalen Amerikanistenkongresses*, vol. 1, pp. 271–280. Stuttgart-Munich.

Boggs, Stanley H.
1954 "Informe sobre la tercera temporada de excavaciones en las ruinas de 'Tazumal'," *Tzunpame*, vol. 5, no. 4, pp. 33–45. San Salvador.

Borhegyi, Stephan F. de
1964 "Pre-Columbian Cultural Similarities and Differences between the Highland Guatemalan and Tropical Rainforest Mayas," *Actas y Memorias del 35 Congreso Internacional de Americanistas*, vol. 1, pp. 215–224. Mexico.
1965a "Archaeological Synthesis of the Guatemalan Highlands," *Handbook of Middle American Indians*, vol. 2, pp. 3–58. University of Texas Press, Austin.

Bovallius, Carl
1887 *Resa I Central-Amerika.* Upsala.

Coe, Michael D.
1962 "Preliminary Report on Archaeological Investigations in Coastal Guanacaste, Costa Rica," *Akten des 34 Internationalen Amerikanistenkongresses*, pp. 358–365. Vienna.

Coe, William R.
1965a "Tikal: Ten Years of Study of a Maya Ruin in the Lowlands of Guatemala," *Expedition*, vol. 8, no. 1, pp. 5–56. University Museum, University of Pennsylvania, Philadelphia.
1965b "Tikal, Guatemala, and Emergent Maya Civilization," *Science* (March 19), vol. 147, no. 3664, pp. 1401–1419. Washington, D.C.

Dumond, D. E., and Florencia Muller
1972 "Classic to Postclassic in Highland Central Mexico," *Science* (March 17), vol. 175, no. 4027, pp. 1208–1215.

Durando, Ottavio
1959 "Primer estudio espectroquímico y geo-quimico de artefactos metálicos encontrados en tumbas de indios de Costa Rica," *Actas del 33 Congreso Internacional de Americanistas*, vol. 2, pp. 327–338. San José, Costa Rica.

Ekholm, Gordon F., and Clifford Evans
1962 "The Interrelationships of New World Cultures: A Co-ordinated Research Program of the Institute of Andean Research," *Akten des 34 Internationalen Amerikanistenkongresses*, pp. 253–278. Vienna.

Haberland, Wolfgang
1960b "Villalba, A Preliminary Report," *Panama Archaeologist*, vol. 3, pp. 9–21. Canal Zone.

Jiménez Moreno, Wigberto
1954–55 "Síntesis de la historia precolonial del valle de México," *Revista Mexicana de Estudios Antropológicos*, vol. 14, pp. 219–236. Mexico.
1959 "Síntesis de la historia pretolteca de Mesoamérica," *Esplendor del México Antiguo*, edited by C. Cook de Leonard, vol. 2, pp. 1019–1108. Mexico.
1966 "Mesoamerica before the Toltecs," *Ancient Oaxaca*, edited by John Paddock, pp. 1–85. Stanford University Press, Stanford, California.

Kennedy, William Jerald
1968 "Archaeological Investigation in the Reventazon River Drainage Area, Costa Rica." Unpublished Ph.D. dissertation, Tulane University, New Orleans, Louisiana.

Kidder, Alfred V., Jesse D. Jennings, and Edwin M. Shook
1946 *Excavations at Kaminaljuyu, Guatemala.* Carnegie Institution of Washington, Publication 561. Washington, D.C.

Ladd, John
1964 *Archeological Investigations in the Parita and Santa María Zones of Panamá.* Bureau of American Ethnology, Bulletin 193. Smithsonian Institution, Washington, D.C.

Lehmann, Walter
1920 *Zentral-Amerika. (Die Sprachen Zentral-Amerikas.)* 2 vols. Berlin.

Linares de Sapir, Olga
1968 *Cultural Chronology of the Gulf of Chiriquí, Panama.* Smithsonian Contributions to Anthropology, vol. 8. Washington, D.C.

Linné, S.
1929 "Darien in the Past," *Göteborgs Kungl.*

Vetenskaps- och Vitterhets-Samhälles Hand-lingar, femte följden, ser. A, I:3. Gothen-burg.

Longyear, John M., III

1952 *Copan Ceramics: A Study of Southeastern Maya Pottery*. Carnegie Institution of Washington, Publication 597. Washington, D.C.

1966 "Archaeological Survey of El Salvador," *Handbook of Middle American Indians*, vol. 4, pp. 132–156. University of Texas Press, Austin.

Lothrop, Samuel K.

1926 *Pottery of Costa Rica and Nicaragua*. Contributions from the Museum of the American Indian, Heye Foundation, vol. 8. 2 vols. New York, New York.

1937 *Coclé: An Archaeological Study of Central Panama*, Part 1. Memoirs of the Peabody Museum, Harvard University, vol 7. Cambridge, Massachusetts.

1942a *Coclé: An Archaeological Study of Central Panama*, Part 2. Memoirs of the Peabody Museum, Harvard University, vol. 8. Cambridge, Massachusetts.

1952 *Metals from the Cenote of Sacrifice, Chichen Itza, Yucatan*. Memoirs of the Peabody Museum, Harvard University, vol. 10, no. 2. Cambridge, Massachusetts.

1954 "Suicide, Sacrifice and Mutilations in Burials at Venado Beach, Panama," *American Antiquity*, vol. 19, no. 3, pp. 226–234. Salt Lake City.

1959a "A Re-appraisal of Isthmian Archaeology," *Amerikanistische Miszellen, Mitteilungen aus dem Museum für Völkerkunde und Vorgeschichte*, vol. 25, pp. 87–91. Hamburg.

1959b "The Archaeological Picture in Southern Central America," *Actas del 33 Congreso Internacional de Americanistas*, vol. 1, pp. 165–172. San José, Costa Rica.

1963 *Archaeology of the Diquís Delta, Costa Rica*. Papers of the Peabody Museum, Harvard University, vol. 51. Cambridge, Massachusetts.

1966 "Archaeology of Lower Central America," *Handbook of Middle American Indians*, vol. 4, pp. 180–208. University of Texas Press, Austin.

Lowe, Gareth W.

1959 *Research in Chiapas, Mexico*. Papers of the New World Archaeological Foundation, nos. 1–2. Publication no. 3. Orinda, California.

Lowe, Gareth W., and J. Alden Mason

1965 "Archaeological Survey of the Chiapas Coast, Highlands, and Upper Grijalva Basin," *Handbook of Middle American Indians*, vol. 2, pp. 195–236. University of Texas Press, Austin.

McGimsey, Charles R., III

1959 "A Survey of Archeologically Known Burial Practices in Panama," *Actas del 33 Congreso Internacional de Americanistas*, vol. 2, pp. 346–356. San José, Costa Rica.

Miles, S. W.

1965 "Sculpture of the Guatemala-Chiapas Highlands and Pacific Slopes, and Associated Hieroglyphs," *Handbook of Middle American Indians*, vol. 2, pp. 237–275. University of Texas Press, Austin.

Norweb, Albert Holden

1964 "Ceramic Stratigraphy in Southwestern Nicaragua," *Actas Memorias del 35 Congreso Internacional de Americanistas*, vol. 1, pp. 551–561. Mexico.

Oviedo y Valdés, Gonzalo Fernández de

1851–55 *Historia general y natural de las Indias, islas y tierra-firme del mar océano*. J. Amador de los Ríos, editor. 4 vols. Madrid.

Parsons, Lee A.

1967 *Bilbao, Guatemala*. Milwaukee Public Museum Publications in Anthropology, vol. 1. Milwaukee, Wisconsin.

Ponce, Alonso

1873 *Relación breve y verdadera de algunas cosas de las muchas que sucedieron al Padre Alonso Ponce en las provincias de la Nueva España, siendo comisario general de aquellas partes . . . escrita por dos religiosos, sus compañeros*, 2 vols. Madrid.

Puleston, Dennis E., and Donald W. Callender, Jr.

1967 "Defensive Earthworks at Tikal," *Expedition*, vol. 9, no. 3, pp. 40–48. University Museum, University of Pennsylvania, Philadelphia.

Rands, Robert L., and Robert E. Smith

1965 "Pottery of the Guatemalan Highlands," *Handbook of Middle American Indians*, vol. 2, pp. 95–145. University of Texas Press, Austin.

Richardson, Francis B.

1940 "Non-Maya Monumental Sculpture of Cen-

tral America," *The Maya and their Neigh-bors*, pp. 395–416. Appleton-Century, New York, New York.

Root William C.
1961 "Pre-Columbian Metalwork of Colombia and its Neighbors," *Essays in Pre–Colum-bian Art and Archaeology* by Samuel K. Lothrop and others, pp. 242–257. Harvard University Press, Cambridge, Massachu-setts.

Sabloff, Jeremy A., and Gordon R. Willey
1967 "The Collapse of Maya Civilization in the Southern Lowlands," *Southwestern Jour-nal of Anthropology*, vol. 23, no. 4, pp. 311–336. Albuquerque, New Mexico.

Shepard, Anna O.
1948 *Plumbate: A Mesoamerican Trade Ware.* Carnegie Institution of Washington, Pub-lication 573. Washington, D.C.

Smith, A. Ledyard, and Alfred V. Kidder
1951 *Excavations at Nebaj, Guatemala, with Notes on the Skeletal Material by T. D. Stewart.* Carnegie Institution of Washing-ton, Publication 594. Washington, D.C.

Smith, Robert E., and James C. Gifford
1965 "Pottery of the Maya Lowlands," *Hand-book of Middle American Indians*, vol. 2, pp. 498–534. University of Texas Press, Austin.

Stone, Doris
1941 *Archaeology of the North Coast of Hon-duras.* Memoirs of the Peabody Museum, Harvard University, vol. 9, no. 1. Cam-bridge, Massachusetts.
1943 "A Preliminary Investigation of the Flood Plain of the Rio Grande de Térraba, Costa Rica," *American Antiquity*, vol. 9, no. 1, pp. 74–88. Menasha, Wisconsin.
1966a "Synthesis of Lower Central American Ethnohistory," *Handbook of Middle Ameri-*

can Indians, vol. 4, pp. 209–233. Univer-sity of Texas Press, Austin.
1966b *Introduction to the Archaeology of Costa Rica*, revised edition. Museo Nacional, San José, Costa Rica.
1966/67 "The Significance of Certain Styles of Ulua Polychrome Ware from Honduras," *Folk*, vols. 8–9, pp. 335–342. Copenhagen.
In Press "An Interpretation of Furnishings from a Grave at Nacascolo, Province of Guanacaste, Costa Rica."

Stone, Doris, and Gerdt Kutscher
In Press *Bilderatlas zur Archäologie Zentralamer-ikas*. Katalog des von W. Lehmann gesam-melten Materials. Monumenta Americana, 5. Berlin.

Stromsvik, Gustav
1936 "Copan," *Carnegie Yearbook*, no. 35, pp. 117–120. Carnegie Institution of Washing-ton, Washington, D.C.

Thompson, J. Eric S.
1948 *An Archaeological Reconnaissance in the Cotzumalhuapa Region, Escuintla, Guate-mala.* Carnegie Institution of Washington, Publication 574. Washington, D.C.

Verrill, A. Hyatt
1927 "Excavations in Coclé Province, Panama," *Indian Notes*, vol. 4, no. 1, pp. 47–61. Mu-seum of the American Indian, Heye Foun-dation, New York, New York.

Warren, Bruce W.
1964 "A Hypothetical Construction of Mayan Origins," *Actas y Memorias del 35 Con-greso Internacional de Americanistas*, vol. 1, pp. 289–305. Mexico.

Willey, Gordon R., and Charles R. McGimsey
1954 *The Monagrillo Culture of Panama.* Papers of the Peabody Museum, Harvard Univer-sity, vol. 49, no. 2. Cambridge, Massachu-setts.

CHAPTER 4. EMPIRE AND TRADE

Aguilar P., Carlos H.
1953 "Retes, un depósito arqueológico en las faldas del Irazu," *Editorial Universitario*, no. 5. San José, Costa Rica.
In Press "Estado actual de la investigación en Guayabo de Turrialba," *Actas del 39 Con-greso Internacional de Americanistas*. Lima.

Alva Ixtlilxochitl, Fernando de

1891–92 *Obras históricas*, vol. 1, *Relaciones; publicadas y anotadas por Alfredo Cha-vero*. Mexico.

Alvarado Tezozomoc, Hernando
1878 *Crónica mexicana escrita por D. Hernando Alvarado Tezozomoc, hacia el año de 1598; anotada por el Sr. Lic. D. Manuel Orozco y Berra y precedida del Codice Ramirez,*

manuscrito del siglo XVI intitulado: Relación del origen de los indios que habitan esta Nueva España según sus historias José M. Vigil, editor. Mexico.

Andagoya, Pascual de
1865 *Narrative of the Proceedings of Pedrarias Dávila in the Provinces of Tierra Firme or Castilla del Oro, and of the Discovery of the South Sea and the Coasts of Peru and Nicaragua*, translated and edited by Clements R. Markham. Hakluyt Society, ser. 1, no. 34. London.

Andrews, E. Wyllys
1965 "Archaeology and Prehistory in the Northern Maya Lowlands: An Introduction," *Handbook of Middle American Indians*, vol. 2, pp. 288–330. University of Texas Press, Austin.

Baudez, Claude F., and Pierre Becquelin
1969 "La séquence céramique de Los Naranjos, Honduras," *Verhandlungen des 38 Internationalen Amerikanistenkongresses*, vol. 1, pp. 221–227. Stuttgart-Munich.

Blackiston, A. H.
1910 "Recent Discoveries in Honduras," *American Anthropologist*, vol. 12, pp. 536–641. Lancaster, Pennsylvania.

Blom, Frans
1932 "Commerce, Trade and Monetary Units of the Maya," *Middle American Research Series*, no. 4, pp. 531–553. Tulane University New Orleans, Louisiana.

Borhegyi, Stephan F. de
1965a "Archaeological Synthesis of the Guatemalan Highlands," *Handbook of Middle American Indians*, vol. 2, pp. 3–58. University of Texas Press, Austin.
1965b "Settlement Patterns of the Guatemalan Highlands," *Handbook of Middle American Indians*, vol. 2, pp. 59–75. University of Texas Press, Austin.

Churchill, Awnsham
1744 *A Collection of Voyages and Travels*, 6 vols. London.

Dahlgren de Jordán, Barbro
1951 "Un petroglifo mixteca en la Guayana Británica," *Homenaje al Doctor Alfonso Caso*, J. Comas et al., editors, pp. 127–132. Mexico.

de Candolle, Alphonse
1959 *Origin of Cultivated Plants*. Hafner Publishing Company, New York, New York.

de Vries, H., et al.
1958 "Groningen Radiocarbon Dates 11," *Science* (Jan. 17), vol. 127, pp. 129–137.

Dibble, Charles E., and Arthur J. O. Anderson
1957 "Florentine Codex," *General History of the Things of New Spain* by Fray Bernardino de Sahagun. Monographs of the School of American Research and Museum of New Mexico, no. 14, part 10, book 9. Santa Fe.

Fernández, Leon
1881–1907 *Colección de documentos para la historia de Costa Rica*. 10 vols. San José, Paris, Barcelona.

Glass, John B.
1966 "Archaeological Survey of Western Honduras," *Handbook of Middle American Indians*, vol. 4, pp. 157–179. University of Texas Press, Austin.

Herrera, Antonio de
1726–30 *Historia general de los hechos de los castellanos en las islas i tierra-firme del mar océano*. 5 vols. Madrid.

Jiménez Moreno, Wigberto
1959 "Síntesis de la historia pretolteca de Mesoamérica," *Esplendor del México Antiguo*, edited by C. Cook de Leonard, vol. 2, pp. 1019–1108. Mexico, D.F.

Kennedy, William Jerald
1968 "Archaeological Investigation in the Reventazon River Drainage Area, Costa Rica." Unpublished Ph.D. dissertation, Tulane University, New Orleans, Louisiana.

Ladd, John
1964 *Archeological Investigations in the Parita and Santa María Zones of Panamá*. Bureau of American Ethnology, Bulletin 193. Smithsonian Institution. Washington, D.C.

Lehmann, Walter
1920 *Zentral-Amerika. (Die Sprachen Zentral-Amerikas.)* 2 vols. Berlin.

Linares de Sapir, Olga
1968 *Cultural Chronology of the Gulf of Chiriquí, Panama.* Smithsonian Contributions to Anthropology, vol. 8. Washington, D.C.

Longyear, John M., III
1966 "Archaeological Survey of El Salvador," *Handbook of Middle American Indians*, vol. 4, pp. 132–156. University of Texas Press, Austin.

López de Cogolludo, Diego
1867–68 *Historia de Yucatán*, vol. 1. 3rd ed. Merida.

López de Gómara, Francisco
1954 *Historia general de las Indias*, 2 vol. Barcelona.
Lothrop, Samuel K.
1926 *Pottery of Costa Rica and Nicaragua*. Contributions from the Museum of the American Indian, Heye Foundation, vol. 8. 2 vols. New York, New York.
1927a "Pottery Types and their Sequence in El Salvador," *Indian Notes and Monographs*, vol. 1, no. 4, pp. 165–200. Museum of the American Indian, Heye Foundation, New York, New York.
1927b "The Word 'Maya' and the Fourth Voyage of Columbus," *Indian Notes*, vol. 4, no. 4, pp. 350–363. Museum of the American Indian, Heye Foundation, New York, New York.
1933 *Atitlan: An Archaeological Study of Ancient Remains on the Borders of Lake Atitlan, Guatemala*. Carnegie Institution of Washington, Publication 444. Washington, D.C.
1942a *Coclé: An Archaeological Study of Central Panama*, Part 2. Memoirs of the Peabody Museum, Harvard University, vol. 8. Cambridge, Massachusetts.
1942b "The Sigua: Southernmost Aztec Outpost," *Proceedings: Eighth American Scientific Congress*, vol. 2, pp. 109–116. Washington, D.C.
1948 "The Archeology of Panama," *Handbook of South American Indians*, vol. 4, pp. 143–167. Bureau of American Ethnology, Bulletin 143. Smithsonian Institution, Washington, D.C.
1950 *Archaeology of Southern Veraguas, Panama*. Memoirs of the Peabody Museum, Harvard University, vol. 9, no. 3. Cambridge, Massachusetts.
1952 *Metals from the Cenote of Sacrifice, Chichen Itza, Yucatan*. Memoirs of the Peabody Museum, Harvard University, vol. 10, no. 2. Cambridge, Massachusetts.
1963 *Archaeology of the Diquís Delta, Costa Rica*. Papers of the Peabody Museum, Harvard University, vol. 51. Cambridge, Massachusetts.
1966 "Archaeology of Lower Central America," *Handbook of Middle American Indians*, vol. 4, pp. 180–208. University of Texas Press, Austin.

Lowe, Gareth W., and J. Alden Mason
1965 "Archaeological Survey of the Chiapas Coast, Highlands, and Upper Grijalva Basin," *Handbook of Middle American Indians*, vol. 2, pp. 195–236. University of Texas Press, Austin.
MacNutt, Francis Augustus, editor
1908 *Letters of Cortes. The Five Letters of Relation from Fernando Cortes to the Emperor, Charles V*, translated and edited with a biographical introduction and notes compiled from original sources. 2 vols. New York and London.
Martinez del Río, Pablo
1966 "Tula en el cuadro de las civilizaciónes prehispánicas," *Tula: Guia Oficial*, pp. 11–19. Mexico.
Mártir de Anglería, Pedro
1944 *Décadas del nuevo mundo*. Buenos Aires.
Oviedo y Valdés, Gonzalo Fernández de
1851–55 *Historia general y natural de las Indias, islas y tierra-firme del mar océano*. J. Amador de los Ríos, editor. 4 vols. Madrid.
Patiño, Victor Manuel
1963 *Plantas cultivadas y animales domésticos en América equinoccial*, vol. 1, *Frutales*. Cali, Colombia.
Peralta, M. M. de
1883 *Costa-Rica, Nicaragua y Panamá, en el siglo XVI*. Madrid.
Ponce, Alonso
1873 *Relación breve y verdadera de algunas cosas de las muchas que sucedieron al Padre Fray Alonso Ponce en las provincias de la Nueva España, siendo comisario general de aquellas partes . . . escrita por dos religiosos, sus compañeros*. 2 vols. Madrid.
Rands, Robert L., and Robert E. Smith
1965 "Pottery of the Guatemalan Highlands," *Handbook of Middle American Indians*, vol. 2, pp. 95–145. University of Texas, Austin.
Rouse, Irving
1948 "The Arawak," *Handbook of South American Indians*, vol. 4, pp. 507–546. Bureau of American Ethnology, Bulletin 143. Smithsonian Institution, Washington, D.C.
Seler, Eduard
1960–61 *Gesammelte Abhandlungen zur amerikanischen Sprach- und Alterthumskunde*. 5 vols. Akademische Druck-U. Verlagsanstalt. 2nd ed. Graz, Austria.

Serrano y Sanz, editor
1908 *Relaciones históricas y geográficas de América Central.* Colección de libros y documentos referentes a la historia de América, vol. 8. Madrid.

Shepard, Anna O.
1948 *Plumbate: A Mesoamerican Trade Ware.* Carnegie Institution of Washington, Publication 573. Washington, D.C.

Spinden, Herbert J.
1915 "Notes on the Archeology of Salvador," *American Anthropologist*, vol. 17, pp. 466–487. Lancaster, Pennsylvania.

Stirling, Matthew W.
1949 "Exploring the Past in Panama," *National Geographic Magazine*, vol. 95, no. 3, pp. 373–400. Washington, D.C.
1950 "Exploring Ancient Panama by Helicopter," *National Geographic Magazine*, vol. 97, no. 2, pp. 227–246. Washington, D.C.

Stone, Doris
1946 "La posición de los Chorotegas en la arqueología centroamericana," *Revista Mexicana de Estudios Antropológicos*, vol. 8, nos. 1, 2, 3, pp. 121–131. Mexico.
1948 "The Basic Cultures of Central America," *Handbook of South American Indians*, vol. 4, pp. 169–193. Bureau of American Ethnology, Bulletin 143. Smithsonian Institution, Washington, D.C.
1954 *Estampas de Honduras.* Impresora Galve, S.A. Mexico.
1957 *The Archaeology of Central and Southern Honduras.* Papers of the Peabody Museum, Harvard University, vol. 49, no. 3. Cambridge, Massachusetts.
1961 "The Stone Sculpture of Costa Rica," *Essays in Pre-Columbian Art and Archaeology* by Samuel K. Lothrop and others, pp. 192–209. Harvard University Press, Cambridge, Massachusetts.
1962 *The Talamancan Tribes of Costa Rica.* Papers of the Peabody Museum, Harvard University, vol. 43, no. 2. Cambridge, Massachusetts.
1963 "Cult Traits in Southeastern Costa Rica and their Significance," *American Antiquity*, vol. 28, no. 3, pp. 339–359. Salt Lake City, Utah.
1966a "Synthesis of Lower Central American Ethnohistory," *Handbook of Middle American Indians*, vol. 4, pp. 209–233. University of Texas Press, Austin.

1966b *Introduction to the Archaeology of Costa Rica.* rev. ed. Museo Nacional, San José, Costa Rica.
In Press "Las figuras articuladas de arcilla en Mesoamérica," *Actas del 39 Congreso Internacional de Americanistas.* Lima.

Stone, Doris, and Carlos Balser
1958 *The Aboriginal Metalwork in the Isthmian Region of America.* Museo Nacional, San José, Costa Rica.

Stone, Doris, and Gerdt Kutscher
In Press *Bilderatlas zur Archäologie Zentralamerikas.* Katalog des von W. Lehmann gesammelten Materials. Monumenta Americana, 5. Berlin.

Strong, William, Alfred Kidder, II, and A. J. Drexel Paul, Jr.
1938 *Preliminary Report on the Smithsonian Institution-Harvard University Archeological Expedition to Northwestern Honduras, 1936.* Smithsonian Miscellaneous Collections, vol. 97, no. 1. Washington, D.C.

Thompson, J. Eric S.
1970 *Maya History and Religion.* University of Oklahoma Press, Norman.

Torquemada, Juan de
1943 *Monarquía Indiana.* 3 vols. 3rd ed. Mexico.

Tozzer, Alfred M.
1941 *Landa's Relación de las cosas de Yucatan,* edited with notes. Papers of the Peabody Museum, Harvard University, vol. 18. Cambridge, Massachusetts.
1957 *Chichen Itza and its Cenote of Sacrifice. A Comparative Study of Contemporaneous Maya and Toltec.* Memoirs of the Peabody Museum, Harvard University, vols. 11, 12. Cambridge, Massachusetts.

Vásquez de Espinosa, Antonio
1942 *Compendium and Description of the West Indies,* translated by Charles Upson Clark. Smithsonian Miscellaneous Collections, vol. 102. Smithsonian Institution, Washington, D.C.

Wauchope, Robert
1941 "Effigy Head Vessel Supports from Zacualpa, Guatemala," *Los Mayas Antiguos*, pp. 211–231. Fondo de Cultura Economica, Mexico.
1942 "Cremations at Zacualpa, Guatemala," *Proceedings, 27th International Congress of Americanists*, vol. 1, pp. 564–573. Mexico.

Index